NICOLAS POUSSIN

Texts

Yuri Zolotov
Natalia Serebriannaïa

Catalogue

Irina Kouznetsova
Marina Maïskaïa
Nadejda Petroussevitch
Natalia Serebriannaïa

Publishing Director: Paul ANDRÉ
Editor: Denise ANDRÉ
Designer: Isabelle DIAS
Computerised Typesetting: DES SOURIS ET DES PAGES

Printed by SAGER in La Loupe (28)
for Parkstone Editions
Copyright 4ᵉ trimestre 1994
ISBN 1 85995 069 8

NICOLAS POUSSIN

The master of colours

Russian Museums Collections
Paintings and drawings

PARKSTONE EDITIONS, BOURNEMOUTH
AURORA EDITIONS, ST. PETERSBURG

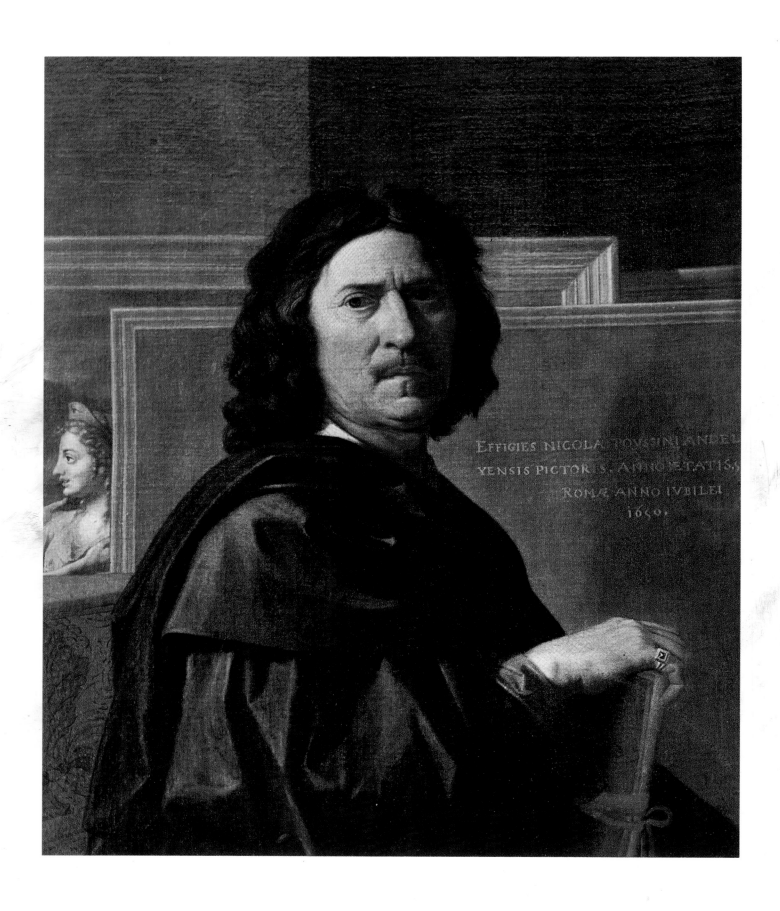

Nicolas Poussin, *Self-portrait.*
1650, Louvre, Paris.

NICOLAS POUSSIN, a great artist of the seventeenth century, was born in Normandy in 1594. Although he referred to himself as being from the small Normandy town of Les Andelys, it is thought by some that he actually came from Villers, a nearby village. The scenery of Poussin's native land is striking in its majestic beauty: the wide bed of the Seine, forced by bare rocky cliffs, makes a smooth turn around stately wooded hills. On top of one of the hills are the mediaeval ruins of the Château Gaillard, formidable even today. The buildings of Les Andelys stretch along a tributary to the Seine, which flows through a wide valley encircled by steep hills. Winding roads lead up to neighbouring villages. In the midst of such magnificence it is easy to understand the effect of the impressions of Poussin's childhood and adolescence on his future work. Undoubtedly, the striking native scenery helped shape his perception of the world. The future artist could not fail to know the wonderful stained-glass panels and reliefs of the town church which had been created by Renaissance masters of the sixteenth century. Though not of the first magnitude, these Renaissance artists gave the young Poussin, through their works, the opportunity to study classic artistic traditions and to develop a feel for plasticity of form and compositional rhythm.

Unfortunately, Poussin's contemporary biographers did not mention any facts of his youth and artistic formation. It is known, however, that he was noticed by Quentin Varin, a painter who came to Les Andelys to execute altarpieces for the local church. Although the visiting artist might have helped the talented young man with his advice, the typical late Mannerist style of the altarpieces, dated 1612, prevents regarding Varin as Poussin's teacher. That same year Poussin left for Paris where, judging by further developments, no patronage was awaiting him to facilitate the start of his career. A nobleman from Poitou gave the beginning artist shelter. An episode told by Poussin's Italian biographer, Giovanni Pietro Bellori, sheds light on their relationship:

when after some time the nobleman took Poussin to his castle in Poitou, his mother kept the young artist busy with "domestic affairs, not leaving him even a moment for his art.[1]" In other words, Poussin was considered a servant.

Proud, the young artist left his patron and headed back to Paris on foot. On his way he stopped at Blois, to execute altarpieces for the church there, and in Cheverny, to paint a few *Bacchanals* commissioned by the lord of the castle. None of the *Bacchanals* survived, but they were seen by André Félibien, the artist's French biographer, who wrote that Poussin "was very young when he did them" and that "one cannot fail to recognize in them the manner of this excellent painter.[2]" As familiar with Poussin's work as Félibien was, his statement testifies to the artist's early formation. It is known, however, that nothing has survived from his Normandy period, and practically nothing from his years in Paris (1612-23). The modern view of Poussin took shape on the basis of his work done at a more mature age, the mists of the centuries obscuring the image of the young artist. This, in part, explains the surprise now elicited by the remark of Giambattista Marino, an Italian poet and Poussin's contemporary, which characterized the youthful Poussin as being filled with a "devilish ardour[3]".

With this in mind, the dissatisfaction felt by Poussin at the studios of Parisian artists becomes more understandable. According to Bellori, "he was striving for knowledge, but found neither a teacher nor lessons to meet his aspirations... Over a short period of time he changed two teachers; one of little talent, the other — Ferdinand the Fleming — praised for his portraits; but both failed to further their gifted student's understanding of the invention of historical scenes or of the beauty of natural forms.[4]" These two teachers of Poussin were Ferdinand Elle and, most likely, Georges Lallemand[5]. Poussin, according to another seventeenth century author, left Lallemand's studio after a month, or perhaps even less, and stayed in Elle's for about three months, indicative of his disillusionment.

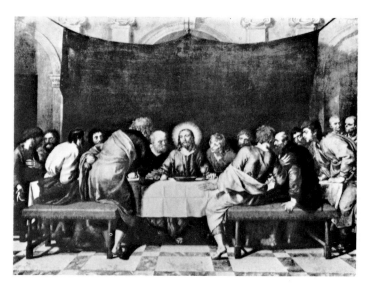

Frans Pourbus, *The Last Supper*.
1618, Louvre, Paris.

Ambroise Dubois (Bosschaert), *Tancred Baptizing Clorinde*.
Louvre, Paris.

It is not by chance that biographers, after criticizing his teachers, proceed to relate Poussin's discovery of engravings from the works of Raphael. The great Renaissance traditions proved to be the most attractive for the young artist, serving as compensation for the weakness of his casual Parisian teachers. A late seventeenth century art treatise explains this as follows: "Painting gains also from prints, and even to a greater degree than architecture, since they have given solid training to a number of artists. This is demonstrated by Marcantonio's engravings after Raphael's drawings, which taught many great graphic artists good taste in drawing. The famous Poussin is a good example of this, since during his youth in Paris he drew from excellent prints. It was then that this great painter fortunately appreciated the manner of Raphael and antiquity, which he successfully followed in all of his wonderful works.[6]"

After Poussin's unavailing stay in Poitou, his Paris life continued to be difficult. Poor health forced him to go back to his native Normandy for an entire year. Poussin returned to Paris (the exact date is unknown) and his painting studies, but soon started to look for a way to go to Italy and see its Renaissance and classical art — something scarce in Paris. According to Bellori, "he first got no farther than Florence, from where, after an accident of some sort halted his

progress, he went back to France.[7]" Bellori's casual mention of Florence, given the absence of details, is usually interpreted as an allusion to Poussin's abortive attempt to reach Rome. But there is more to it than that. In the seventeenth century, it was difficult for a beginning artist without means to travel to Italy. If there was no rich patron, then other ways had to be found. Some artists, the most impulsive and reckless, entered the ranks of mercenary troops. Who, then, was responsible for financing Poussin's trip to Florence?

It is tempting to connect his trip with the construction and decoration of the Palais de Luxembourg. Built for the French Queen, Marie de Médicis, it enlivened artistic life in Paris. Back in 1611, Marie de Médicis asked her aunt, the Duchess of Tuscany, for the plans of the Palazzo Pitti, in order to be guided by them "in the construction and decoration of my palace[8]". A few days later a builder was sent to Florence. Construction of the Palais de Luxembourg was started in 1615 and later Italian and French masters (especially those who had been to Italy, such as Guillaume Berthelot) were commissioned for its decoration. Shortly after Poussin's arrival in Paris he made the acquaintance of a certain Courtois, referred to by Bellori as the "royal mathematician" and now thought to have been the Queen's valet and custodian of the

8

royal art collection.[9] There is also Félibien's evidence that "Duchesne, then in charge of all painting work in the palace for Marie de Médicis, employed Poussin to execute a few small pieces for certain wainscots in the apartments.[10]" Though Félibien provides no date for the commission, the context indicates a relatively late stage of the work (early 1620s). It is, however, enough to confirm Poussin's connection with the decorators of the palace and to therefore allow for the possibility that Poussin's journey to Florence was the result of some order from the court.

Whether this was the case or not, the first major Italian artistic centre visited by the young Poussin was Florence. While the French master's artistic system was his own and independent, it was consistently based on the harmonious use of pure local colours, very much in keeping with the tradition of the Tuscan Quattrocento. The strength of the impressions made on Poussin during his visit to Florence, brief as it was, is clearly revealed in his works. Considering the insignificance of his Paris lessons, Poussin's visiting Florence before Venice and Rome possibly played a special role in his formation as an artist. "A few years later", wrote Bellori, "a second attempt to travel to Italy was undertaken but it came to naught.[11]"

Nicolas Poussin, *The Bull-Jupiter and Europa.* C. 1622-1623, Royal Library, Windsor Castle.

During these early years in Paris, according to one of his contemporaries, Poussin thought *The Last Supper* by Frans Pourbus the Younger and a composition by Toussaint Dubreuil "the two most beautiful paintings he ever saw.[12]" In the work by Pourbus, Poussin was perhaps attracted by the calm balance of the compositional scheme. As for Dubreuil, a master of the so-called second Fontainebleau school, it was only natural that the young Norman's attention be drawn to his painting. The artists working in the Royal Fontainebleau Palace at the turn of the seventeenth century were the most prominent figures in French art at the time. Moreover, they were considered to be continuing the traditions of the French Renaissance, for it was precisely at Fontainebleau that large fresco cycles were created in the sixteenth century. Poussin doubtless studied these murals and paintings. Pierre Jean Mariette stated that he had expressed complete approval of them and that he had noted that there was nothing better than the Galerie d'Ulysse frescoes by Primaticcio to "develop an artist and stimulate his talent[13]". Since Toussaint Dubreuil and Ambroise Dubois, another master of the second Fontainebleau school, later also worked in the same gallery, Poussin would also have been acquainted with their productions.

These painters, however, belonged to the late Mannerist trend, whose stereotypes, as his work testifies, were alien to Poussin. The sixteenth century Fontainebleau was called a "new Rome" by Giorgio Vasari and for Poussin, who had not yet seen the real Rome, the efforts of the masters of the first and second Fontainebleau schools provided a necessary clue for the treatment of subject-matter and composition. Through the study of refined and exquisite scenes from Greek and Roman mythology he was trying to grasp the classic origins half lost in the works of these schools. When Poussin first came to Paris, Ambroise Dubois and Martin Freminet were still living.

By the early 1620s the young Poussin, an avid student of the examples available to him, had managed to become well established in Paris. Proof of this was an order he received for an

altarpiece, *The Death of the Virgin,* for Notre Dame. This painting disappeared in the early nineteenth century but some idea of it may be rendered by a still extant sketch by Gabriel de Saint-Aubin. Six big temperas, commissioned in 1622 by the Jesuits, from the life of St. Ignatius Loyola and St. Francis Xavier were also lost. According to Bellori, they "were recognized as being superior for their inventiveness and unusual vivaciousness[14]".

The Italian poet, Giambattista Marino, who was then in Paris, saw and greatly appreciated these paintings. He invited the artist to live in his house and commissioned him to execute a series of drawings for Ovid's *Metamorphoses.* These are the only works that have come down to us from Poussin's Parisian years, which makes them all the more valuable in the appraisal of this period. Noting Marino's strong influence on the young artist, Bellori wrote that the poet helped Poussin "to succeed in elaborating subjects and in rendering emotions and approved of his being possessed by the Muses which was no less intense than the passion the poets have for imitation". "These drawings clearly show," the biographer continued, "how fruitful it was for him, how much his experience was enriched by the good examples of Raphael and Giulio and, finally, how much, under the influence of Marino, he absorbed the poetic mood, which completely corresponded to the colours of painting and which, in future, he employed to the best advantage in his works.[15]"

Thus, what was, in effect, the patronage of Marino, was eagerly accepted by the young artist. Judging by Bellori's story, the poet, about twenty five years Poussin's senior, contributed to the artist's spiritual development. Marino's work is generally classified as baroque, but the drawings done for him by Poussin, definitely show that the poet did not impose any of the baroque principles on the artist. The relationship between them can be best explained by Marino's statements on art, contained in the treatise *Dicierie sacre* published in Turin in 1614, shortly before the poet came to Paris. In the treatise, which in part is devoted to art's edifying and ennobling function, Marino compared the world to an orchestra, united by "the rules of harmony". "Orderliness" is innate in nature; conflict and dissonance are caused by evil forces hostile to man. Marino felt that "the beautiful music of the universe" is based on rhythm and proportion and that art is dominated by an "inner intellectual design"; intellect is superior to emotions, thought — to practical execution. Marino's attention to painting was neither casual nor superficial: it was the main theme of his book of verses, *Galleria.* He maintained that "poetry is like painting that speaks while painting is silent poetry[16]." Marino placed Raphael first in the history of painting, believing that only his art was absolute perfection[17]. This was no off-hand remark, but an elaborate commentary on the merits of many great masters.

It is easy to imagine how Marino unfolded all these ideas to Poussin, his young house guest. Unmarked by illiberal professionalism, Marino's thinking was, on the contrary, broad-minded, and his spiritual aspirations, as has been proved by literary historians, tended towards the ideas of the great thinkers of the time — Giordano Bruno, Galileo and Giulio Cesare Vanini. Vanini,

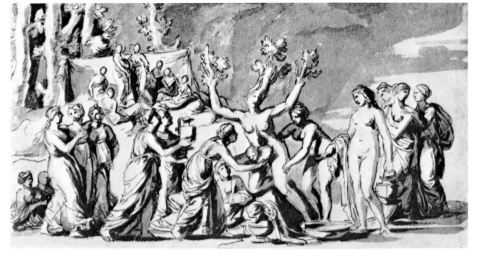

Nicolas Poussin, *The Birth of Adonis.*
Early 1620s, drawing, Royal Library, Windsor Castle.

incidentally, was then living in France and had books published there in which he quoted many of the philosophers of antiquity and developed rationalistic conceptions of the structure of the Universe (*Amphytheatrum aeternae providentiae*, 1615, and *De admirandis naturae reginae deaeque mortalium arcanis*, 1616). "Very much of the same frame of mind," wrote the literary historian Ilya Golenishchev-Kutuzov, "Marino, like Vanini, had to keep his ideas secret... Marino had no wish to be a martyr: one year after Vanini left Paris, having been denounced by the Sorbonne, he was condemned in Toulouse to having his tongue pulled out and to death at the stake. Churches of all denominations and secular authorities were uniting, driven by the common fear of liberated thought revolting against them.[18]"

Here, perhaps, we come upon a very significant track, particularly since documents of the time bear witness to Poussin's friendly relations with the French *libertines*. But we are getting ahead of ourselves. First let us turn to the drawings Poussin did for Marino. Numbering only sixteen (Royal Library, Windsor Castle; Museum of Fine Arts, Budapest), these drawings indicate a careful study of the literary source, Ovid's poem *Metamorphoses*. For example, the one that in all books about Poussin is still mistakenly entitled *Apollo Guarding the Herds of Admetus*, easily recalls the episode from the second book of the poem where Jupiter summons Mercury and orders him to drive the herd of King Agenor, the father of Europa, to the sea. When the herd approaches Europa, who is sitting by the sea with her maiden companions, Jupiter turns into a bull (then follows the well-known story of Europa's kidnapping by Jupiter). Poussin depicts Jupiter in the guise of a bull gambolling among the cows, and to the right behind them Europa and her companions.

Our interpretation of the theme of this drawing adds to the dominating motif of this series — the metamorphosis of the ruler of Olympus himself.

The episodes of the poem are usually represented by multifigured scenes, marked by expressive dramatic action which is paralleled by a strict rhythmical compositional structure. The movements and postures of the figures are correlated and often characterized by mutual balance and plastic energy; the *dramatis personae* are reserved and calm. All this is suggestive of Poussin's belief in nature governed by immanent purpose, in the harmony between the rational and the emotional. The artist strove to intellectualize the pagan images and sensual motifs. These drawings prove that the stylistic basis of Poussin, by then almost thirty, had already taken shape during his years in Paris.

The work of the great master was not a mixture of traditions. Poussin's independent and original genius was able to rise above the routine of the Paris workshops and left the stereotypes of late Mannerism far behind. This was achieved thanks to the striking artistic impressions, however sparse in number they were, but, most important, owing to some broader ideological impulses and the affect of the intellectual milieu. Poussin's connection with Marino, of all people, was but natural.

A description of the intellectual life in France when Poussin lived in Paris is appropriate here. The murder of King Henry IV in 1610 by Ravaillac, a catholic fanatic, was followed by a period of discord and internal strife. After devastating religious wars, the reign of Henry IV showed the perspectives of national development under the entrenchment of absolutism. During the second decade of the seventeenth century, however, belief in reasonable state policy was again undermined by mediocre rulers, and the church could not, though it tried, regain the authority it had lost during the fratricidal wars of the late sixteenth century. At that time the thinking was influenced by the philosophic scepticism of Michel de Montaigne. It is not by chance that Poussin, in his mature years, echoed this very philosopher[19]. In a letter dated 22 June 1648, the artist, inspired by Montaigne's ideas, made observations on the "extreme wisdom and extreme stupidity" which save man from the vicissitudes of life[20]. Poussin's maxim concerning "the courage and wisdom one must master to remain firm and steadfast before the efforts of

that blind madwoman" (*i.e.*, human destiny)[21], coincides almost literally with words of the French philosopher Pierre Charron, a follower of Montaigne. Commenting on Poussin's statements, art historians usually, and legitimately, compare them to the ideas of the stoics of antiquity. It should be remembered, however, that in French ethics of the late sixteenth and early seventeenth centuries, the idea of man's moral staunchness and his ability to rebuff social evil grew and became decisive. The moralist Guillaume du Vair termed it an effort of willpower and Malherbe, a poet — staunchness of soul ("la constance"). This idea was organically linked with that of supremacy of reason and its opposition to blind faith. Based on these ideas, Malherbe's poetry, quite naturally, became widely popular in the early seventeenth century. René Descartes, in 1618, was already at work at his early treatise, *Compendium musicae*, wherein he set forth the principle that lucidity and proportionality are necessary for beauty in art.

The close connection of Poussin's thinking and art with these ideas is quite obvious. On the other hand, one can hardly believe that Poussin could have been attracted by the Spanish brand of religious mysticism or the theories of church ideologists expounding "devout humanism" which proclaimed man as a creation essentially imperfect and unfinished[22].

Those years saw an upsurge of French freethinking or libertinage. The poet Théophile de Viau is considered to have been the leader of the *libertins*. True, his role was great. The scepticism of the free-thinking poets combined with their dream of elevated human relations, a gravitation towards the heroic and the idea of personal freedom as an integral part of a natural and orderly universe. There is a plausible hypothesis that in his novel *Francion* (written in

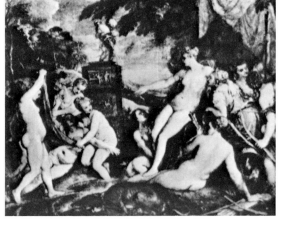

Titian, *Diana and Callisto.*
National Gallery of Scotland, Edinburgh.

1622 and published in early 1623), Charles Sorel portrayed precisely those Parisian *libertins* headed by Théophile de Viau. The unruly and witty braves of the university district advocated the natural laws of being and dreamt of the Golden Age when everyone would be equal[23].

Significantly, when Poussin returned from his first trip to Italy he lived for a time in the Collège de Laon situated right in the Latin Quarter[24], which usually housed sixteen students of the arts[25]. This fact serves to support the possibility that Poussin had direct contact with the *libertins* in his early years.

In the poetry of Théophile de Viau the images of scenery populated by the heroes of classical mythology alternate with philosophical digressions. At that time the interest in classical mythology and the works of ancient thinkers (in 1609, for example, the texts of Epicurus were published in France) was coupled with renewed attention to the natural philosophy of the Renaissance. De Viau's poetry reflected this trend by expressing the concept of nature's life-giving forces as a source of all existence of four elements underlying the Universe, and of the universal soul of the world (panpsychism). In *Pyramus and Thisbe*, written by the poet in 1621, love is shown not as vulgar passion, but as a flame that purifies and uplifts the human soul. Like Charron, de Viau espoused self-reliance: a man of dignity and nobility is "to have a soul which resists all the blows of fate and which does not involve anything low in its acts[26]". His idea of the spirit's grandeur and ability to resist is especially important for an objective judgement of the views of seventeenth century *libertins*. In 1623 the libertine poet was siezed and sentenced to penance and, like the philosopher Vanini, condemned to death at the stake. He escaped but was recaptured, thrown into the dungeons of La Con-

12

ciergerie and later forced into exile, where, short-ly thereafter, he died, undoubtedly as a result of the torments he had suffered in prison.

The ranks of free-thinkers included not only poets but also scholars. Gabriel Naudé, the dominant figure among them, studied medicine as a young man and already in 1620 wrote his first treatise marked by scepticism. His *Instruction à la France sur la vérité de l'histoire des Frères de la Roze-Croix* (Instruction to France on the True History of Rosicrucians) appeared three years later. The activity of the Rosicrucian Society was used by Naudé as a pretext for attacking super-stition and quackery, to which he opposed truly scientific knowledge. In his treatise, Naudé spoke in favour of the great thinkers of the past: Aristotle, Plato, Epicurus and Seneca, as well as the new ones: Thomas More, Campanella and Galileo. Naudé centered on his main premise — to discern exact knowledge from superstition, truth from delusion — a principle, central to seventeeth century thought, which became esta-blished with the help of Descartes. However, in this respect, Naudé's works have not received the attention they deserve. In *Apologie pour tous les grands personnages, qui ont été faussement soupçonnés de magie* (Apology of the Great People Mistakenly Suspected of Witch-craft), Naudé further developed his ideas, challenging the Catho-lic doctrine of the contemptibil-ity of man wallowing in sin. "Man," he wrote, "can be seen as a creation perfect and finished, similar to his Creator and the boldest in all Nature[27]". Also typical is Naudé's reference to Aristotle's "natura bene ordi-nata[28]"; later Poussin would say: "les choses bien ordonnées[29]".

School of Raphael,
The Triumph of Galatea. 1513,
Fresco, Villa Farnesina, Rome.

It was precisely this *libertin érudit* who was later mentioned as being one of Poussin's closest friends. Even if they did not know each other in their early years, the views of the young Naudé arc relevant, as they were typical of France's intellectual life of the period when Poussin lived in Paris. Soon after Poussin's Parisian years the Italian connoisseur of art, Giulio Mancini, would write: "Having mastered Latin and gained erudit-ion in history and mythology, he turned to studying painting... and, having made enough progress in it, he came to Italy[30]". An outstand-ing and most learned physician, Mancini could hardly have been impressed by a superficial knowledge of art. It is likely, then, that his remark was not only accurate but also reflected the reputation Poussin had among the literati circles of that time. This gives further proof of the necessity of turning to early seventeenth century French social thought.

According to Bellori, Poussin's third attempt to get to Italy was connected with Marino's depart-ure from Paris: the poet wanted the artist to accompany him. Something interfered, however; perhaps, the above-mentioned commission from Notre Dame. Marino left Paris in the spring of 1623 and Poussin a few months later. But, again according to Bellori, Poussin did not arrive in Rome till the spring of 1624. It is only logical that if the artist had remained in Paris till the following spring it would have been easier for the biographer to say that Poussin left a year after Marino. A remark from Man-cini's notes cleared up this dis-crepancy; there, among other things about the artist, he wrote that Poussin "... came to Italy and, having stayed for some time in Venice to absorb its ideas and Venetian manner, arrived in Rome[31]". A treatise of 1693-95 corroborates this. The French author, Loménie de Brienne, stated there that Poussin "first went to Venice[32]" Thus, Pous-sin's long aspired acquaintance with the Italian classics began in Florence, continued in Venice and, only after that, did he arrive in Rome where he was particularly attracted by the works of antiquity and Raphael. This sequence of events

13

had a considerable impact on the artist's work during his first years in Rome.

Having neither connections nor orders, Poussin's life in Rome was initially rather difficult and he was forced to sell his pantings for practically nothing. As an example, Bellori mentions Poussin's *Battles* (Pushkin Museum of Fine Arts, Moscow; Hermitage, St. Petersburg). Refuting the view that Poussin was an "overgrown pupil" of the Bologna school when in Rome, the *Battles* betray the artist's maturity. Their composition has a strict rhythm and, though the subjects are drawn from the Bible, there is no religious exaltation about the warriors who look like the characters of the epic tales of antiquity. In 1621, a few years before Poussin came to Rome, an ancient sarcophagus with the relief depicting the *Battle between the Romans and the Barbarians* (Museo Nazionale Romano, Rome) was discovered. Poussin may have seen the sarcophagus in the collection of Cardinal Lodovico Ludovisi. Also traceable in the *Battles* are the effects of Poussin's study of the paintings of Raphael and his school. Jacques Thuillier, for example, compares the *Battles* with Raphael's composition *The Sun Stayed by Joshua*, noting that they have in common general layout, motif of a mountain and two luminaries, as well as the shape of the warriors' shields[33]. *Moses and the Daughters of Jethro* (1523, Uffizi, Florence) by Rosso Fiorentino was at the time part of Antonio Medici's collection in Florence and its analogy with Poussin's *Battles is* also worth consideration. In it the figures are moved to the foreground and the colour scheme is determined by a dark bronze carnation with bright accents of greenish-blue and lilac vestments, highlighted with white. The design of Poussin's paintings has many affinities with Fiorentino's. But this, given the latter's great influence on the art of the French Renaissance, is not surprising: the works of the Italian artist could have aroused Poussin's interest both at Fontainebleau and in Florence. It should be stressed again, however, that all of Poussin's impressions blended into a new and completely original style. The continuity between his Parisian and Roman periods is shown by the similarity between the battle scenes done for Marino in Paris and the paintings just analysed.

In Rome the French artist improved his practical knowledge. He took measurements of classical statues, tried his hand at sculpture and, together with the Flemish François Duquesnoy, made bas-reliefs from Titian's *Bacchanals*. Bellori says that Poussin carefully examined the monuments of antiquity, made sketches of the best of them, was also "diligently studying geometry, perspective or optics", and resumed his studies, begun in Paris, of anatomy[34]. Bellori insists on showing Poussin as a follower of the Carracci brothers and of Domenichino, that is, of the Roman-Bolognese academic style. This view should be treated with caution, all the more so since the artist himself in his letters, while frequently praising the classic marble statues and Raphael's *Madonnas*, only once mentioned the painters of the Bologna school, observing, reservedly, that they "are not without artistry or knowledge[35]". The second half of the 1620s was a time of extreme creative activity for Poussin. In Italy he not only encountered the greatest classical heritage he was eager to absorb, but also found himself in the midst of a new artistic milieu: the Caravaggists were still working, the "neoVenetian movement" was being born, and baroque traditions were gaining strength, especially in large

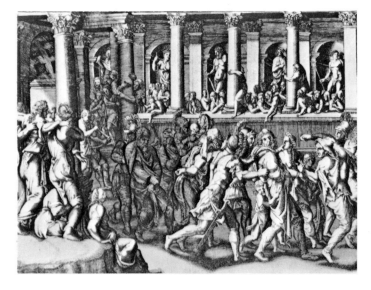

The Triumph of Scipio.
Engraving by G. Ghisi from the painting by Giulio Romano.

14

altarpieces and monumental church and palace murals. A less self-confident artist would have yielded to the pressure of the new artistic environment. Not so Poussin. In just a few years he achieved an independent and respected status. Furthermore, a group of like-minded artists, both French and Italian, formed around him. Giulio Mancini, in 1627-28, was already praising Poussin above all other artists as "able to evoke any story, fable, or poem by virtue of his literary erudition and then, with the help of his brush, to successfully implement it.[36]"

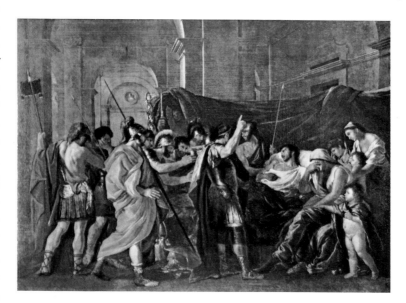

Nicolas Poussin, *The Death of Germanicus.* Late 1620s, Institute of Arts, Minneapolis.

Cardinal Francesco Barberini and other Roman patrons started to commission works from Poussin such as, among others, *The Death of Germanicus* (Institute of Arts, Minneapolis) and *The Triumph of Flora* (Louvre, Paris). In these works, themes of heroic deeds are treated in their moral aspects, while sensual motifs are ennobled by an elevating strength of spirit. Poussin's heroes are endowed with generosity and an ability to control emotions. The combination of heroic themes with the motif of the revival of life is also legitimate, as seen in the eloquent interaction of Ajax and Flora.

In 1628 after only four years in Rome, Poussin was honoured with a commission from the Vatican to paint an altarpiece for St. Peter's, *The Martyrdom of St. Erasmus* (1628-29, Pinacoteca Vaticana, Rome). Originally the commission was to be given to Pietro da Cortona, an Italian artist, who had already produced two sketches for it marked by turbulent movement. In Poussin's painting, in spite of the dramatic nature of the event, the emotions are reserved and the themes of the martyr's staunchness and compassion for him are central. In Roman baroque style this was totally unheard-of: church doctrines firmly stated that salvation was possible only through the will of providence, not through man's inner force. Poussin imparted to the scene of martyrdom a heroic resonance. He, moreover, accomplished here a pioneering pictorial task, rendering realistically the effect of daylight by means of light colours enlivened by tinted shadows. Though *The Martyrdom of St. Erasmus* had a profound impact on his contemporaries and stirred controversy, Poussin never became a painter of altarpieces depicting the ecstasies and martyrdom of the saints. Church authorities were used to a more traditional treatment of such themes. In 1630, at any rate, when Roman artists were summoned to judge who should be entrusted with the decoration of a chapel in San Luigi dei Francesi, the preference was accorded to Charles Mellin of Lorraine, not to Poussin. It was then that Poussin seems to have made a definitive choice regarding the direction of his career. He now intended to devote his art to "cabinet pictures" for a cultivated audience. As is shown by the documents from the trial, in 1631, of the art collector Valguarnera, to which Poussin was called to give testimony, his pictures were not only eagerly bought by art patrons, but copied by Italian artists as well.

A series of paintings were done around the same time, including *The Plague at Ashdod* (Louvre, Paris) and *The Realm of Flora* (Gemäldegalerie, Dresden). They are stylistically similar to the first version of *The Arcadian Shepherds* and a few other paintings. The subjects of this series were

borrowed usually from classical or Renaissance literature rather than from the Bible. But whereas Poussin's Paris drawings for Ovid's poem rather closely followed the literary source, in his work of the late 1620s and early 1630s the artist began to mould classical motifs into his own poetic meditations on man's lofty mission, on heroism and compassion. These paintings were often based on a dramatic conflict. Thus, *Midas before Bacchus* (Alte Pinakothek, Munich) contains a reflection on the gloomy fate of the greedy Midas; in *The Arcadian Shepherds* (Devonshire collection, Chatsworth) the theme of tranquil happiness is intruded upon by a *memento mori* motif, and in *The Realm of Flora* the image of Ajax throwing himself on the sword is opposed by that of the Goddess of Spring incarnating the revival of life and joy of existence. In Poussin's paintings the dramatic struggle does not break the dominant sense of harmony: his characters are not without hope, they transcend suffering and petty worldly passions. The more tragic the theme, the more profoundly sounds the message of the loftiness of human thoughts and emotions. In the *Plague* the biblical story is transformed so that the motifs of religious fanaticism and God's merciless retribution give way to a more prominent theme of all-conquering humaneness. Poussin himself, explaining the message of a later canvas, spoke about consolation, compassion and merciful acts [37].

The 1960 Paris exhibition clearly showed that in its painterly manner *The Plague at Ashdod* bears affinity to *Tancred and Erminia* (Hermitage, St. Petersburg). Though not mentioned in manuscripts and never engraved, the *Tancred and*

Nicolas Poussin, *The Martyrdom of St. Erasmus.* 1628, drawing, Uffizi, Florence (on the left).

Pietro da Cortona, *The Martyrdom of St. Erasmus.* C. 1628, drawing, Uffizi, Florence (on the right).

Erminia has undeniable artistic merits. An admirer of the poetry and theoretical works by Torquato Tasso, Poussin derived the subject from his poem, *Jerusalem Delivered.* Erminia, the daughter of the king of Antioch, is in love with the Christian knight Tancred. Upon finding him fallen on the battlefield, she takes a sword and cuts off her hair to bind his wounds. Erminia (so say the verses) is driven by love and compassion. The picture has not a hint of conflict, though Erminia's love should have clashed with her religion, which was different from Tancred's. Reflecting the complete lack of inner struggle or hesitation in Erminia's impulse, Poussin's painting is ruled by harmony, paralleled by stylistic means. The general outlines of the group strive to form a tondo, framed, in its turn, by the figures of the horses. The point of the princess' sword marks the middle vertical axis of the composition, but the characters are shifted to the left of it and given a backdrop of the sky at sunset over the soft contours of the hills. This kind of composition was typical of Poussin's work at the turn of the 1630s, when valuing free movement, he was still seeking inner balance.

The colour scheme of the Hermitage painting is built upon pure intense colours, but various shades used for the environment are also important. The mood of the scenery seems to echo the emotions of the characters. By then, landscape had become of serious interest to the artist, though he preferred the so-called historic genre. It is not by chance that during this period he painted *The Realm of Flora* in light colours trying

to pervade with light the space from the figures in the foreground to the distant sunlit hills.

The Realm of Flora (Gemäldegalerie, Dresden) has one other peculiarity: with no overall action or event, it is instead constructed around the rhythmic correlation of groups and figures, each one presenting a variation on the common theme of love and revitalization. This type of composition, recalling a piece of music, drew Poussin especially strongly. The artist acted like a poet who renders moods and emotions by the metre and sonority of verse. But if compared to the analogous rhythmical bases underlying the styles of Malherbe and Corneille, major differences should not be disregarded. While Corneille's characters are capable of horrible acts, with Poussin, turbulent passions and perturbation are always countered by a harmonious ideal. The mythological figures of *The Realm of Flora* are lost in contemplation, the entire picture is governed by an inner concord and even the madman Ajax, committing

Nicolas Poussin, *The Massacre of the Innocents.* C. 1630, drawing, Musée des Beaux-Arts, Lille.

Nicolas Poussin, *The Massacre of the Innocents.* C. 1630, drawing, Musée Condé, Chantilly.

suicide, seems to be soothed by his resolution. It would hardly be a mistake to say that the theme of suffering was foreign to Poussin, explaining why there are so few depictions of the Passions of Christ in his work. *The Deposition* (Hermitage, St. Petersburg) is one of them. In it the postures and movements of the characters are convincingly true-to-life to such a degree as to form a demarkation line between Poussin's dramatic expressiveness and the superficial effectiveness of altarpieces done by many Roman

artists. Especially natural is the figure of John, who, as Christ slips from the cross, supports his heavy body on his lap. The landscape in the background, lit by the disquieting glow of the sunset filtering through an ominous cloud, echoes the leitmotif of the painting.

In connection with the features of *The Realm of Flora* already mentioned, we feel it important to stress the special significance which the theme of advocation of poetry had in the artist's work of the late 1620s and the early 1630s. This painting, along with such compositions as *Parnassus* (Prado, Madrid), a variation of Raphael's mural by the same name in the Vatican's Stanza della Segnatura; *The Inspiration of the Poet* (Niedersächsische Landesgalerie, Hannover); and *The Inspiration of the Epic Poet* (Louvre, Paris), made up a manifesto of a sort stating the artist's love of poetry and his belief in the affinity between the two creative arts. The portrayal of a poet receiving inspiration from Apollo himself conceals the idea of freedom of artistic creation — a matter of principle in the age when an artist was dependent on art patrons, not infrequently a humiliating position. It is precisely in this particular context that Bellori's exclamation of admiration for Poussin's "poetic designs, conceived by his fortunate genius[38]" takes on a new meaning.

Among his early Roman works there are many "bacchic subjects", as Poussin called them, such as *Bacchanal with a Guitar Player* (Louvre, Paris). The general golden tonality of the paint-

17

ing, its alternating light and shade, and vigorous expressive brushstrokes, all reveal the poetic and excited perception of the world characteristic of the artist during this period. However, his compositions, when compared to Rubens's *Bacchanals,* seem confined and reserved, for the emotional impact of Poussin's "bacchic scenes" stems from his sensation of the poetic integrity of the human being revealing itself in concord with nature, rather than in irrepressible sensual impulses.

Venus, a Faun and Putti (Hermitage, St. Petersburg) is marked by a strict sense of measure[39]". Venus, who turns away from the faun, is hardly a typical ecstatic bacchante accompanying Dionysus on his agitating march. Even though the faun has the broad face with high cheekbones typical of minor Roman deities, he is still completely different from the lustful satyrs of Flemish *Bacchanals.* Restrained emotions are paralleled by a strict compositional rhythm. Curiously enough, in this case Poussin gives a clue to his interpretation of the bacchic theme: on the left two putti are fighting and one, a goat-legged satyr, has been downed by the other. This scene undoubtedly symbolizes the victory of spiritual love over crude sensuality, personified by the defeated satyr ("Amor vincit Panem").

There is no strict borderline in Poussin's art between "bacchic subjects" and other episodes from ancient mythology: elevated feelings, specific for Poussin's artistic ideal, always dominate.

To Poussin, antique tradition meant not so much a set of stylistic forms to be followed (though this was important) as a prototype of spiritual freedom and poetic harmony. Certainly, this reflected Poussin's dream of the Golden Age of humanity. It cannot be denied that Poussin's work during his first ten years in Italy anticipated romantic outlook. The artist's admiration for antiquity, which is so evident in his paintings, was in no way a means to assert some abstract academic doctrine.

Modern literature on Poussin continues to rehash outdated formulas of the triumph of reason over emotions, of duty over personal interest. When holding these formulas up against the actual message of the works discussed herein,

18

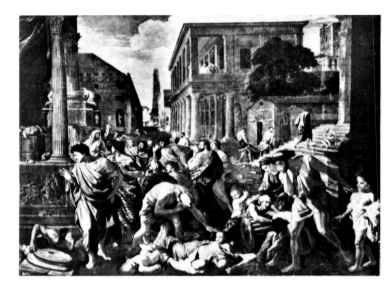

Nicolas Poussin, *The Plague at Ashdod.* 1630-1631, Louvre, Paris.

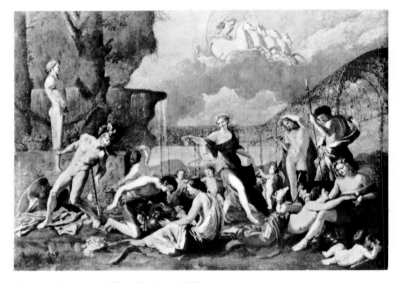

Nicolas Poussin, *The Realm of Flora.* 1631, Gemäldegalerie, Dresden.

one cannot help being at least mildly perplexed. The great French thinkers of the seventeenth century saw as the ideal of human behaviour not the ascetic suppression of desires, but moral dignity and effort, which mobilize man's resources in the struggle of life. The fundamental thesis of Pierre Gassendi is appropriate here: "We possess a freedom of choice based on reason[40]". Undoubtedly, for Poussin, reason was not the gaoler, but the ally of emotions. But still, and significantly, Poussin's contemporaries spoke about the supremacy of the intellect as "the major component of the soul[41]".

By the mid-1630s Poussin took increasing interest in history and in the moral significance of human acts carried out for the common good. Increasingly often, the lyrical plots from Ovid or Tasso gave way to episodes from ancient historians. Commenting on one of these historical paintings, Poussin said: "It is done, as it should be, in a stricter manner, since its subject-matter is heroic[42]". To pinpoint an exact date or picture which marks the sudden change or maturity of Poussin's historical thinking is hardly legitimate, yet it is not by chance that this change coincided with the growth of the artist's popularity in France. The appearance of many followers of his style in Paris testifies to this, as do the commissions from the *de facto* ruler of France, Cardinal Richelieu. Even though Richelieu's order was just for a series of *Bacchanals* (a letter informing the cardinal that two paintings of the series were ready, is dated 1636[43]), they differed, both in message and style, from Poussin's earlier bacchic scenes.

The Triumph of Neptune and Amphitrite (Museum of Art, Philadelphia), for example, shows that Poussin's former lyrical fantasy developed into a more solemn and strict imagery adding eloquence to this mythological scene. Though the subject of this painting has been much debated, knowledgeable contemporaries of Poussin called it *The Triumph of Neptune*. Represented with a trident, his invariable attribute, the God of the Sea is looking at the central female figure while a cupid aloft aims at her with his arrow. All this definitely demonstrates that the main theme of the painting is the love between Neptune and Amphitrite, who are being showered by cupids with roses and myrtle flowers

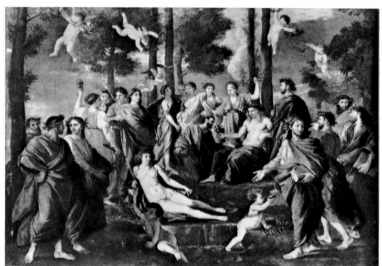

Nicolas Poussin, *Parnassus.*
Second half, 1620s, Prado, Madrid.

(symbols of amorous attraction). So far no attention has been paid to yet another cupid who has already shot his arrow at a man who is carrying a nymph over his shoulder. Who are represented in this scene of the nymph's abduction? The character, tall and with hypertrophied muscles, is thought to be the cyclops Polyphemus who is carrying away his beloved nereid Galatea. Polyphemus was considered Neptune's son, so his presence in the picture is quite logical.

The shifting of Neptune's figure to the left gives Amphitrite the central position. The purposeful use of majestic imagery — two nereids respectfully hold Amphitrite's elbows and her pink drapery as tritons trumpet their horns in her praise — as well as the overall intonation of apotheosis can possibly be explained by the origin of the commission, by the task of hailing France as a great maritime power. Hence, the general representativeness of the design, the domination of strict symmetry (the balanced postures of characters, the placement of Amphitrite's face at the intersection of the diagonals in the geometric centre) and, what is most important, the hierarchy of thematic motifs and figures. The painting retains the poetic features of Poussin's work, but this poetry acquires here a dithyrambic character.

Thus Poussin himself contributed toward the wish of Cardinal Richelieu to have him as the royal painter in Paris. But to continue with the Roman period of the 1630s: taken from Plutarch, *The Saving of the Infant Pyrrhus* (Louvre, Paris) was painted no later than 1634[44]. The action occurs as if on a stage: on the right in the background the rearguard is beating off an enemy attack, while women look back on the 19

soldiers with worry and fear. The main motif, a warrior carrying an infant, occupies the middle of the canvas. The group of figures to the left represent the event's crucial moment. The figure of a man casting stones changes the action's orientation, directing it toward the rear. The effective compositional treatment is made complete by the figures of the horsemen, riding up the road to the buildings of Megara.

Though the theme of flight in *The Saving of the Infant Pyrrhus* suggests depicting a scene of despair and panic, Poussin stressed the idea of the warriors' resolution. The artist found a plastic equivalent to adequately convey the heroic message of the historic event. In this way, in the 1630s, a new compositional system, corresponding to active dramatic action, was evolving in the historical genre.

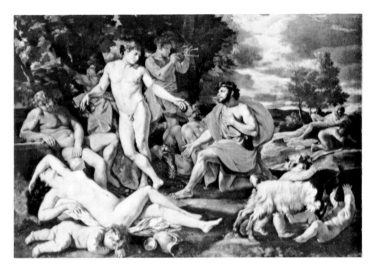

Nicolas Poussin, *Midas before Bacchus.* C. 1630, Alte Pinakothek, Munich.

For Poussin the theme of the vicissitudes of life became more pronounced during this period. The undisturbed tranquillity of *The Realm of Flora* gave way to more disquieting motifs of human hardships and tragedy. The action took on a mass character and the artist's historical thinking acquired a larger scale. While working on the painting *The Israelites Gathering Manna* (Louvre, Paris), Poussin wrote about the figures' movements: "You will easily see which of them are languishing, which admiring, which are pitiful, who is committing an act of charity, of great necessity, who wants to be satiated, who — to console... read history and the picture to find out if everything is appropriate to the subject[45]".
Around this same time, Poussin was given a large commission by the Italian art patron, Cassiano dal Pozzo, for a series of compositions *The Seven Sacraments* (Rutland collection, Belvoir Castle, England; National Gallery of Art,

Washington). This series, according to Bellori, brought the artist "great fame". Bellori also felt it important to point out that the characters in the series were dressed in "the apostolic vestments of the early church[46]". Thus Poussin's iconography amazed his contemporaries, as the artist had turned to the early age of Christianity, *i.e.*, again to the age of antiquity[47], rather than to the Catholic rites of the seventeenth century. In all probability this was prompted by more than just Poussin's interest in ancient history and its moral lessons; the artist was likely to have shared a mistrust, common then, of the Catholic clergy. At that time an interest in early Christianity reflected a tendency toward a definite world outlook. Already Jean Bodin (1530-1596), a philosopher who was held in high esteem even in the seventeenth century, thought that in any religious system the only rational element is that which corresponds to nature and reason.

In this series, the artist's independence is manifested by originality and variety of approaches. *Penance is* treated in the Renaissance tradition as a luxurious feast; in the *Eucharist,* the drama of the moment is rendered by a complex interplay of light and shade; *Extreme Unction* is perceived as an apotheosis of man's dignity in the face of death; and in the *Ordination* the classical transformation of a Christian sacrament reaches its climax making it seem more reminiscent of Raphael's *The School of Athens* than of a Catholic ceremony.

The second version of *The Arcadian Shepherds* (Louvre, Paris), for a long time chronologically misplaced, is now known to be from the late 1630s. One of Poussin's genuine masterpieces, it is a lucid expression of his outlook. The

20

Louvre painting, unlike the first version of the same name, is marked by the spiritual maturity of its characters, as well as by a greater tranquillity and strictness of composition. The tomb is placed in the centre and the personages' postures are rhythmically coordinated with its horizontal and vertical lines. The basic thematic motif of the painting is the consoling gesture of a woman laying her hand on the shoulder of the young shepherd. Though the characters of the painting react differently to the *memento mori,* their state can be defined as a concentration of spiritual forces that oppose fate.

An inventory, with reference to the date 13 July 1640, of an Italian seventeenth century collection, mentions a picture "of the story of Scipio Africanus painted by Poussin[48]" along with its dimensions which coincide with those of *The Magnanimity of Scipio* (Pushkin Museum of Fine Arts, Moscow). Thus, this painting is also from the late 1630s. The artist was attracted by an episode from Roman history: against the background of a defeated and burning city, the fiancée of a Carthaginian is mercifully returned to him by the Roman conqueror. The picture, however, is obviously devoted to a different victory, that of mercy and reason over base passions. The tripartite composition corresponds to the focal points of narration and is dominated by a solemn rhetorical intonation. *The Magnanimity of Scipio* asserts a certain ideal of human behaviour and, in this sense, is normative, as were many other works of the same period[49]. These same solemn intonations are explicit in *The Finding of Moses* (Louvre, Paris) and in *Venus Arming Aeneas* (Musée des Beaux-Arts, Rouen).

Nicolas Poussin, *Bacchanal with a Guitar Player.* C. 1620, Louvre, Paris.

The romantic legend which has Poussin's disillusionment with people as the reason for his turning to landscape painting in his old age still surfaces in books about him. Considering that an interest in nature always played an important role in Poussin's work, this legend was doubted even before. Recently, some documents have been found which — by giving new dates to two well-known pictures: *Landscape with St. Matthew and the Angel* (Museum Dahlem, Berlin) and *Landscape with St. John on Patmos* (Art Institute, Chicago) — confirm that Poussin was a brilliant landscape painter as early as the 1630s. Each of these canvases was referred to in the above-mentioned inventory in an entry dated 1640[50]. This discovery radically changes our notion of the artist's creative evolution.

The above-mentioned landscapes, similar to Poussin's other paintings of the late 1630s, are characterized by an elevated and idealized imagery and, unlike seventeenth century Dutch landscapes, were rendered from imagination. They do, certainly, reflect actual impressions of the artist. The Berlin canvas, for instance, is suggestive of the banks of the Tiber with the old tower Torre di Quinto. By processing and generalizing his impressions, Poussin gave an epic character to his pictures of nature, treating it as the scenery of great historical events. Guez de Balzac, the French writer and coeval with Poussin, wrote from Rome: "Never do I go up the Palatine or the Capitoline Hill without experiencing a change of mood and thoughts, different than usual: the air inspires me with something grandiose and noble, of which I had no idea before[51]".

21

Poussin created a special type of ideal landscape in which it was as if nature was steeped from the past. Fragments of ancient buildings are reminiscent of the days gone by. Matthew the Evangelist looks like an ancient philosopher. Though there are other terms for Poussin's landscapes (ideal, heroic), they could be called historical. At first glance, the composition of *Landscape with St. Matthew* brings to mind stage scenery wings, a device used, for example, by Annibale Carracci. With each turn of the river the cliffs along its banks are brought forward marking the perspective of space as it recedes into the background. But this superficial resemblance to scenery wings is deceptive, for the essence of the picture lies in its feeling of space and grandeur. With the plastic expressiveness possessed by the hills and cliffs the composition is built by the powerful rhythm of their volumes. A stream, which portrayed by a Dutch artist would be modest and unpretentious, with Poussin flows truly grandly. Through a space between the trees, vast valleys with mountain ranges linking up to the horizon can be seen. An image of a serene and harmonious world is created by all of this, proportionate to a man, whose soul is pure, elevated and untroubled.

Though in many ways similar to the Berlin painting, *Landscape with St. John on Patmos* assigns a more important role to architecture. The space is formed by the geometric shapes of ancient ruins; a sharp turn in a road leads the viewer's eye to the middle distance where the relief abruptly drops down to a body of water surrounded by trees and bushes. Out of the distinct plastic volumes of the dark greenery rises an obelisk and a ruin topped with an impressive

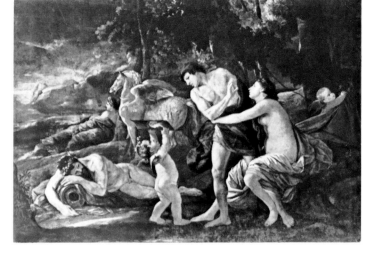

Nicolas Poussin, *Cephalus and Aurora*.
National Gallery, London.

entablature supported by Corinthian columns. These architectural fragments seem to be a materialization of the creative thought of the past epochs. The artist's landscapes of the late 1630s show especially clearly how much Poussin's art gained from Roman antiquity and how much inspired he was by classical images.

In one of his letters of 1639, speaking about his life in the Eternal City, Poussin recollected the Italian proverb, "He who is all right does not plan to move[52]". This was not without reason. With Poussin grown so famous, the French royal court had it in mind to bring Poussin back to his native country. The artist was informed about the plan by Paul Fréart de Chantelou, who later became his permanent patron and addressee, and the artist Jean Le Maire. Writing in response, Poussin put forth many conditions, among them that his stay in Paris should be limited to five years and that he should not be required to do any monumental paintings[53]. That same year, François Sublet de Noyers, Superintendent of Royal Buildings, sent Poussin an invitation indicating that his conditions had been accepted. A brevet signed the very next day by Louis XIII, however, stated clearly that Poussin had to contribute to "the ornamentation and decoration of our royal buildings[54]". While the artist could set conditions before the King's officials, he could hardly do so before the King himself.

As yet unaware of the King's order, Poussin, on the same day that it was issued, 15 January 1639, attempted to turn down the invitation in the letter containing the Italian proverb. Complaining to Chantelou about the poor state of his health, the artist also reminded him that he was quite content with his life in Italy. Poussin's cor-

respondence leaves us with no doubt that the artist, fully aware of the ways of the royal court and the state of the Parisian artistic school headed by Simon Vouet, had ominous premonitions. Upon receiving letters from the King and Sublet de Noyers, Poussin was forced to change his tactics. In order to gain time he resorted to delaying tactics and even tried to intimidate them back in Paris with reports of deteriorating chronic illness which could possibly lead to his death. A year and a half passed and Poussin had still not left Rome, when Sublet de Noyers requested that Chantelou communicate with the artist, which he did in a letter dated 13 August 1640, in the following words: "Kings have very long arms and it will be most difficult to prevent a great King such as ours from feeling insulted by a person who was born his subject and went back on his word[55]".

It need not be explained that this threat from the King's official meant death at the hands of a hired assassin. In view of this sinister development, Poussin was left without options. Having the foresight to have his wife remain in Rome, on 28 October 1640, accompanied by his assistants, the artist left for the port of Civitavecchia and arrived in Paris on 17 December 1640[56].

Poussin's stay in France turned out to be brief and rather dramatic. At first everything was very ceremonious: he was received by Louis XIII and Cardinal Richelieu, honoured with the title of First Painter to the King and given generous commissions and a pavilion in the Tuileries. Poussin, however, could hardly have been swept off his feet by all of that. In the same letter where he described all the honours he had been paid the artist expressed the hope that his stay in Paris "will not be long[57]".

Shortly after this, the King signed a brevet, according to which Poussin was "put in charge of all painting and decoration works done from now on to adorn our Royal Buildings; His Majesty orders that no other artist can do work for His Majesty without showing his sketches to and getting the opinion and approval of the above-mentioned Sieur Poussin[58]". With a stroke of the royal pen Poussin became the official leader of the French artistic school and, as future developments would show, had all of the royal artists set against him. But their plotting was the least of it, though Poussin was soon made its victim. The problem lay in the profound and fundamental divergence between the adulatory art of Simon Vouet and his followers and the heroic ideals which permeated Poussin's work.

Within a few days of his arrival in Paris, Poussin commenced work on the numerous commissions which had been given to him. Among them, to name but a few, were altarpieces for the chapel of the Château of Saint-Germain-en-Laye and for the Jesuit Noviciate in Paris, compositions for Cardinal Richelieu's palace (the most famous of which is *Time Saving Truth from Envy and Discord,* Louvre, Paris), and, most notable of all, the decoration of the Grande Galerie in the Louvre. The artist had to start doing sketches for the latter work immediately. Though Poussin worked ceaselessly, his discouragement was repeatedly revealed in letters he wrote in the autumn of 1641, in one of which he said that he had put a millstone around his neck[59]. To his Italian patron Cassiano dal Pozzo he complained: "Without any break I work at one thing or another... I swear to you, Your Excellence, that if I stay in this country much longer I shall become a dauber like others

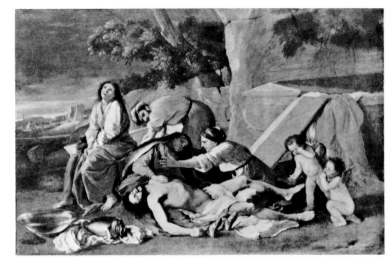

Nicolas Poussin, *The Lamentation.*
Late 1620s, Alte Pinakothek, Munich.

23

here[60]". And with bitterness he wrote: "It seems that they do not know how to use me, having me come with no clear-cut plan — they look like those animals who all want to pass where one of them has trodden[61]".

As is proved by many documents, it was Poussin's Parisian patrons who gave him his allegorical subjects. A letter he wrote on 20 March 1642 mentions that he is waiting for a subject to be given to him[62]. The painting for Cardinal Richelieu, that was cited above, is typical of the allegories which were requested. Poussin tried to treat such themes in a reserved manner, clearly wanting to avoid overornate window-dressing effects.

The decoration of the Louvre's Grande Galerie, begun under the direction of Poussin, has not come down to us. There are, however, old sketches, descriptions, and, what is of the greatest value, drawings by Poussin and his assistants, such as the *Decorative Composition with Atlantes* (Hermitage, St. Petersburg). This drawing illustrates Poussin's approach to the design of a typical element of the gallery decor. The artist rejected the use of illusionary baroque patterns which could break the architectonics of the interior. In contrast to the Parisian court artists, he also came up with the pioneer idea of basing the entire gallery decoration on a representational, rather than purely decorative theme. Moreover, the theme was not just representational, but heroic-scenes from the life of Hercules. Thus in the royal palace, according to the surviving drawings, Poussin was to recreate one of the greatest heroic legends of the past.

A programmatic letter written by the artist to Sublet de Noyers is indicative of the struggle that Poussin had to lead in Paris. Having enumerated the categories of his adversaries, he then stated his opposition to the alien artistic system and underlined his basic principle of revealing the interior architectonics by the whole system of decoration. "It should be remembered that everything I place on this vault must be regarded as panels covering it, so that no body breaks, recedes or protrudes from the surface of the vault, and instead so that these panels

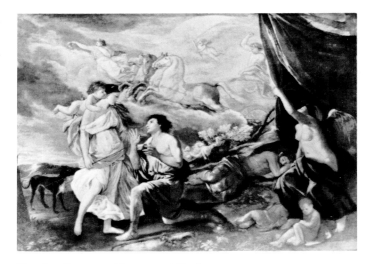

Nicolas Poussin, *Diana and Endymion.*
Late 1620s-early 1630s, Institute of Arts, Detroit.

emphasize its arc and shape[63]". Poussin rejected the idea of overloaded and clashing forms and set forth a remarkable reasoning: "It runs counter to the order and example of nature itself to put elements which are bigger and more massive on the highest places, and to make components thinner and weaker carry things which are the biggest and heaviest. It is due to this gross ignorance that all buildings constructed with such poor knowledge and concepts seem wretched, squat and sunk under their own burden rather than alive, slender, light-weight and easily carrying themselves, the way nature and reason teach they should be created[64]". Poussin's intervening, thus, into more general artistic problems, naturally prompts a conjecture: isn't it possible that around this time he met and gave impetus to the work of young Parisian architects who cherished new ideas?

Poussin's address to Sublet de Noyers was more outspoken than any of his letters before or after. Though it perhaps suggests the hopelessness of his situation, Poussin was not alone. He had friends in Paris, and not only among artists. Poussin and the *libertins érudits* met upon his arrival in Paris as old friends. Pierre Bourdelot on 28 January 1642 wrote: "I saw M. Poussin today, who is all right but always longing for Rome; we are going to launch a revelry[65]". In another of his letters the same Pierre Bourdelot told about one of these meetings: "MM. Naudé,

24

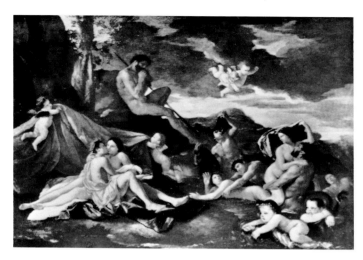

Nicolas Poussin, *Acis and Galatea.*
National Gallery of Ireland, Dublin.

Nicolas Poussin, *Theseus Finding His Father's Arms.*
1630s, Musée Condé, Chantilly.

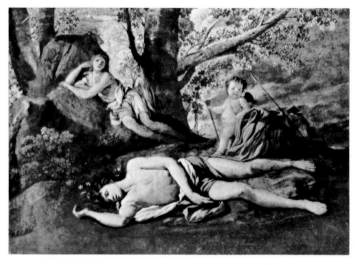

Nicolas Poussin, *Echo and Narcissus.*
Louvre, Paris.

Patin and Richer — doctors and very learned men — were present, as well as the good M. Gassendi, and MM. Poussin, Le Maire and Remy, the famous artists [66]".

The information about Poussin's close relations with the *libertins érudits is* extremely significant. The role played by such contacts, though there is no way to reveal the contents of their conversations, nonetheless deserves consideration. A letter written by Guy Patin contains the following: "M. Naudé, Cardinal Mazarin's librarian, and a close friend of Monsieur Gassendi as well as mine, invited us to have lunch next Sunday and to stay at his house in Gentilly with the promise that there we shall indulge in debauchery." Then follows a truly remarkable explanation: "Naudé drinks nothing but water, and the others also abstain from liquor, so that the party will stay true to Ovid's slogan *Vina fugit, gaudetque meris abstemius undis* (One who is abstemious avoids wine, enjoying pure water)." Patin goes on to say: "It will be a feast, but a philosophical one, and may be more than that." This last allusion is clearly explained further on: "Last year I went with Naudé alone to Gentilly for a tête-à-tête. There were no witnesses, and this was not needed: we spoke quite freely about everything so that nobody could be shocked [67]".

If one is familiar with the books and social activities of the French *libertins érudits,* it is easy to imagine their discussions. Poussin's closeness to this intellectual milieu could not have been mere coincidence. In his report to a Parisian conference devoted to Poussin, the French historian René Pintard concluded that the independent thinking of the *libertins* could be correlated with "similar confessions in the letters of Poussin; middling beliefs, as suggested by some of his works; the frequent visible coldness of his religious scenes and a sometimes strange unity of the Christian and the profane [68]".

A letter that Naudé wrote to Cassiano dal Pozzo, dated 18 April 1642, refers directly to Poussin's Parisian conflict: "In frank conversations I had with him in the house of M. Bourdelot I completely discovered his intention not to stay here much longer and to return to Rome, where, as

he says, it is much better for the health of the body and the tranquillity of the soul. Even if this is true, I still think that it can be a pretext since, speaking confidentially, Your Excellence, though M. Poussin is very experienced and is known as such among many dignitaries, Vouet is nonetheless very persistent and uses every opportunity to vex with his rivalry. Being wild and forceful, he strives to superiority by hook or by crook... I also think that the dignitaries were too immoderate, having given so many commissions to M. Poussin, that, though working ceaselessly, he could not hope to do them in all his life. These troubles were supplemented by others, for the above-mentioned Signor Poussin, when making drawings or cartoons, often encountered ignorant painters who could not properly imitate his manner[69]".

In late July 1642, Poussin had a decisive talk with Sublet de Noyers. As the artist wrote himself, he had taken the opportunity of informing the King's official of his wish to return to Italy in order to be able to bring his wife to Paris[70]. Having received permission to leave till the following spring, taking with him a valisette, Poussin departed from Paris in September by a usual mail carriage[71]. This departure had more of the appearance of a flight, and the possibility that he was in some threat of danger, of which we are unaware, should not be ruled out. Is it only by chance that the *libertins érudits* actively assisted the artist's departure? On the way to Italy Poussin stopped in Lyon where lived another of his artist friends, Jacques Stella. It was via Stella that in November 1642 Sublet de Noyers heard about Poussin's deliberate refusal to return to Paris under any circumstances. This immediate and blunt indication of the

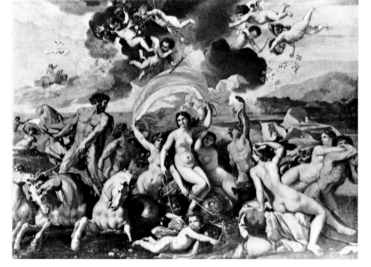

Nicolas Poussin, *The Triumph of Neptune and Amphitrite.*
C. 1636, Museum of Arts, Philadelphia.

artist's intention is further proof of the sharpness of the conflict he had left behind[72].

After this Poussin remained in Rome for good. However, by accepting many commissions from French collectors of his work, he maintained contacts with France. His fame in Europe was now at its height. Though the artist shunned the comparison, he was called the Raphael of his century[73]. French poets wrote verses in his honour, hailing him as the king of painting and the glory of France. Meanwhile, the glory of France was living on a quiet street in the Eternal City and Parisian aristocrats had to endure the rigours of quite a long journey in order to see their celebrity as if he were some overseas marvel.

From then on Poussin stayed away from everyday concerns, both mundane and clerical. In a letter dated 8 May 1650, the artist wrote mockingly about the "miracles" of the church and the credulity of the masses: "A procession from Florence brought here a wooden crucifix, on which a beard had grown and which every day increases in length by more than four inches. Rumour has it that one of these days the Pope is going to trim it ceremoniously[74]". The artist tried to avoid praise and honours. In 1657, when given the opportunity to head the Roman Academy (Accademia di San Luca), he modestly turned down the privilege. Poussin's rare capacity for work determined his strictly regulated lifestyle. For relaxation he took walks on Mount Pincio had conversations with his friends there and welcomed those who wished to listen to him. Bellori wrote: "He spoke well about art; so convincingly that not only painters, but other educated people came to listen to his quite interesting views on painting,

which he expressed not in moralizing speeches but during lively discussions[75]".

Bellori, who knew Poussin well at this time, gave the following description: "As for disposition and character traits, in addition to what has already been said, Poussin was endowed with a shrewd and farsighted mind. He avoided the court and the nobility, but was in no way embarrassed when meeting them; on the contrary, he seemed superior to them by virtue of his noble ideas[76]".

Further evidence of Poussin's insight is supplied by remarks made here and there in his business letters to clients. Though always brief, these opinions about art and reaction to European affairs reveal the sentiments of the artist, who valued, most of all, independence and peace of mind. In 1649 he wrote: "It is still a great pleasure to live in an age when such great things are happening, especially if one can hide in some quiet corner and watch the comedy from there at one's ease[77]". Particularly bitter are Poussin's famous and often cited words: "I am frightened by the cruelty of our age. Virtue, conscience and religion have been banished from the people; there is nothing but vice, fraud and self-interest. All is lost, I do not hope for the good, everything is full of evil[78]". These sombre thoughts, though they have a wider meaning, could have been inspired by the Fronde events. But the artist was not totally without hope: "If this major disorder (as often happens) could be the cause of some good reform, as for me, I would be extremely glad[79]". Poussin, like the *libertins érudits,* not only advocated social changes, but was also fearful of "people's stupidity and inconstancy[80]".

In 1649 and 1650, Poussin painted two self-portraits (Staatliche Museen, Berlin; Louvre, Paris) which, while different, complement each other.

Nicolas Poussin, *David Victorious.*
Prado, Madrid.

Poussin was not a portrait-painter, but with these two works he made a contribution to this genre as well. Velázquez depicting himself in his painting *Las Meniñas* (Prado, Madrid) chose to elevate the importance of artistic creation, Rubens removed all indications of his profession and painted himself as a grandee. Rembrandt, in spite of all the surroundings and accessories of his self-portraits, revealed his artistic nature by his insightful look. Poussin decided on a different approach and, although he is shown with all the attributes of a painter, it is as if he was caught in a moment of meditation, the moment of the conception of a new idea or painting. For Poussin art was reason's domain, as these two self-portraits make apparent. But that is not all they convey, especially the Louvre painting. A cloth draped over the shoulder, the figure's upright posture, the energetic turn of the head and the position of the arm all spell an inner force. The furrowed brow, tight lips and indomitable look speak of his independent character. And all of these are indicative of his resolute opposition to the "cruelty of the age" he wrote of in his letter of 1648. Poussin's self-portraits assert personal dignity, the right to choose one's stand necessary to rebuff "all attacks of misfortune[81]".

In his later years Poussin continued to work often in the historical genre. He painted numerous compositions of *The Holy Family,* among them some of large dimension, as well as several of vertical format (Hermitage, St. Petersburg, etc) and, for Chantelou, another *Seven Sacraments* series. Old Testament themes were still of attraction to the artist as acts of mercy, as exemplified by the 1649 painting *Moses Striking the Rock* (Hermitage, St. Petersburg, date indicated by Félibien). An earlier picture of this subject

27

(National Gallery of Scotland, Edinburgh) was dominated by the motifs of quenched thirst and gratefulness. The Hermitage canvas has more to it. While certainly containing characters expressing simple joy, the central group — a mother agonizing over her child, an exhausted warrior and other figures — is strikingly dramatic.

Poussin's style during this period enhanced the importance of the rhythmical structure of the picture and the energetic plasticity of forms, which totally prevail over the colour scheme. A vivid example is afforded by *Madonna at the Steps* (Museum of Art, Cleveland). Instead of a landscape environment, this composition is dominated by an architectural setting in which powerful geometric shapes are especially stressed. The local colours of the vestments clearly perform the function of chiaroscuro modelling of forms. The same tendencies are also manifest in *The Holy Family in Egypt* (1655-57, Hermitage, St. Petersburg). *Madonna in Egypt*, as Poussin called it, is well documented by descriptions of his work on it, contained in several of the artist's letters. In one of them he explained the details of the subject-matter, which he had borrowed from the mosaics of the Roman Temple of Fortuna in Palestrina "in order to enliven the picture with novelty and variety, and to show that the Madonna represented is in Egypt[82]". This explanation deserves special attention. Presently, the symbolic meaning of every detail, even a secondary one, that Poussin included in a painting, often becomes a source of heated iconographic debates. In this case, however, where the artist himself quite clearly states that he only sought "novelty and variety", there is no room for abstract speculations. A conclusion suggests itself that in other cases as well, matters are much simpler than as interpreted by the esoterically minded twentieth century scholars.

At a fountain near the temple, Maria with the infant, and Joseph are resting on the ground. The tired travellers are refreshing themselves with figs proffered by a boy, while a young Egyptian woman pours water into a bowl held out by Joseph. It is evident that the artist wanted to emphasize here those human actions that arise from kindness and compassion, as well as those impulses that establish confidence between people. Interrelations with this inner meaning are revealed by the composition's governing rhythm. Thus, Maria's dignified gesture is echoed in turn by Joseph's figure. The postures of the women are also mutually balanced. The figures are rhymed, as in poetry; they are consonant, as in music; and in Poussin's later works, regardless of one's estimate of their colour scheme, it is

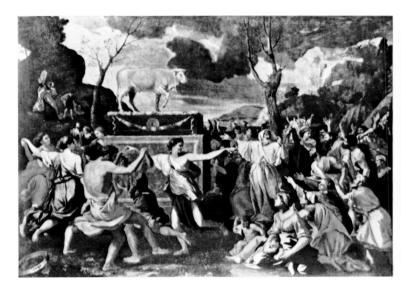

Nicolas Poussin, *The Adoration of the Golden Calf*. National Gallery, London.

this rhythm that attests to his supreme maturity and artistic wisdom.

Whether or not this harmony can be "verified by algebra"? At any rate the fact that the vanishing point is over the Madonna's head and under the portico leads to a simple, though significant conclusion: the viewer looks on the tired travellers a bit from above, joining, as it were, those who are giving them the gifts of mercy. The compositional structure thus supports the message of the painting and facilitates its perception and understanding.

Many of the pictures of Poussin's last years are devoted to the theme of compassion, which underlies all his art. In a society where cruelty, lawlessness and selfish interests ruled, the artist tried to restore the value of such simple notions as sympathy and mercy. This explains Poussin's constant adherence to the historical

genre as a form of maintaining his artistic and moral ideals.

With this stand of Poussin's in mind it is easier to comprehend the message of such paintings as *The Birth of Bacchus* (Fogg Art Museum, Harvard University, Cambridge, USA) which combines two mythological episodes: the birth of Bacchus and the death of Narcissus, which follow one after another in the third book of Ovid's *Metamorphoses*. An allegorical interpretation of the

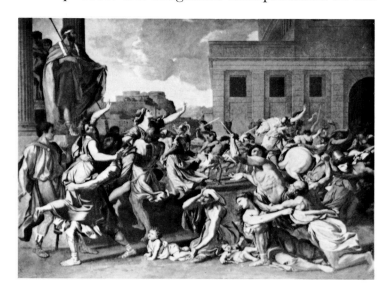

Nicolas Poussin, *The Rape of the Sabines*.
Mid-1630s, Metropolitan Museum of Art, New York.

painting occurs in modern literature where the themes of the appearance of life (the infant Bacchus), its end (Narcissus), and its revival (flowers growing from the body of Narcissus) are related and the conclusion is sometimes drawn that Poussin wished to express the idea of nature's cycle. However, Poussin's dislike of allegory should not be ignored. It would be more accurate to think of the picture as an artistic image rather than as an allegory. The central placing of the nymph of Nysa, who with great care and joy is receiving the infant from Mercury's hands, is purposeful. This dominating theme of human sympathy is naturally contrasted to the motif of Narcissus' self-fixation. Poussin's imagery is an independent poetical system, not an illustration of conceptions of natural philosophy, and it adresses the viewers with a summation of his thoughts on human nature. With Poussin, as his art reveals, artistic truth is synonymous neither with an abstract philosophic formula nor with an ordinary episode from life. *The Birth of Bacchus*, as well as many other later paintings, proves that a strict division between Poussin's works of the historical and landscape genres is artificial: there is no evidence to support the traditional opposing of them as being from different stages of the artist's evolution. Both genres, each to the measure of its potential, embodied Poussin's artistic creed. Poussin, in fact, always regarded himself as a painter of historical pieces. While his letters covered much, there are very few words about landscape painting. But none of the great artists of the seventeenth century, be it Rubens, Rembrandt, Velázquez, Jan Vermeer van Delft or Poussin, disregarded landscape painting; after all, during this period the search for an explanation of the Universe based on reason was going on more intensively than ever before. Not so long before, the real world had seemed so finite and commensurate to man. Now its full boundlessness was revealed and the world lost its former scale, so that it could be embraced by thought only. The image of man as being like a "thinking reed" in relation to the world (put forward by Blaise Pascal), gave rise to a tragic sense of overwhelming infiniteness and, at the same time, to a belief in reason as the only means for embracing the Universe. This perception of the world peculiar to the seventeenth century, in one way or another, was a powerful stimulus to the development of landscape painting.

When studying Poussin's landscapes, attention is often focused on their possible analogies in the works of earlier artists. No analogies, however, should overshadow the main point: the fundamental novelty and importance of Poussin's own artistic conception of nature. In this connection it may be of greater value to consider the general spiritual bases of the French national culture, especially the ideas of harmony and the eternal beauty of existence, which appear in the works of Malherbe and other French poets of the first half of the seventeenth century. Poussin's landscapes rise above everyday concerns: his

tranquil and magnificent scenery is not dependent on the events taking place on its foreground; human passions cannot disturb its serenity, nor curb its primordial forces. The most natural characters in this landscape environment are those who form its organic part.

This is why it is risky to define the essence of Poussin's landscapes on the basis of the scene formed by the staffage figures in the picture. There is convincing verification that the artist could freely change the foreground scenes of his compositions. For instance, in a Louvre drawing, undoubtedly connected with the *Landscape with a Man Killed by a Snake* (National Gallery, London), there are two characters engaged in a peaceful conversation; in a graphic sketch from the Dijon Museum, which relates to the same picture, the artist depicted a fisherman heading toward a lake; while the London painting shows the tragic scene of a man's death.[83] In analysing Poussin's landscapes, the main thing is to discover the laws of their imagery and structure, rather than to interpret the particular thematic motifs.

All this notwithstanding, it cannot be denied that Poussin strove to fill in his landscape paintings, which were evocative of the past, with historical figures. This is exemplified by two pictures devoted to the fate of Phocion, an Athenian general of the fourth century B.C. famous for his high moral principles, who was condemned to death on false charges. *Landscape with Diogenes* (1648, according to Félibien; Louvre, Paris), provides another example. When portraying this Greek philosopher of the cynic school, Poussin might have recollected his words, narrated by another ancient philosopher: "To fortune he could oppose courage, to convention — nature, to passion — reason[84]". The picture recreates an image of the world remarkable in scope and generalization. A thicket over a spring, the unruffled smooth surface of the water, an open valley with a road, mighty rocks, a town perched on hilltop — all these elements together create a composition of unusual grandeur. Diogenes, an ascetic, when seeing a young man drinking water from a brook with his cupped hands, throws away his cup as excessive. Though fitting into the landscape, this staffage scene, as any other, does in no way account for the main merits of Poussin's system of landscape painting.

Russian museums house two of Poussin's landscape masterpieces. According to Félibien, one of them, *Landscape with Polyphemus* (Hermitage, St. Petersburg) was done in 1649. The date of *Landscape with Hercules* (Pushkin Museum of Fine Arts, Moscow) has not been indicated in any source, which has caused a protracted discussion on their chronological placement in relation to each other. Most art historians feel that they were done in different periods, but a concordance of compositional patterns and dimensions suggests that they could make a pair. Further contributing to this hypothesis is the symmetry in their diagonal structures, in the positioning of bare rocks forming chains receding into the distance, and in the placing of the main characters on the tops of the rocks. There is also a great deal of affinity in the figures and objects of the foreground (including symmetrically arranged vessels).

The subjects of these two paintings were borrowed from Ovid's *Metamorphoses* and Virgil's *Aeneid,* though, as of yet, no one has succeeded completely in identifying the respective texts in the ancient poems from which they were taken. In the Hermitage painting two main personages — Galatea and Acis — have not yet been located, while the Moscow canvas contains figures not even mentioned by Evander, whom Virgil made the narrator of the battle on the Aventine hill. As Mikhail Alpatov justly emphasized, Poussin did not illustrate mythological texts, but instead made up his own legends[85]. The artist was not constrained by his literary erudition; on the contrary, this helped his poetic imagination.

Both landscapes re-created the image of humanity's Golden Age, with which Poussin was so enchanted. The lives of the characters, at one with the magnificent scenery, are represented with a charming poetic integrity. The epic nature of the paintings makes them equal to a general picture of the world. Hills and valleys, fields and groves, lakes and bays of the sea, mythological

figures and tillers of the soil all comprise a multiform image of perfect and flourishing nature. Poussin, unlike other landscape painters of the seventeenth century, did not portray either dawns or twilights, preferring, usually, midday, when all of nature's creative forces were in full swing. The artist unfolded the space freely and broadly, making skilful use of additional diagonals, alternating ground levels and colour zones. At the same time, he resorted to no outward

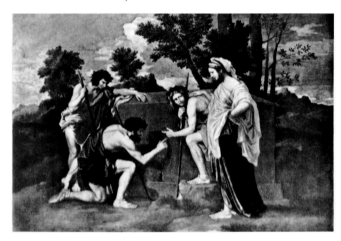

Nicolas Poussin, *The Arcadian Sheperds*.
Late 1630s, Louvre, Paris.

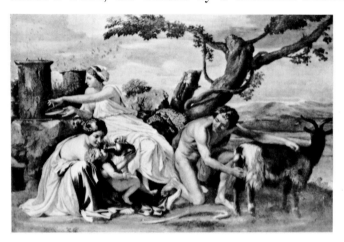

Nicolas Poussin, *The Nurture of Jupiter*.
1630s, Museum Dahlem, Berlin.

effects. To render spatial depth he toned down the colour contrasts and intensity, which in *Landscape with Polyphemus* can be clearly seen in a comparison of the foreground figures with that of Polyphemus. In his landscapes Poussin utilized the capabilities of colour for constructing effective volumes, modelling bodies and varying shades of greenery. Thus, the crown of the tree in the Hermitage canvas has remarkably diverse colour gradations. A special role is played by the transparent coloured shadows used to paint the rocks.

Similar principles and conclusions can be applied to the four late landscapes, making up *The Four Seasons* cycle (1660-64; Louvre, Paris), Poussin's "swan song".

The real message of these pictures cannot be determined by theological interpretations or iconographic comparisons[86]. Similarly, it is simplistic to construe the sad story of the blind hunter Orion in search of healing (*Landscape*

with Orion; 1658, Metropolitan Museum of Art, New York) as "the drama of the circulation of water in nature[87]". Along with all of Poussin's masterpieces, *The Four Seasons* became a part of world culture by virtue of their artistic merits. *Spring is* the poetic image of the joyful blooming of life; *Summer* — an epic of earthly labour; *Autumn* — a tribute to nature's abundance. The paintings of this final series, summing up the artist's work, are united by a common theme, that of the apotheosis of being. Nature is interpreted as a stage for human activity, with life as an integral part of the natural process. The rhythm of people's lives is subordinate to the laws of the Universe. From this naturally follows the idea of human concord and compassion. The meaning of the gesture that Voos makes responding to Ruth's entreaty (*Summer*), echoes the motif of the child's rescue from the deluge depicted in *Winter*. Seen in the distance, Noah's Ark appears lifeless and seems without a promise of escape.

Even considering its tragic subject-matter, the main theme of *Winter is* not death but hope; once again, Poussin remains true to the ideals of compassion.

Poussin's hands had for a long time already been shaking and, as a result, work made was quite painful. In spite of his disability, however, his last canvases gained still more notable artistic merits. With great energy and new scope, the

31

landscape space is moulded by the natural forms themselves. In *Summer* this role is assigned to a wall of unharvested corn, the resilient lines of the road skirting the field and the rows of rocks which take the viewer's eye to the distant mountain ranges. The texture of each object is rendered by strikingly plastic strokes, while the gradation of planes is conveyed by colour relations. The *Four Seasons* cycle is indeed Poussin's artistic testament. No less significant, too, is the synthesis of the landscape and historical genres, that was achieved in Poussin's late period, as exemplified by the unfinished *Apollo and Daphne* (Louvre, Paris). The artist's last works also anticipated many of the coloristic discoveries of future ages.

In continuing with the analysis of Poussin's works, a brief description of his method and artistic principles is in order. Further support for the conclusions contained here is given by Poussin's programmatic letter to Sublet de Noyers... To begin with, it should be stressed that Poussin was not the author of abstract doctrines, as he was later portrayed by seventeenth century ideologues of academism. His principles were based on practice. And he expected theoreticians to appreciate practice in the same way. In one of his last letters, Poussin wrote: "There is a certain N... who writes about artists and their lives in a high-flown style devoid of wit and understanding. He approaches art as a man who has mastered neither its theory nor its practice. Many of those who dared to do this were rewarded with well-deserved derision[88]".

There are descriptions of Poussin's creative method written by his contemporaries. Joachim von Sandrart, a German artist,

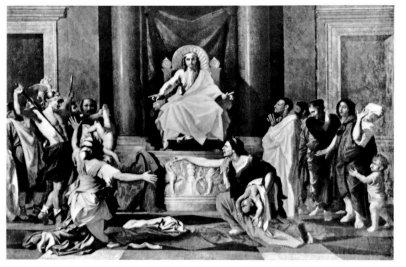

Nicolas Poussin, *The Judgement of Solomon.*
1649, Louvre, Paris.

met Poussin in the late 1620s and left us these vivid and ingenuous impressions: "He could always take part in a lively discussion; he always had a notebook in which he recorded everything necessary for himself both by drawing and by writing. When he conceived some idea, he carefully reread the chosen text, thought it over and then drew two quick sketches of general composition on paper. Or, if it was a historical theme, he distributed, according to his idea, nude wax figures made for this purpose in the postures required by the story on a smooth board marked with a stone. On these figures, at his own discretion, he put clothes made of wet paper or light fabric and stitched with thread, and then placed them at a proper distance from the 'horizon'. This done, he began to paint in colour his pictures on a canvas... He often employed live models devoting to them a lot of time. When working, he stopped for walks to ponder on his picture[89]".

In 1648, the young Félibien, while in Rome, recorded the following statement of Poussin's: "Skilful people must work with the help of intellect; that is to say, they must know beforehand what they want to make[90]". Poussin's words, judging by the context, were aimed against literal depiction in art. He thought it necessary to thoroughly contemplate a future work and to raise it to a level of generalization. By studying a literary source, he was seeking in the chosen plot a deep message worthy of artistic materialization. The artist also thought about the forms of embodying the subject, to which end he sketched different versions of the composition. When informing his clients about a conceived work, Poussin often used the

words "l'idée" (idea) and "la pensée" (thought). Thus, in a letter dated 1647, the artist announced: "I have found the thought, I mean the conception of the idea, and the work of the mind is over[91]". But this does not represent any aesthetic formula; the essence of this statement is not that the execution of a picture was preceded by some speculative conceptions or other to be then transposed into the language of art. All terms such as thought, conception, idea, etc. relate to the creative process, and, in the artistic vernacular of the time, referred either to the initial compositional sketch or to a more elaborate one. Therefore, Poussin always considered "the work of the mind" as an integral part of the creative process, and the nucleus of the future work was already outlined in the plastic forms of the first sketch. There are a large number of these "pensées" that have come down to us, possessing always both expressiveness and poetical fantasy. Of course, the artist could not ignore the wishes of his clients if they suggested an idea themselves, but he was glad when he was given freedom of choice (see the letter of 17 March 1644 to Chantelou about the *Seven Sacraments*[92]). Poussin did not use manuals like *Iconologia* by Cesare Ripa; with his literary erudition, a compilation of ancient mythology was hardly needed. Responding to detractors, the artist proudly stated that he never lacked the knowledge to give his characters the necessary expressions[93]. In view of this, a mocking remark that Poussin once made in Félibien's hearing is not surprising. It concerned those dramatic poets, who, unfamiliar with the customs of the age, cannot enter their characters into the sentiments, peculiar to the time[94]. The artist needed knowledge not in order to paint secondary details with historical accuracy (for instance, having copied a depiction of an ancient triclinium, a couch for reclining at meals, he painted it in the composition completely differently). Poussin found examples of heroic acts and superior qualities of human nature in the works of ancient and Renaissance authors. His artistic ideal does not present an uncritical admiration of the past since, first and foremost, it reminds the viewer

that dignity and principles must be kept in any situation.

In the seventeenth century, the ideal of harmony in art could be realized only as an effort of will and in opposition to the disharmony of the real world. What is termed "limitation" of personality, a feature distinguishing the art and culture of the epoch of absolutism from those of the Renaissance, was not a self-limitation imposed by conviction, but rather a forced condition necessitated by the pressure of reality. In this context, incidentally it becomes clear why, in spite of the differences between the imagery of Poussin and the playwright Pierre Corneille, they were united by the cult of willpower. Poussin was so persistent in his striving for a harmonious ideal, so uncompromising in maintaining the unity of the aesthetic and the ethical, that as the years passed his exalted style acquired a more strict and rigid character. Though seemingly stable and quiet, his artistic system is inwardly tense.

While we may say that Poussin's imagery, in its opposition to the forces of evil, tended to be self-contained, this should not be identified either with elitism or isolation from the real world. To achieve harmony in the seventeenth century was like an act of heroic resistance. At that time life was suggesting many other solutions to the artist. Without understanding this, there is no way to understand Poussin.

To Raphael or Titian (in his *poésies*) the harmonious imaginary world was precious by virtue of its own perfection. But Poussin cherished his ideal world in so far as it compensated for the grievous imperfection of reality (remember, for example, his saying "I am frightened by the cruelty of our age..."). His art, which evinced compassion, with time evolved into a demand for it. This stand taken by the artist has the estrangement of a prophet. A lucid world of reason and pure sentiments created by Poussin's mind and skill was proudly superior to the fussy worldly reality, as an incarnate dream of a free and reasonable universe.

To conclude that Poussin's imagery was a utopian abstraction would be incorrect. For him, the artistic interpretation of life lay in studying

its hidden law — the sense of passions, motives and actions. Poussin's method revealed that his pictures were not created spontaneously, but were carefully constructed. Well-balanced elements, verified proportions, well-matched postures, and concordant rhythms — these were not an application of some set rules, but Poussin's novel poetics. The artist's high ideals, incarnate in his characters' inner motivations and emotional traits, called for corresponding plastic equivalents. Poussin's poetics had a powerful and beneficial impact on the art of the next epochs. With this in mind, it is easier to understand the specificity of Poussin's themes. His artistic system had no need for scenes of everyday life,

torical genre, which yet levels out considerable differences.

It should be noted that Poussin chose those episodes from stories that contained the spiritual, moral and lyrico-emotional climax of the action, but that did not require exposing the characters' complex inner lives. If there had been a moment of inward struggle or tormenting doubt — all this was in the past. The die was cast, the decision arrived at, the choice made. As a matter of fact, the French artist was also strictly opposed to the official Catholic iconography of the Counter-Reformation age, with its attempts to restore shaken faith by picture of martyrdom and ecstasy. Poussin paid the least possible tribute

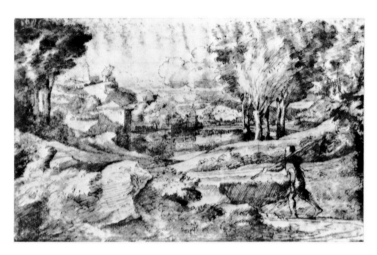

Nicolas Poussin, *Landscape.*
C. 1648, drawing, Musée des Beaux-Arts, Dijon.

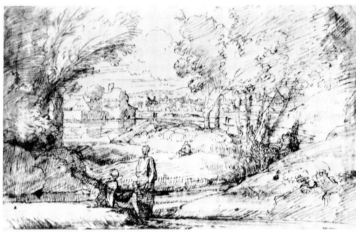

Nicolas Poussin, *Landscape.*
C. 1648, Louvre, Paris.

devoid of high ethical potential. The essence of Poussin's creative method was exactly such that he could not embody his thoughts on a man destined to perform his moral duty in the face of life's trials and tribulations, otherwise than in the so-called poetical inventions (*poetiche invenzioni*). The term was coined by Bellori, the artist's contemporary, and therefore characterizes aesthetic ideas of the seventeenth century. Theoreticians of the time, from Mancini to Bellori, singled out three thematic types of this kind: 'history', 'legend', and 'poetry' (*storia, favola, poesia*). Poussin preferred his own terms: "heroic" and "bacchic" subjects[95]. More widely used in art criticism is a broader term — his-

to this tendency (*The Martyrdom of St. Erasmus* and some other paintings). He also avoided the scenes of bloody clashes, crimes and assassinations, *i.e.* the motifs so popular with the Caravaggists.

Poussin attached great importance to "invention", an underlying principle of the art of the epoch. Recommending a young artist in a letter, he wrote with approval: "He builds effective compositions, is inventive and uses colours quite skilfully[96]". The epithet "inventive" speaks of Poussin's own preferences. The unfolding of action in a historical scene required "invention". Not accidentally, in his description of Poussin's method, Sandrart put emphasis on what he

termed 'action'. But to invent the action was not enough; its presentation on the canvas was also necessary. This is why, in Poussin's method, composition (or to use his terminology, "disposition" or "distribution"[97]) assumed such significance. Improvisation was not at all characteristic for Poussin. When deciding on a composition, he acted carefully and methodically. When addressing a client, the artist usually indicated the number of figures in the picture. The role of each figure in the general action was thoroughly balanced and determined. In his creative process, Poussin was using the method of deduction, *i.e.* proceeded from the general to the particular. This is clearly demonstrated by his compositional drawings. At the first stage of the subject's treatment in a graphic sketch the artist was not so much interested in the individual figures as in the basic groupings, that is, the plastic nuclei of the composition.

The academic doctrine (Federico Zuccaro, Roland Fréart de Chambray, etc.) that put artistic conception over execution, proclaimed "disegno" (understood as artistic conception) superior to the painter's practical work. Such an opposition is not present either in Poussin's reasoning or practice. He always ascribed an equal role to execution.

Poussin's sketches reveal another peculiarity of his method. In them he tried to verify not just the correlation of the main plastic elements or rhythmical structures, but the balance of light of the future painting. There is no doubt that many of these graphic sketches were done from a previously constructed model — wax figures arranged in a box. Sandrart describes this box, but an especially detailed description comes from Le Blond de la Tour, an artist from Bordeaux.[98] Such an aid had been used before: by Tintoretto, Greco, Barocci and others. Le Blond de la Tour in particular pointed out the holes for light, which helped the artist to determine the lighting of the figures in the interior. It is easy to visualize the artist moving his wax figures and arranging them in groups, while verifying compositional relations. Thus, in search of the optimally convincing action, Poussin first constructed a scale model of the future picture in three-dimensional space. Then, sketches were made from the model, many of which one can easily recognize among Poussin's drawings. The principle of the initial construction was the cornerstone of the artist's method and quite naturally, it had an effect on his works. This principle is directly connected with Poussin's theories on architectonics and architectural decor, quoted earlier from his letter to Sublet de Noyers. Like an architect, the artist built the picture's composition, seeking orderliness and commensurability

Nicolas Poussin, *Landscape with a Man Killed by a Snake.* 1648, National Gallery, London.

of parts in the name of harmony of the whole. Since the bulk of Poussin's extant drawings comprises sketches made from these models, it may be appropriate to discuss the distinctive features of his graphics as a whole. According to his contemporaries, Poussin drew a great deal, and from nature as well. The 450 existing drawings are but a small share of Poussin's heritage and since their number is clearly incongruous with the full scope, it is impossible to classify them with complete accuracy. In 1678, Jean Dughet, the artist's brother-in-law, listed drawings "from the antiques, Raphael, Giulio Romano and others", "various invented designs", and "landscapes, animals, heads".[99]

35

The preparatory sketches mentioned here are fascinating in their spontaneity: as if born of the artist's imagination but containing, at the same time, impressions of life, these sketches demonstrate the artist's poetic ardour. The same traits are explicit in his landscape studies. Yet it is characteristic, that even at the stage of a drawing the artist's vision of nature received a definite compositional expression. This applies even more so to the preliminary drawings made from his models, which are dominated by lucidity, balance and plastic clarity.

Though brilliant at drawing, Poussin, along with the majority of the seventeenth century masters, did not regard it as a self-contained art, subordinating it to his work on the painting. The artist's favourite technique was pen and bistre, often used over pencil sketch. Bistre wash gave rich and varied tonal effects. However, Poussin's wash, in keeping with his desire to reveal the plastic form, was marked by the energy of chiaroscuro contrasts, rather than by the softness of nuances. Against deep lush shades the paper's surface looks luminous.

Poussin's drawing technique underwent some changes. In his early sketches (*The Martyrdom of St. Erasmus*, Uffizi, Florence, etc.), intense hatching of parallel lines prevailed. This hatching did not follow the outline but rendered the figures' plasticity as well as the light-and-shade contrasts by means of vigorous shadows. The drawing's expressiveness was further enhanced by the attractive use of wash technique. The artist emphasized the main elements, while the background details were merely suggested with a few strokes. In his mature period this strong pen-and-ink shading gave way to a brush-and-wash technique. Finally, in his late years Poussin's favourite technique was fine pen drawing. Light and exquisite, done in meandering and broken lines, these drawings lost their former dramatic effect, and light-and-shade transitions became softer and more delicate. Such a technique enabled the artist to convey the feeling of space and air as required by the canons of landscape. Incidentally, Poussin applied this technique for historical scenes as well (*Achilles on*

the Island of Scyros, Hermitage, St. Petersburg). A diary that Félibien kept in Rome records one of Poussin's statements: "Speaking about painting, he said that just as twenty-four letters of the alphabet serve to form our words and express our thoughts, so the outlines of human bodies are indicative of different passions of the soul, of what is hidden in the mind[100]". Though very close to the sayings of Renaissance artists (Alberti, Leonardo da Vinci), Poussin's statement was a result of his own practice and one of the cornerstones of his method. Among the means of artistic reflection of emotions, Poussin chose precisely the language of the body, of its postures and movements. While the exponents of another seventeenth century trend, such as Jacques Callot and Frans Hals, paid close attention to individual facial expressions, the faces of Poussin's characters are rather impassive; the artist's desire to sometimes endow them with greater emotionality often resulted in strange grimaces. Postures and gestures usually provided the principal expressions. This may be why, in the Hermitage painting, Poussin has Esther fainting before Ahasuerus since he could hardly have managed to give adequate facial expression to her conflicting emotions.

Art theory in the seventeenth century widely used the concept of 'passions' (*affetti*), but in his letters, even when describing the feelings of his characters, Poussin does not use the term. The reason may lie in the essential difference between his artistic system and the methods of the Roman baroque painters. Emotions in Italian baroque painting were always portrayed as extreme excitement and exaltation, whereas Poussin was more inclined to depict people who could control their passions. Hence, the noble reserve of postures, movements and gestures, that is always so fascinating in his works.

In one of his letters Poussin spoke about the "natural attitudes" of his characters[101]. Certainly, he was not referring to just any natural movements, in the same way that not every emotion or passion deserved to be depicted on his canvas. However, within the limits of his ideal the artist found clear plastic formulae of emotional

impulses. In this he was assisted by classical examples, as if, to use the apt remark of Sébastien Bourdon, by a compass in the ocean of impressions[102]. Poussin often expressed his admiration for the lessons of perfectly represented nature supplied by classical works. He wrote: "Never do I feel more inspired to work, as when I have seen something beautiful[103]". The artist ceaselessly studied classical monuments, collected ancient sculptures and also used engravings, mainly from the works of Raphael and his school, especially when designing plot and composition. Yet no one can allege that Poussin repeated classical motifs: his imagination absorbed and transformed them. Even Poussin's sketches from the Roman reliefs possess a rare emotional quality, which reflects the artist's own interpretation of the original.

It would be naive to think that the artist could borrow from a classical or any other kind of source such an expressive posture as that of the woman sitting in the Munich *Lamentation,* or as ingenuous a movement as that of the beautiful companion of Arcadian shepherds in the subject's first version. Bellori, Félibien and Le Brun all insisted on the decisive role of Poussin's classical studies in his method. But the testimonies of Mancini and Sandrart about the artist's work with a life model seem much more convincing[104]. Certainly, neither a mock-up perspective box, nor the impressions from classical or Renaissance monuments could replace the study of a real life without which Poussin's execution of the painting would have been impossible. Quite reliable seems Félibien's reference to Poussin's words that "it is by observing things that an artist

becomes skilful much sooner than by tiring himself copying them[105]". To mention here Poussin's endless studies of anatomy both in Paris and in Rome is very much apropos.

Naturally, questions of the painting's actual execution also pertain to Poussin's method. But since the peculiarities of compositional and colour techniques were discussed in connection with the analysis of the artist's works, it only remains to sum up some characteristic features.

When outlining on the canvas in chalk or charcoal the contours of groups, figures, architectural or landscape details, Poussin carefully correlated them with the dimensions of the canvas. Important positions in his system of preliminary drawing were assigned to the point of intersection of the canvas's diagonals, its middle vertical axis and additional axes. The compositional structure of Poussin's pictures was usually based on two principles: mutual balance of forms (the arrangement of groups around the centre and the major axes) and their free and seemingly counterpoised relationship (decentralization with the help of additional axes shifted sidewards). It was only the interaction of these two principles that made possible such a striking organic result — a feeling of harmony combined with the freedom and mobility of design. Academic artists of the second half of the seventeenth century, who claimed to be Poussin's followers, but in fact reduced his method to a dry doctrine, tried hard to achieve the similar effect — but to no avail. His secret was beyond the reach of doctrinaires.

As for brushwork, Poussin did it thoughtfully and leisurely: he was contemptuous of the

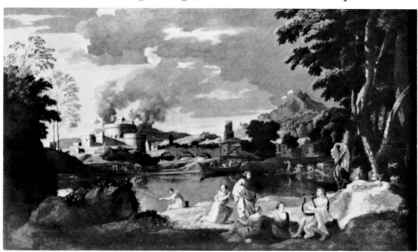

Nicolas Poussin, *Landscape with Orpheus and Eurydice.* C. 1648-1651, Louvre, Paris.

"daubers" who, "whistling", painted a picture in one day[106]. "I think," the artist wrote, "that I manage a lot if in one day I paint one head so that it has the due effect[107]". From his letters we know that first he painted the landscape or architectural background and lastly the figures. At the final stage Poussin especially valued the definiteness of the plastic form, which he referred to as a "good relief[108]".

The colour scheme of Poussin's pictures changed in the course of his evolution. In the early Italian period the artist liked to render the changing light with the help of reflexes; he was fascinated by the effects of the natural light in a landscape environment, his relationship of colours was emotional. By the early 1630s his palette had become lighter, which distinguished his art from the chromatic systems of that time. At the end of the decade the compositional role of colour increased, the alternation of local colour accents promoted the "reading" of multi-figured pictures. The plastic function of colour, predominant during the late 1640s, was elaborated most fully and comprehensively in the artist's last works. Thus, the colour scheme was the most mobile element of Poussin's artistic system, which again shows his great creative potential as a painter and therefore proves the necessity of studying his means of expression: too long and too often has Poussin been spoken about as if he had not been a great painter, but an illustrator of his own or somebody else's postulates, a translator of non-artistic ideas into the artistic language.

The artist himself justly said that his profession needed no words[109]. Hence, the question of Poussin's so-called theoretical ideas should be treated with greater caution. The material available to art historians must be differentiated. The artist's set of principles, for example, is usually said to include a "theory of the modes" and a number of other similar discourses found in his letters. Yet there is a difference between Poussin's own ideas, born of his artistic experience, and the passages that he copied from the works of classical and Renaissance theoreticians. It cannot be disputed that these passages speak of

Poussin's erudition and that his creative interests determined their choice. But they are not the same as the lively and resolute polemics, contained in his programmatic letter to Sublet de Noyers.

Let us recall exactly which passages are meant. They are: a discourse on the two kinds of visual perception, translated from a Renaissance treatise on perspective written by a Venetian Daniele Barbaro, and contained in the 1642 letter to Sublet de Noyers[110]; a discourse on the "modes", copied incorrectly from a work published in Venice in 1558 by the musicologist Gioseffo Zarlino and included in a letter dated 24 November 1647[111]; and, in a 27 June 1655 letter, a section of a treatise written by the ancient Roman rhetorician Quintilian, which gives characteristics of the artists of antiquity[112]. The twelve *Osservationi sopra la pittura*, which Bellori, in a supplement to his biography of Poussin, presents as the artist's authentic sayings, also have a number of coincidences with certain works on aesthetics[113]. All this has long been known. A new example, however, is provided by our own discovery.

In Bellori's supplement, the title of the third observation on painting, "How Art Surpasses Nature", has always seemed strange. Poussin's letters contain no statements to the effect that art has superiority or supremacy over nature. The artist consistently stressed the necessity of studying nature. Certainly his images have an ideal character; still, the artist never shared the seventeenth century academic doctrine on the supremacy of art over nature. Furthermore, the content is incongruous with the title of the extract. So when it was discovered that "How Art Surpasses Nature" was actually a shortened extract from *Poetica d'Aristotele vulgarizzata e sposta*[114], an aesthetical treatise by Lodovico Castelvetro (1505-1571), everything became clear. A comparison with Castelvetro's text revealed the true meaning of this "observation" — it deals with the relationship between the poet's natural talents (*natura*) and his art (*arte*), which in this context means not artistic activity in general but the skills acquired by a poet or

38

speaker through training. The Italian theorist was disputing Horace and Quintilian, who had suggested a harmonious solution of the problem, and gave preference to training and knowledge over the natural gift. To connect this stand of Castelvetro with the mannerist or academic conception of art's superiority over "imperfect" nature would be a complete delusion. Castelvetro's idea was quite different. Underlying his theory was a firm belief in the power of knowledge. In this sense he was a forerunner of the seventeenth century *libertins érudits*. Incidentally, Castelvetro was a free-thinker himself, and having been accused of heresy, was forced to leave Italy. Castelvetro's aesthetic ideas may have attracted Poussin's attention; it was also possible that his interest was promoted by his friends among the French *libertins*.

Bellori mentioned that he had found "Observations on Painting" in the library of Cardinal Massimi, who patronized the artist in his late years and visited him in his home. It is known that Poussin gave the Cardinal *Apollo and Daphne* as a gift when he realized that he had no hope of finishing it. It can be easily imagined how on one of Massimi's visits, the artist might have handed him a small bundle of papers containing his notes. It is unlikely that these notes, usually only a few lines each, were entitled. It very well may be, that before publishing them, Bellori gave them his own titles. If that was the case, it becomes clear why the title of the third excerpt corresponds neither to its meaning, nor to Poussin's ideas. Bellori's bias would not be surprising, especially considering his doctrines and demands for idealization in art.

It would be ridiculous to think that our discovery, based on the critical comparison of the texts, diminishes the importance of Poussin's creative principles. The main thing holds true: Poussin's interest in art theory was deep and well-grounded. This discovery also strengthens the thesis that the artist's independent stand was inherent in his work itself. Such finds provide clues for understanding the ties between Poussin's ideas and the aesthetic theories of the sixteenth and seventeenth centuries.

A few months before he died in 1665, the artist wrote a letter containing his most detailed theoretical discourse. Though the ideas presented there appear to be thoroughly pondered, they do not form a comprehensive aesthetic programme. The essence of the discourse is not in the brief enumeration of the optical bases of perception, nor in the scholastic classification of the component parts of painting, but rather rests in Poussin's maintenance of his artistic creed. Hardly accidental that the letter begins as follows: "It is necessary to wake up from such a long silence. One should make oneself heard while the pulse still beats[115]".

The letter dated 1 March 1665 was addressed to Roland Fréart de Chambray and was written in response to his aesthetic treatise *Idée de la perfection de la peinture*, which the author had sent to Poussin[116]. The artist's reaction to his compatriot's book was reserved, he treated it as a preliminary preparation for generalizations which could then be made by someone else. Further on referring to a work written in Latin by Franciscus Junius, *De pictura veterum libri tres*, Poussin said that he would include its classification in his letter[117]. The meaning of this reference remains somewhat unclear: the classification of artistic categories in Junius's bulky treatise was completely

Tempest. Engraving by Louis de Chatillon from Poussin's painting, Metropolitan Museum of Art, New York.

39

different from that set forth in Poussin's letter. Nor was Poussin about to repeat the system suggested by Fréart de Chambray, who considered the basic concepts underlying art to be "decency" (*bienséance*) and "conformity" (*costume*)[118]. The first had never been used by Poussin; and the second concept only once, in this very letter under discussion. Yet both of these were unquestionably accepted by the academic doctrine of the time as the criteria for judging the merits of historical painting, which should be based on the principle of idealization. The way such criteria were used can be illustrated by the following characteristic example: in his treatise Fréart de Chambray condemned Michelangelo for being a "free-thinker, trampling on the rules of art" and for ignoring precisely this "decency"[119].

It is surprising that up till now little attention has been given to the difference that separates Poussin's theoretical ideas from the then current academic doctrine. A letter of 1665 reads that painting is an "imitation". Though widely repeated, everyone had his own understanding of the cliché. Moreover, the same was said in the Royal Academy. At an academic conference in 1672, the artist Jean-Baptiste de Champaigne declared that the "aim of the painter is to imitate nature". Explaining further, he continued: "The best quality of a painter is to imitate perfect nature[120]". Not any nature, but perfect nature. This doctrine complied with the academic hierarchy of subjects and genres. Poussin's ideas were different. He defined the artist's work as follows: "It is an imitation, by means of lines and colours on a surface, of everything that is under the Sun[121]". Though Poussin himself did not aim to paint all subjects, he proclaimed their equal status in art. Such was his key principle.

His second principle describes the aim of painting as "pleasure[122]". This sounds unexpected: it was traditionally held that Poussin identified art's aim with didactic function. Was it by chance that Poussin proclaimed this principle of hedonism exactly when the Royal Academy was making strenuous efforts to limit the function of art to praise for the absolute monarch? The suggestion arises that by putting forward this prin-

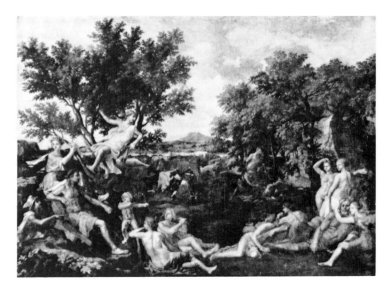

Nicolas Poussin, *Apollo and Daphne.* Early 1660s, Louvre, Paris.

Nicolas Poussin, *Winter, or the Deluge.* 1660-1664, Louvre, Paris.

ciple the artist was trying to broaden the creative process beyond the utilitarian role persistently assigned to it by academism. This principle also discloses the similarity of Poussin's ideas to the aesthetic tradition reflected in Castelvetro's hedonism and Gassendi's epicurean philosophy. The third principle formulated in the letter of 1665 brings us back to the theme that earlier drew our attention to the treatise by Castelvetro. Poussin raises the question of the relationship between the artist's natural gift and the skill gained through training. Let us meditate on what follows in the letter after the definitions of paint-

ing and its aim. Having listed the elements of visual perception, Poussin terms them "principles that every person who has reason can master[123]". He then goes on to say, "What comes after this cannot be learnt: it is innate in the artist[124]". Yet in "what comes after" Poussin includes disposition, ornament, decorum, beauty, grace, vivaciousness, conformity, plausibility, and reason in everything[125]. His only reservation concerns the theme ("None of its properties should be received from the artist"[126]). These qualities which he has enumerated, Poussin insists, must be innate in the artist, they cannot be learnt. Concluding his letter, Poussin recollects the famous symbol of poetic inspiration — Virgil's golden branch "which nobody can find or break off if he is not brought to it by fate[127]". So, in the letter of 1665, Poussin went back to the problem that had once been a subject of dispute between Castelvetro and Francesco Patrizi. While Poussin did not side with Patrizi and his neo-Platonic concept of divine revelation, neither did he go along with Castelvetro and insisted on the supremacy of an artistic gift, endowed by fate. Incidentally, in his paintings devoted to the *Inspiration of a Poet* theme (Louvre, Paris; Niedersächsiche Landesgalerie, Hanover), this gift comes from Apollo himself, which conceptually is analogous with Virgil's idea of the "golden branch".

Summing up, it may be said that in the letter of 1665 Poussin put forward three basic principles: 1. painting is an imitation; 2. its aim is pleasure; 3. innate in the artist is a natural gift which cannot be given or taken away. What does all this mean? Need this be explained? Indeed, it does: this letter sounds like a will.

But can this be explained? Perhaps it can if put into a historical and artistic context. Poussin lived and worked in the age when art was breaking with the system of workshop dependence, when the artist was changing from an artisan to a creative analyst of the world. This went along with the realization of the artist's social mission and of the role of his creative act as an expression of spiritual freedom. However, the time when the letter in question was written, was very much unlike earlier stages of the development of artistic self-consciousness. A new danger of the academic regimentation in art was then impending, thus restricting its creative potentials. Poussin experienced something of this tendency during his dramatic stay in Paris in 1640-42, and later on also clearly realized what French artistic life was like.

In these conditions the principle of the supremacy of the natural talent over the skills acquired in the process of training was a means to defend the artist's creative independence. Poussin's letter was his artistic will. It brings to mind the 1642 letter to Sublet de Noyers, where he boldly defended his principles. Contrasted to contemporary academic doctrines, the ideas expressed in it acquired a sense of warning. The content of the theoretical discourse of 1665 embodied the principles suggested by Poussin's wonderful self-portrait in the Louvre, which shows the artist maintaining his moral and aesthetic stand in the face of cruel realities.

Yuri ZOLOTOV

41

NOTES

1. G. P. Bellori, *Le vite de'pittori, scultori et architetti moderni*, part I, Rome, 1672, p. 409.

2. *Nicolas Poussin*. Ouvrage publié sous la direction de A. Chastel, Paris, 1960, vol. 2, p. 185 (further: Colloque Poussin).

3. *Musée du Louvre. Exposition Nicolas Poussin*. Préface: G. Bazin. Catalogue: A. Blunt. Biographie: Ch. Sterling. Documents de Laboratoire: M. Hours, Paris, 1960, p. 213 (further: Exposition Poussin).

4. G. P. Bellori, *op. cit.*, p. 408.

5. The second name was indicated by Roger de Piles in 1799, see: Colloque Poussin, vol. 2, p. 230.

6. *Ibid.*, p. 228.

7. G. P. Bellori, *op. cit.*, p. 409.

8. R. Crozet, *La Vie artistique en France au XVII^e siècle (1598-1661). Les artistes et la société*, Paris, 1954, p. 61.

9. A. Blunt, *Nicolas Poussin*, New York, 1967, p. 34.

10. Quoted from Colloque Poussin, vol. 2, pp. 198, 199. See also: D. Marrow, "Maria de Medici and the Decoration of the Luxembourg Palace", *The Burlington Magazine*, 1979, December, pp. 783-791.

11. G. P. Bellori, *op. cit.*, pp. 409, 410.

12. Colloque Poussin, vol. 2, p. 148.

13. P. J. Mariette, *Abecedario*, vol. 4, Paris, 1857-58, p. 212.

14. G P. Bellori, *op. cit.*, p. 410.

15. G. P. Bellori, *op. cit.*, pp. 410, 411.

16. G. B. Marino, *Dicierie sacre*, Venice, 1643, pp. 52, 133 (1st ed., Turin, 1614).

17. *Ibid.*, p. 10.

18. I. N. Golenishchev-Kutuzov, *Roman Literatures*, Moscow, 1975, p. 251.

19. *N. Poussin. Lettres et propos sur l'art* (textes réunis et présentés par A. Blunt), Paris, 1964, p. 134 (further: Poussin 1964)

20. *Ibid.*, pp. 129, 130.

21. *Ibid.*, p. 129.

22. J Delumeau, *Le Catholicisme entre Luther et Voltaire*, Paris, 1971, p. 94.

23. A. Adam, *Théophile de Viau et la libre pensée française en 1620*, Geneva, 1966, p. 433.

24. Colloque Poussin, vol. 2, p. 198.

25. *Ibid.*, vol. 1, p. 58.

26. A Adam, *op. cit.*, p. 304.

27. G. Naudé, *Apologie pour tous les grands personnages qui ont été faussement soupçonnés de magie*, Paris, 1625, p. 17.

28. *Ibid.*, p. 229.

29. Poussin 1964, p. 57.

30. G. Mancini, *Considerazione sulla pittura*, Rome, 1956, p. 261.

31. *Ibid.*

32. Colloque Poussin, vol. 2, p. 213. The sources were first compared and the conclusion on Poussin's staying in Venice was made by D. Mahon, an English scholar.

33. Colloque Poussin, vol. 2, pl. 306.

34. G. P. Bellori, *op. cit.*, p. 412.

35. Poussin 1964, pp. 60, 61.

36. G. Mancini, *op. cit.*, p. 251.

37. Letter of 28 April 1639 (see: Poussin 1964, p. 36).

38. G. P. Bellori, *op. cit.*, p. 423.

39. Ch. Mesenzeva, "Zum Problem: Dürer und die Antike. Albrecht Dürers Kupferstich *Die Hexe*", *Zeitschrift für Kunstgeschichte*, 1983, 46, p. 199.

40. P. Gassendi, *Syntagma philosophiae Epicuri*, The Hague / Comits, 1659, p. 265.

41. A. Mascardi, *Dell'Arte Historica*, Rome, 1636, p. 157.

42. Poussin 1964, p. 27.

43. Colloque Poussin, vol. 1, pp. 31-35; vol. 2, p. 57.

44. The new dating is based on the documents published in the article: L. Barroero, "Nuove acquisizioni per la cronologia di Poussin", *Bolletino d'arte*, 1979, 4, pp. 69-74.

45. Poussin 1964, p. 36.

46. G. P. Bellori, *op. cit.*, p. 416.

47. A. Blunt, *op. cit.*, pp. 187-190; J. Vanuxem, "Les *Tableaux Sacrés* de Richeome et l'iconographie de l'Eucharistie chez Poussin", in: Colloque Poussin, vol. I, pp. 151-162.

48. L. Barroero, *op. cit.*, p. 70.

49. When working at the picture's composition Poussin used engravings; in this case similar motifs are found in the drawing *The Eagle* by the studio of Giulio Romano for the painting decoration of Palazzo del Té in Mantua (*Catalogue of the Ellesmere Collection*, New York, 1972, part 2, ill. 21), as well as in the anonymous engraving *Christ before Pilate* (J. Levenson, C. Oberhuber, J. Sheehan, *Early Italian Engravings from the National Gallery of Art*, Washington, 1973, pp. 242, 243, cat. 90).

50. L. Barroero, *op. cit.*, p. 70. Dimensions coincide in this case as well.

51. Quoted from: R. Mortier, *La Poétique des ruines en France. Ses origines, ses variations de la Renaissance à Victor Hugo*, Geneva, 1974, p. 86.

52. Poussin 1964, p. 29.

53. Exposition Poussin, pp. 234, 235.

54. "Correspondance de Nicolas Poussin, publiée d'après les originaux par Charles Jouanny", *Nouvelles archives d'art français*, vol. 5, Paris, 1911, pp. 7, 8 (further: Corr. 1911).

55. Colloque Poussin, vol. 2, p. 61.

56. *Ibid.*, p. 63.

57. Poussin 1964, p. 40.

58. Corr. 1911, p. 52.

59. Poussin 1964, p. 49.

60. Corr. 1911, pp. 96, 97.

61. *Ibid.*, pp. 128, 129.

62. *Ibid.*, p.54.

63. *Ibid.*, p. 63.

64 *Ibid.*, pp. 63, 64.

65. Colloque Poussin, vol. 2, p. 64.

66. *Ibid.*, p. 66.

67. G. Patin, *Lettres choisies*, vol. 1, Cologne, 1691, pp. 51, 52.

68. Colloque Poussin, vol. 1, p. 38.

69. *Ibid.*, vol. 2, p. 65.

70. Poussin 1964, p. 69.

71. Colloque Poussin, vol. 2, pp. 67, 68.

72. *Ibid.*, p. 68.

73. Poussin 1964, pp. 80, 81.

74. *Ibid.*, p. 144.

75. G P Bellori, *op. cit.*, p. 436.

76. *Ibid.*, p. 440.

77. Poussin 1964, p. 135.

78. *Ibid.*, pp. 131, 132.

79. *Ibid.*

80. *Ibid.*, p. 140; cf: *Ibid.*, p. 137.

81. *Ibid.*, p. 130.

82. *Ibid.*, pp. 158, 159.

83. J Shearman, "Les dessins de paysages de Poussin", in: Colloque Poussin, vol. 1, pp. 179-188; A. Blunt, *op. cit.*, pp. 297-299.

84. Laertius Diogenis, *De vita et moribus philosophorum*, Antwerp, 1566, p. 229.

85. M. Alpatov, "Poussins *Landschatt mit Hercules und Cacus* in Moskau", ill.: *Walter Friedlaender zum 90. Geburtstag*, Berlin, 1965, pp. 11, 14.

86. W. Sauerlaender, "Die Jahreszeiten. Ein Beitrag zur allegorischen Landschaft beim späten Poussin", *Münchner Jahrbuch der bildenden Kunst*, 3rd series, 7, 1956; 1957, pp. 169-184.

87. E. H. Gombrich, "The Subject of Poussin's *Orion*", *The Burlington Magazine*, 1944, February, pp. 37-41.

88. Poussin 1964, p. 163.

89. Quoted from: Colloque Poussin, vol. 2, p. 163.

90. *Ibid.*, p. 81.

91. Poussin 1964, p. 126.

92. *Ibid.*, p. 90

93. *Ibid.*, p. 65.

94. Colloque Poussin, vol. 2, p. 80.

95. Poussin 1964, pp. 27, 135.

96. *Ibid.*, p. 43.

97. *Ibid.*, pp. 27, 47, 90, 94.

98. Colloque Poussin, vol. 2, p. 146.

99. A. Blunt, *The Drawings of Poussin*, New Haven / London, 1979, p. 193.

100. Colloque Poussin, vol. 2, p. 80.

101. Poussin 1964, p. 27.

102. H. Jouin, *Conférences de l'Académie Royale de peinture et de sculpture....*, Paris, 1883, p. 139.

103. Poussin 1964, p. 53.

104. G. Mancini, *op. cit.*, p. 261. See also note 89.

105. Quoted from: Poussin 1964, p. 181.

106. *Ibid.*, p. 50.

107. Corr. 1911, p. 317.

108. *Ibid.*, pp. 43, 155.

109. *Ibid.*, p. 33.

110. Poussin 1964, pp. 62, 63. See also: C. Goldstein, "The Meaning of Poussin's Letter to De Noyers", *The Burlington Magazine*, 1966, May, pp. 233-239.

111. Poussin 1964, pp. 123, 124. See the commentary by A. Blunt to this edition of the letters, as well as P. Alfassa, "L'Origine de la lettre de Poussin sur les modes d'après un travail récent", *Bulletin de la société de l'histoire de l'art française*. Année 1933, Paris, 1934, pp. 125-143.

112. Poussin 1964, p. 152.

113. A. Blunt, "Poussin's Notes on Painting", *Journal of the Warburg Institute*, 1937-1938, vol. 1, pp. 344-351.

114. Cf.: G. P. Bellori, *op. cit.*, p. 460; L. Castelvetro, *Poetica d'Aristotele vulgarizzatta e sposta*, Basel, 1576, p. 69. See the comparison of the texts in: Y. K. Zolotov, "On Poussin's Aesthetic Ideas", *Iskusstvo*, 1981, 11, pp. 58-65.

115. Poussin 1964, p. 163.

116. R. Fréart de Chambray, *Idée de la perfection de la peinture*, Paris, 1672.

117. Franciscus Junius, *De pictura veterum libri tres*, Rotterdam, 1694. The first edition was published in 1637.

118. R. Fréart de Chambray, *op. cit.*, pp. 14, 15.

119. *Ibid.*, préface and p. 14.

120. A. Fontaine, *Conférences inédites de l'Académie Royale de Peinture et de Sculpture d'après les manuscrits des archives de l'Ecole des Beaux-Arts*, Paris, s.a., p. 30.

121. Poussin 1964, p. 163.

122. *Ibid.*

123. *Ibid.*, p. 164.

124. *Ibid.*

125. In the original Poussin used the terms "disposition, ornement, décoré (sic!), beauté, grâce, vivacité, costume, vraisemblance, jugement partout" (*Ibid.*, p. 165). The criteria for their choice are hard to find. The meaning of "décoré" is unclear, our translation as "decorum" is conditional.

126. On the similarity of this phrase to the statement by T. Tasso see the commentary by A. Blunt to the edition of Poussin's letters: *Ibid.*, p. 164.

127. *Ibid.*, p. 165.

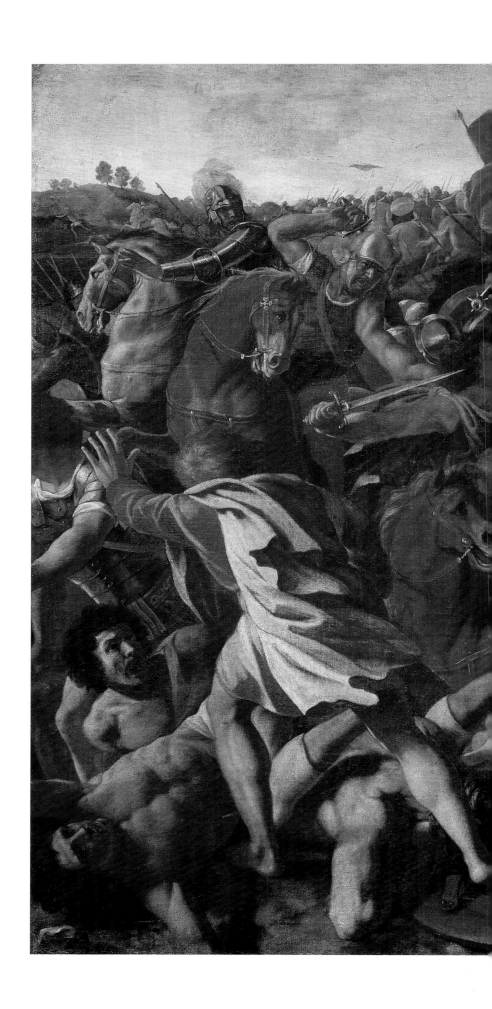

Joshua's Victory over the Amalekites.

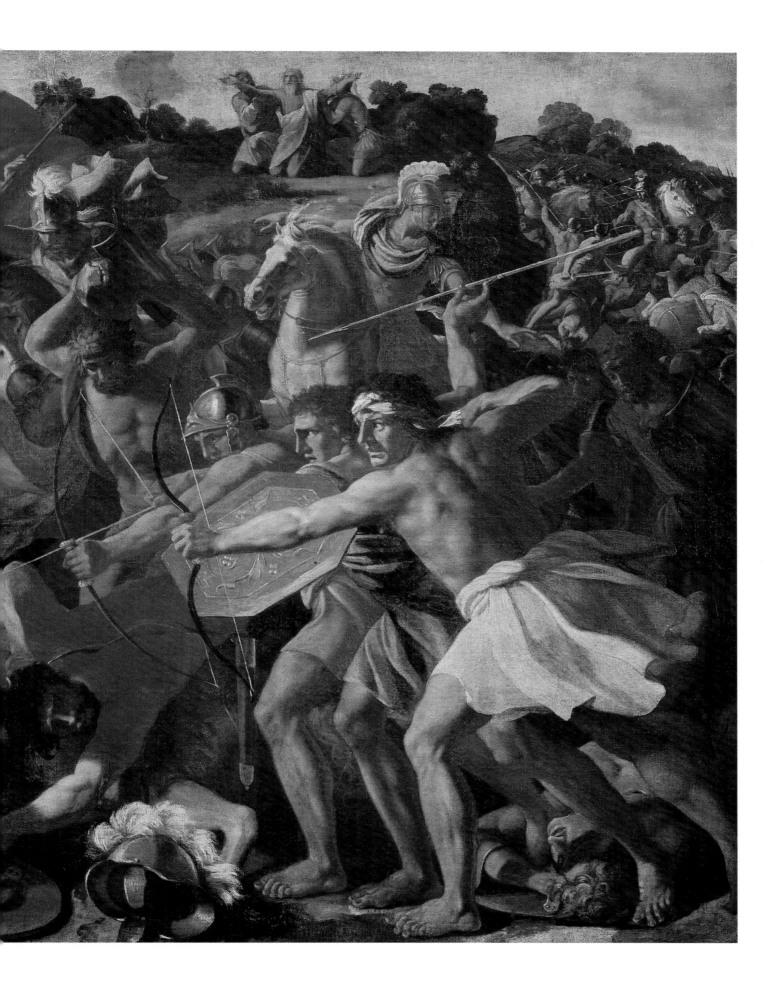

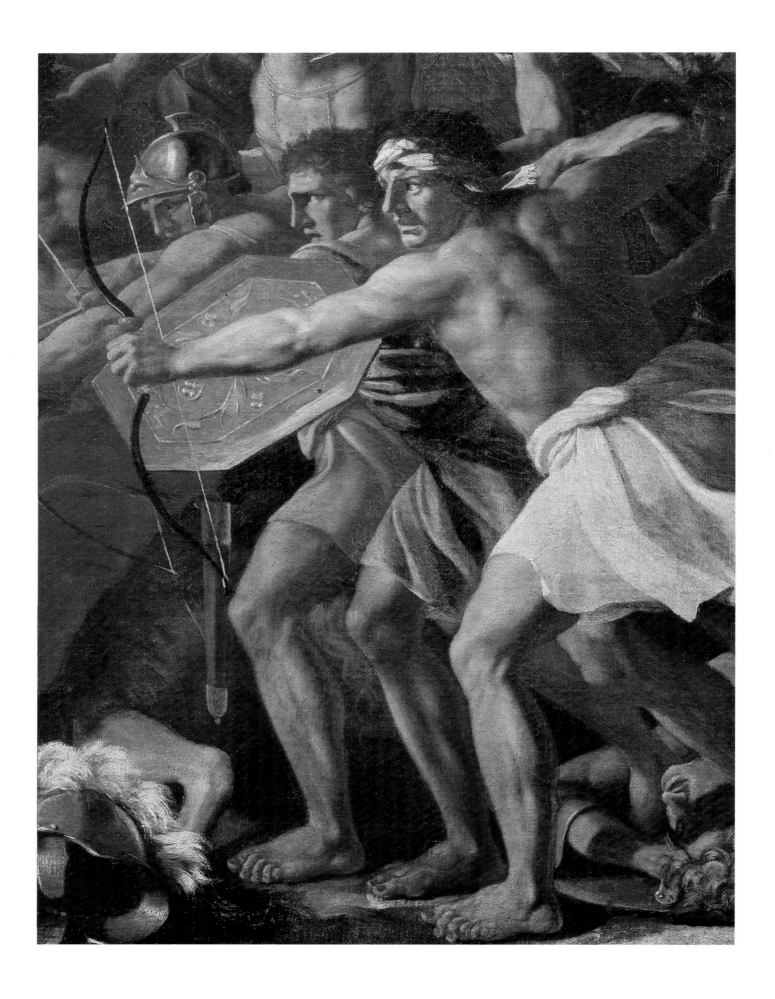

1. JOSHUA'S VICTORY OVER THE AMALEKITES

Oil on canvas, 97.5 x 134 cm.
The Hermitage, St. Petersburg, inv. No 1195.
Companion to *Joshua's Victory over the Amorites*
(Pushkin Museum of Fine Arts, Moscow).
Exodus 17:10-13.

Attribution and date are based on statements by Bellori (1672) and Félibien (1725), who, in turn, referred to Poussin's own words describing his having painted two battle pieces at the beginning of his stay in Italy and selling them for very little money — just seven scudi each. This probably happened during the period when Cardinal Barberini to whom Poussin had letters of recommendation and on whose support he was counting, was away, *i.e.*, from March 1625 to October 1626. Most experts agree that the two battle pieces in question are *Joshua's Victory over the Amalekites* from the Hermitage and *Joshua's Victory over the Amorites* from the Pushkin Museum of Fine Arts.
There are various views on their chronological placement. Volskaya (1946) thinks it logical to refer both paintings to Poussin's earlier, Parisian, period. This view is borne out by the deliberate three-dimensional quality of representation, the relief-like composition reminiscent of the works of the artists of the second school of Fontainebleau and the absence of Titian's influence in the colour scheme so characteristic of Poussin's Roman period. Thuillier (1961) also stressed that both pictures are distinct from works of the Roman period because they show nothing of the impact of the Venetian and Caravaggio schools. He was of the opinion that Poussin's impressions of the reliefs of the Roman sarcophagi and the Vatican frescoes by Raphael's studio whose presence is felt in both canvases, could have been formed by the engravings of Delaune and Antonio Tempesta. The majority of experts place the two pictures between 1624 and 1625 (Grautoff 1914; Sterling 1957; Mahon 1962; Blunt 1966; Badt 1969; Wild 1980), assigning them to Poussin's early Roman period. This seems the most plausible.
The Royal Library of Windsor Castle has a few Poussin drawings of battle scenes. These drawings are similar to the illustrations for Marino and were done during the Parisian period. Though the drawings are not preliminary sketches for the Hermi-

tage painting, they do suggest that Poussin had conceived the latter before he came to Rome. On the basis of these drawings, Blunt (1967) concluded that the artist was planning to produce a whole series of battle pieces. *Gideon's Victory over the Midianites,* a painting ascribed to Poussin and belonging to the Pinacoteca Vaticana was first displayed in 1960. However, many specialists question Poussin's authorship (A. Blunt, «Colloque Nicolas Poussin», *The Burlington Magazine,* 1960, No. 668, p. 330; J. Thuillier, «Poussin: Lost Masterworks Discovered», *Art News,* 1961, Summer, pp. 41, 58, 59; Wild 1966).
Joshua's Victory over the Amalekites has some obvious borrowings such as the man with a stone, which repeats an analogous figure in Giulio Romano's fresco *The Martyrdom of St. Stephanus* (Church of St. Stephanus, Genoa) (Blunt 1966; A. Venturi, *Storia dell'arte italiano,* Milan,1901-40, IX, 2, pl. 300). Many specialists also feel that Poussin used the representations of classical bas-reliefs in his battle pieces (Thuillier 1960; Blunt 1967; Wild 1980).
The battling warriors in *Joshua's Victory over the Amorites* are painted differently than they are in the Hermitage *Victory:* none of them are done so as to look like painted reliefs. The Hermitage painting has a well-pronounced diagonal composition, while in the Pushkin Museum painting the diagonal is interrupted by perpendiculars, making the composition more complicated. The space of the painting is filled with more turbulent and confusing motion, indicative of an obviously increased influence of Italian art and thus suggestive that *Joshua's Victory over the Amorites* was done later than *Joshua's Victory over the Amalekites.*
Félibien noted in 1685 that both pictures were part of the collection of the Duke de Noailles. Le Comte saw them with the collection in 1700. According to Blunt, following the death of Duke Anne-Jules de Noailles, Marshal of France, the pictures were inherited by his son Adrien-Maurice, also a marshal of France (Blunt 1966). After his death, the pictures were not among the items of the collection when it was sold in 1767. Possibly these are the same paintings that appeared at the Dufresne auction (winter, Amsterdam, 22.8.1770, Nos. 102, 103).

Provenance: 1763-74, entered the Hermitage, together with *Joshua's Victory over the Amorites* (Pushkin Museum of Fine Arts, Moscou).

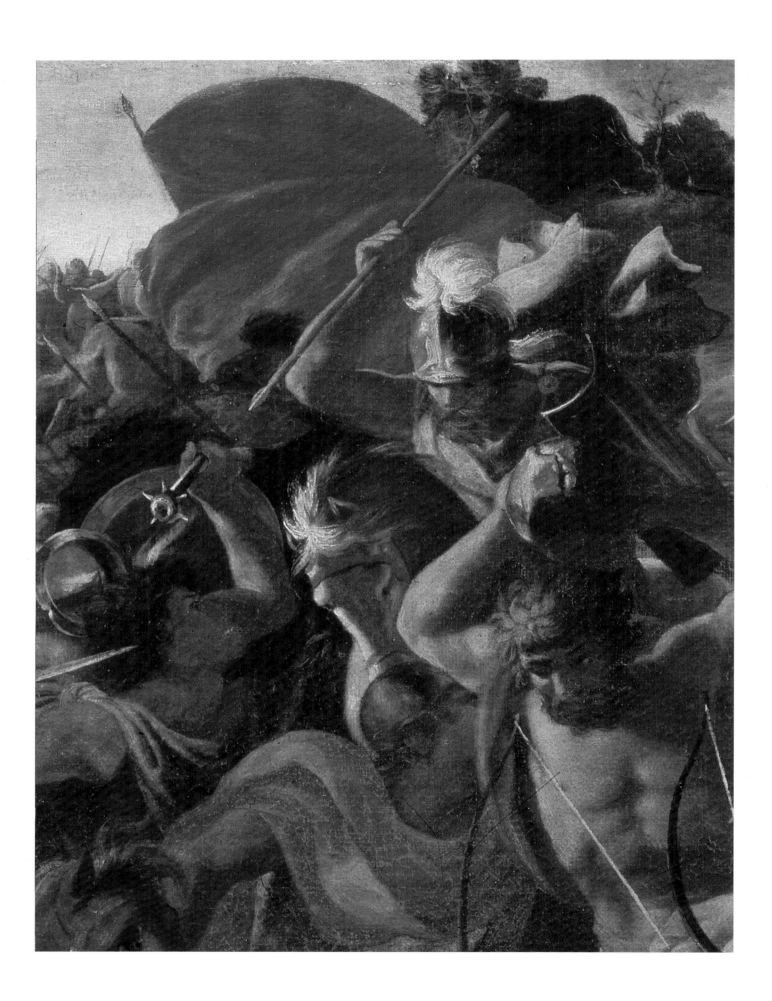

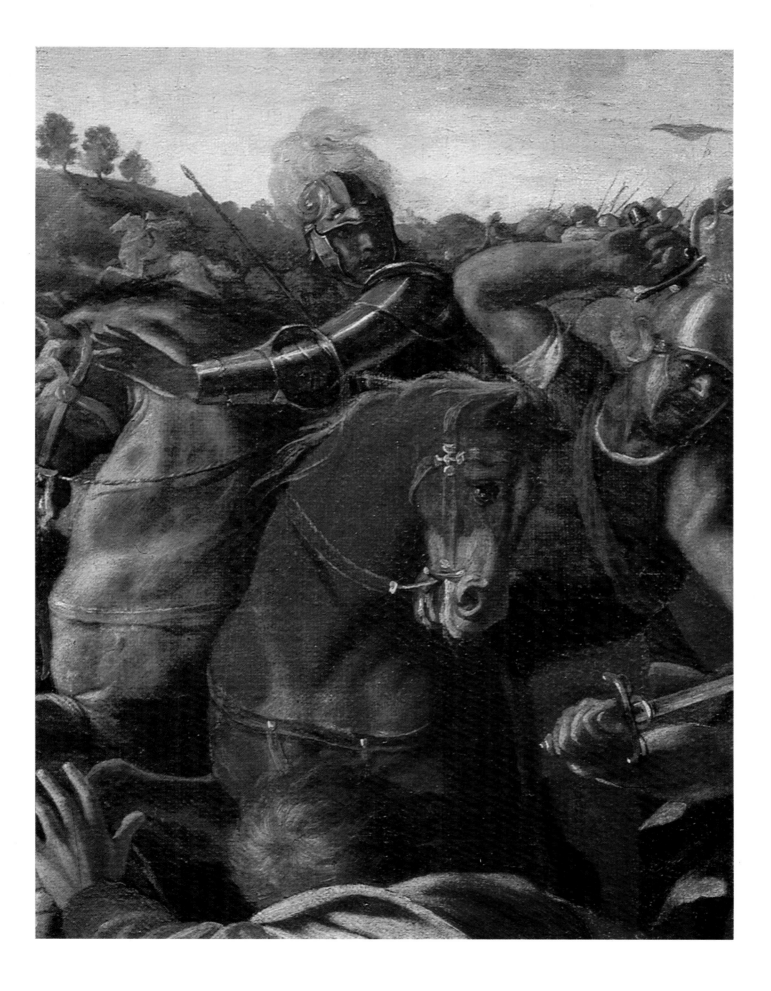

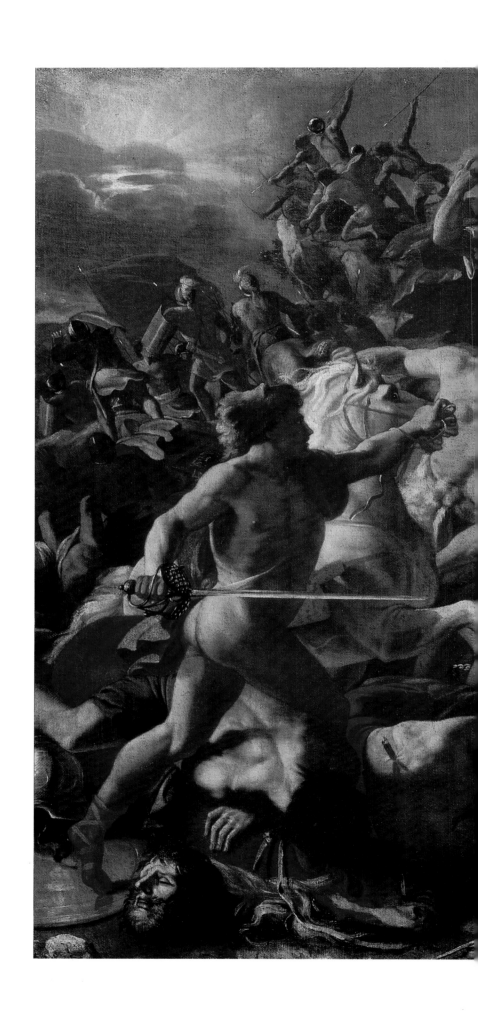

Joshua's Victory over the Amorites.

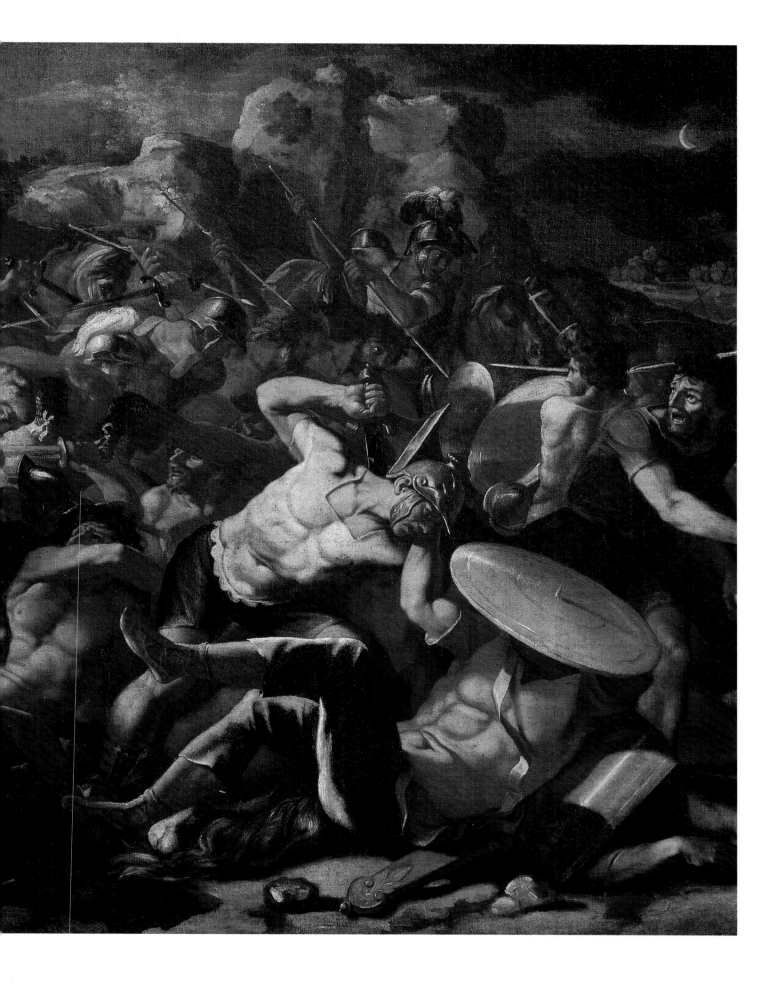

2. JOSHUA'S VICTORY OVER THE AMORITES

Oil on canvas, 96 x 134 cm.
The Pushkin Museum of Fine Arts, Moscow, inv. No 1046.
Companion to *Joshua's Victory over the Amalekites*
(Hermitage, St. Petersburg).
Joshua 12-14.

This is one of the oldest surviving paintings by Poussin. Along with the Hermitage picture, it is most likely one of the battle scenes mentioned by Bellori (1672) as being painted in Rome during the time when Cardinal Barberini, to whom the artist had been introduced, was away — from March 1625 to October 1626. Bellori also tells that Poussin had a great deal of difficulty selling the two pictures and was only able to get seven scudi for each of them. *Joshua's Victory over the Amorites* clearly reveals Poussin's zealous study of classical bas- reliefs, as well as of the works of Raphael's school, primarily those by Giulio Romano.

The picture's specific stylistic traits, such as the two-dimensional character of the composition, which unfolds from the bottom to the top, the multitude of large figures in complex poses, the emphasis on contours and the somewhat rigid modelling of the muscles of the naked bodies seem to indicate the influence of the Fontainebleau school whose works Poussin could not fail to have seen in Paris. It was precisely these stylistic affinities that prompted Hourticq (1937) and Volskaya (1946) to *assign Joshua's Victory over the Amorites* to Poussin's pre-Roman period, which, however, considering Bellori's statement, can hardly be correct. *Gideon's Victory over the Midianites,* a painting belonging to the Pinacoteca Vaticana, is similar to the pictures housed in the Hermitage and the Pushkin Museum of Fine Arts in terms of dimensions, composition and colour scheme. Thuillier's attributing it to Poussin (1961) was supported by such prominent experts as Mahon (1962) and Blunt (1966). The latter thinks that the Vatican painting makes up a series with the ones in the Hermitage and the Pushkin Museum.

The Fitzwilliam Museum in Cambridge has a preliminary drawing for *Joshua's Victory over the Amorites,* done in bistre, pen and wash. It had earlier been ascribed to Giulio Romano, but was then re-attributed by Blunt (Drawings, 5, No. 388, pl. 288). Grautoff (1914) named another drawing in the Albertina Museum (Alb. 11345) as being a preliminary one by Poussin for the painting, but this was completely rejected by Friedlaender (W. Friedlaender, «Zeichnungen Nicolas Poussin in der Albertina» *Belvedere,* 1930, 9, p. 57) and other researchers.

Provenance: late 17th century, Duke de Noailles collection, Paris; from 1763-74 to 1927, The Hermitage, St. Petersburg; since 1927, The Pushkin Museum of Fine Arts, Moscow.

Nicolas Poussin, *Perseus and Phineus.*
Copy of Polydoro da Caravaggio's picture of the same title, Louvre, Paris.

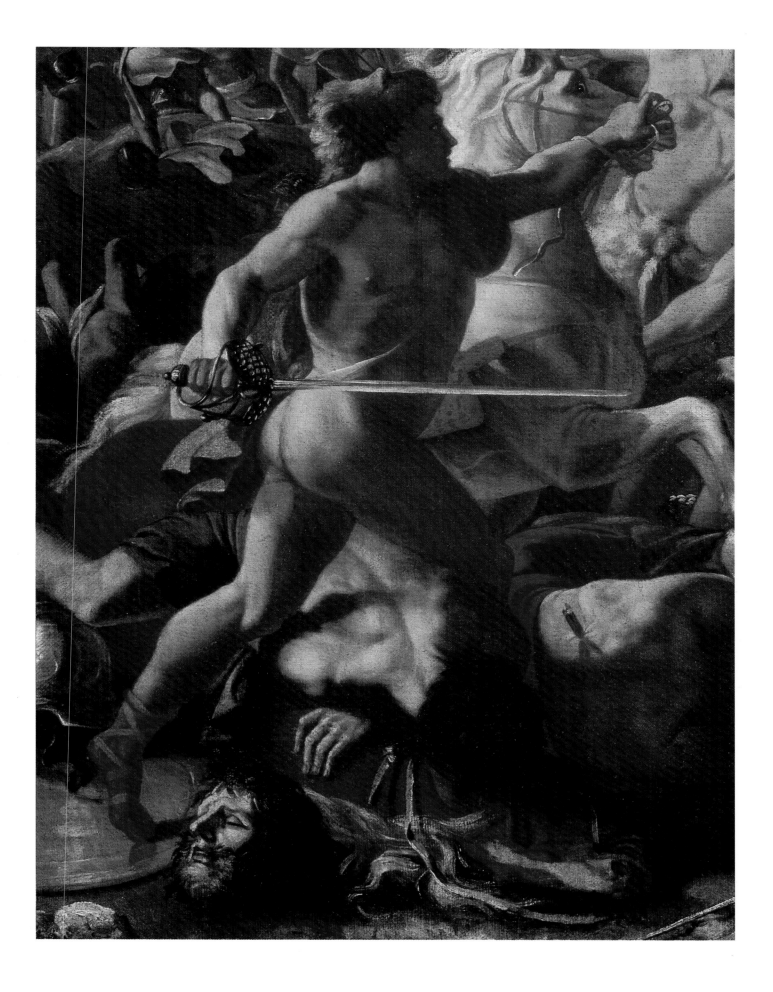

3. ELEPHANT

Pen and bistre wash, 22.6 x 14.8 cm, relined.
The Hermitage, St. Petersburg, inv. No 8174.

Elephant is one of the artist's sketches of animals
which are very seldom found in his heritage. Pous-
sin's authorship was determined by Blunt and
confirmed by the discovery of the picture *Hannibal
Crossing the Alps* done around 1625-26 (Blunt
1967, 2, pl. 7). The sketches may be referred to the
same period. A frontal view of an elephant occurs
in the drawing *The Indian Triumph of Bacchus*
(1630s, Windsor Castle, England. Blunt 1945,
No. 199, pl. 48; Drawings, 3, *No.* 185, pl. 147).

Provenance: H. Brühl collection, Dresden; since 1769,
The Hermitage, St. Petersburg.

4. RHINOCEROS

Pen and bistre wash, 22.8 x 14.7 cm, relined.
The Hermitage, St. Petersburg, inv. No 8175.

From a series of drawings done in the 1620s (see
Nos. 3, 5 and 6).

Provenance: H. Brühl collection, Dresden; since 1769,
The Hermitage, St. Petersburg.

5. *CAMEL*

Pen and bistre wash, 23 x 14.8 cm, relined.
The Hermitage, St. Petersburg, inv. No 8176.

From a series of drawings done in the mid-1620s
(see Nos. 3, 4 and 6).

Provenance: H. Brühl collection, Dresden; since 1769,
The Hermitage, St. Petersburg.

6. *CAMEL*

Pen and bistre wash, 22.8 x 16.2 cm, relined.
The Hermitage, St. Petersburg, inv. No 8177.

From a series of drawings done in the mid-1620s
(see Nos. 3, 4 and 5).

Provenance: H. Brühl collection, Dresden; since 1769,
The Hermitage, St. Petersburg.

7. THE DEPOSITION

Oil on canvas, 120 x 98 cm.
The Hermitage, St. Petersburg, inv. No 1200.
Matthew 27:59-61, Mark 15:46, Luke 23:53, John 19:38-40.

The scene has been given an unusual iconographic treatment: the lamentation takes place directly at the base of the cross. It became a kind of a rule with Poussin to choose biblical subjects that were either rather rarely found in European seventeenth-century art (Poussin, for example, throughout all his life was attracted by the themes from the story of Moses), or that possessed an unusual iconography. The attribution to Poussin is traditional. It has been accepted by the majority of experts, with the exception of Wild (1966), who ascribed it to Charles Mellin through comparison with Poussin's *Lamentation* (Alte Pinakothek, Munich) and *The Martyrdom of St. Erasmus* (Pinacoteca Vaticana). Her analysis, however, is too superficial to be convincing. Just a year later, in 1967, Blunt, the major authority on Poussin, in a monograph about the artist, stressed the emotional affinity between the St. Petersburg and Munich pictures. A comparison of these canvases clearly shows that the manner of painting the draperies and the characters' faces is identical, the ways of modelling Christ's body are similar and the face of John the Baptist is repeated in both works. The irregularities in the drawing of the angels' faces noted by Wild also occur in *The Lamentation:* the cheek of the angel down on one knee is not sufficiently foreshortened. A similar figure of an angel appears in *David Victorious* (Dulwich College, London). There is no question that Blunt is right in saying that the pictures are very similar both in emotional effect and style. But while *The Deposition* depicts a tragedy devoid of hope, *The Lamentation,* despite its explicit theatrical representation of deeply tragic feelings, shows grief less desperate and rendered more by the characters' gestures, movements and facial expressions than by the colour scheme or composition. Poussin's work of the late 1620s is marked by an outpourig of tragic sensations.
Chronologically *The Deposition is* placed between 1630 and 1631 by Grautoff, around 1630 by Sterling, around 1629-30 by Mahon and Blunt, and in the first Roman years (before 1627-28) by Thuillier. The painting's dark, deep background, abruptly changing into the white folds of the cloth, and the interest in the contrasts of light and shade suggest that it was done during the late 1620s. At the same time the work's simple eloquence and the deep, though not excessive pathos prompt its placement at not earlier than 1627-28. A date close to that of *The Lamentation* in Munich seems the most plausible: the two pictures were undoubtedly executed around the same time, *i.e.* in 1628-29.
The Deposition, which reveals the influence of baroque art, is one of the artist's earliest works based on a theme from the Gospels. The picture is marked by dynamism and intensity.
On top of that, the composition is an example of an artistic concept implemented with rare perfection. The picture's space is organised by a white cloth hanging diagonally from the cross. This has an extremely powerful emotional impact on the viewer, demonstrating Poussin's attention to compositional and coloristic effects. The cloth's brilliant whiteness emphasises the dark tones of the background and the mournful and sombre vestments of the Virgin Mary and John, their pale yellowish faces distorted with grief. Some specialists note, in this connection, that the emotions in the picture are «dramatic» but «superficial» (Friedlaender 1966), and that its tragic spirit «is not quite convincing» (Sterling 1957). There exists a drawing that may have been done by F. Chauveau as a preliminary one for his engraving that appeared at the V. W. Newman sale of May 8, 1923 (No. 22).

Replicas and copies: 1. The closest to the Hermitage painting in terms of style and the facial type of the Virgin Mary is *The Pietà* (Musée des Beaux-Arts, Cherbourg); 2. Chigi collection, Castelfusano; 3. Church St.-Rémy, Dieppe.

Engravings: 1. F. Chauveau (1667 or 1677?) (Andresen 1863, No. 204; Wildenstein 1955, No. 68); 2. B. Audran (Andresen 1863, No. 203); 3. Picart (Wildenstein 1955, p. 193).

Bonaffé (1884) mentions a painting on the *Lamentation* theme that after 1673 belonged to Jean de la Fourcade. Brice (1684) wrote that such a picture was in the collection of Pierre de Beauchamp, the royal ballet-master. Blunt makes the supposition that our canvas was among those at the J.-B. Grimbergs sale in Brussels on May 4, 1716. It is possible that it was the same painting in all three cases.

Provenance: H. Brühl collection, Dresden; since 1768, The Hermitage, St. Petersburg.

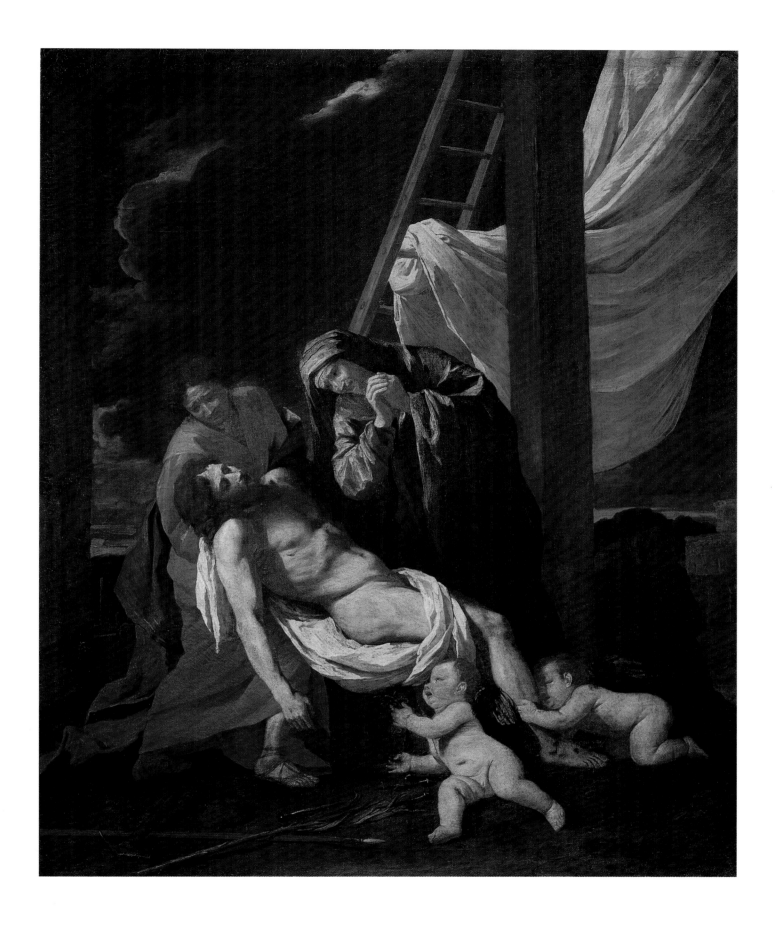

The Deposition.

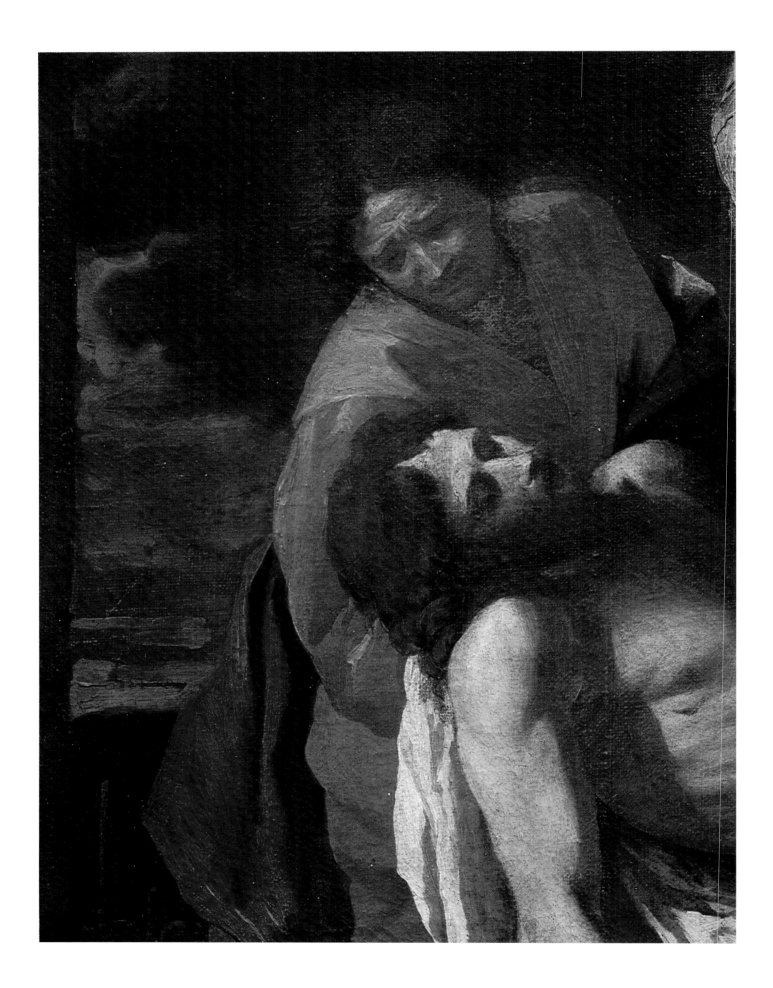

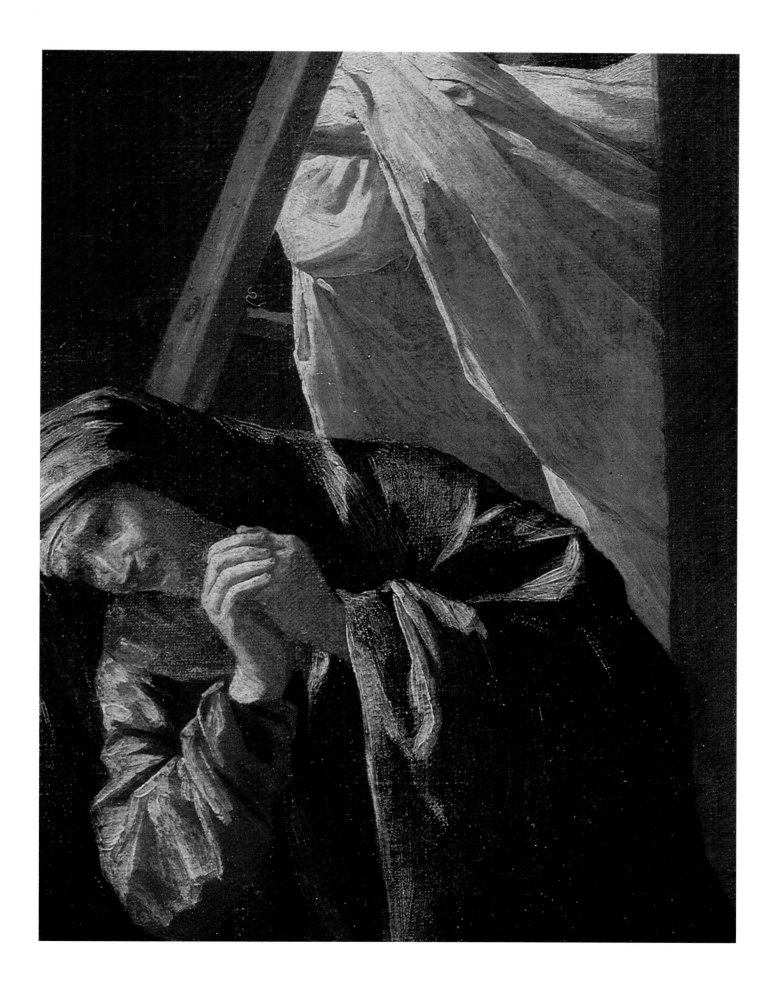

8. TANCRED AND ERMINIA

Oil on canvas, 98 x 147 cm.
The Hermitage, St. Petersburg, inv. No 1189.
Torquato Tasso, *Jerusalem Delivered*. Canto XIX.

Though the heroes of Tasso's poem were depicted by the artists both of the sixteenth and seventeenth centuries (especially by those of the Fontainebleau school in the sixteenth century), Poussin was the first to use the episode with Erminia saving Tancred.

No engravings were made of the picture in the seventeenth century, no preliminary drawings have survived, and there is no written mention of it. The only researcher to question Poussin's authorship was Wild. In a 1967 article entitled *Charles Mellin or Nicolas Poussin*, though advancing no arguments, she called the attribution doubtful. Comparing in her study of Poussin (1980) the St. Petersburg canvas with *Tancred and Erminia* in Birmingham (Barber Institute of Fine Arts), whose authenticity she does not challenge, Wild primarily draws attention to the fact that the former is less «intense» in composition, in the modelling of the bodies and draperies and in the expression of Erminia's passion. On comparing the two pictures, the differences in composition and emotional message do indeed catch the eye. Both canvases have a diagonal structure, yet in the Birmingham one the diagonal is less explicit because of the more overloaded composition, while the Hermitage painting is devoid of any superfluous details. The postures of Tancred and Erminia in the Birmingham painting are affected. In the one at the Hermitage Tancred's body is limp, his whole image is the personification of suffering. The kneeling figure of Vafrino forms a compact compositional group with that of Tancred; their left arms are not intertwined, which is what makes the composition of the Birmingham canvas heavy; their right arms form a smooth line, continuing the line of Vafrino's leg and running almost parallel with Tancred's body. In contrast to this, in the Birmingham picture the right arms are in a complex foreshortened position.

Poussin dispenses with extra gestures, which split and weaken the composition, for the sake of a natural and terse effect. These two figures and the body of the white horse behind Erminia make up a wide light-coloured diagonal band which is cut in half by the intervening figure of Erminia. Her face, revealing both tenderness and resolution, her eyes, anxiously watching Tancred's face, and her impulsive gesture are all much more in compliance with the picture's emotional message, than the calm, more static and less expressive Erminia in the Birmingham canvas.

In fact, the modelling of the bodies in the Hermitage painting is softer. It is appropriate to recall here a letter Poussin wrote to artist Jacques Stella concerning the *Rinaldo and Armida* (Corr. 1911, p. 4). In it he explains that such a theme calls for a softer manner than does a heroic subject. This fully applies to the two paintings in question, since, though they have the same subject-matter, the artist's aim in each case was different. In the Birmingham canvas he stressed the heroic aspect of Erminia's act, accentuating her loyalty and resolution, and consequently painted the picture «in a stricter» manner. This is manifest in the clear, vivid modelling of the bodies and the more energetic draperies. It should be noted that draperies executed in a «soft» manner appear in Poussin's works of 1629-33: *The Arcadian Shepherds* (Devonshire collection, Chatsworth), *The Realm of Flora* (Gemäldegalerie, Dresden), *The Youth of Bacchus* (Louvre, Paris) and *Venus and Mercury* (Dulwich College, London).

Wild mentions the presence of tones alien to Poussin, and a landscape made up of elements on a small scale. Thuillier (1974) also notes these «terrains peu construits... types des arbres qui surprend». However, such details may contain deviations from Poussin's style, because it is these parts of the canvas that have been the most restored. The picture's landscape is not unlike others typical of Poussin: cf. *Rinaldo and Armida* (Dulwich College, London) and *The Death of Adonis* (Musée des Beaux-Arts, Caen).

Thuillier thinks it strange that a painting of such significance and poetical merits has no written mention. This question pertains to not just the Hermitage painting and perhaps requires special research. Many canvases by Poussin with similar subject- matter, done in a «soft» poetic manner, are not mentioned in any written sources before the mideighteenth century and sometimes later. Among them are such famous works as *Cephalus and Aurora* (National Gallery, London), *Olympus and Marsyas* (Louvre, Paris), *Diana and Endymion* (Institute of Arts, Detroit), *Mars and Venus*

65

(Museum of Fine Arts, Boston), *The Inspiration of the Epic Poet* (Louvre, Paris), *The Nurture of Jupiter* (Museum Dahlem, Berlin), as well as the Birmingham *Tancred and Erminia.* Kozhina (1977) made what seems a quite legitimate supposition that the reason for this may be the aesthetic ideals of the age.

It is difficult to date Poussin's works, especially the early ones, since the constant change of manner was, in fact, one of his principles. Volskaya and Hourtisq place the painting between 1625 and 1627, Francastel and Gertz around 1630-31, Sterling after 1630, Mahon and Thuillier in 1631, Blunt in 1635 (1960) and between 1631 and 1633 (1966), Grautoff between 1630 and 1635, Glikman around 1635, and Friedlaender in 1637. The date which we find the most plausible is 1630-31.

Many experts think that the already mentioned version of *Tancred and Erminia* in Birmingham is more perfect, dramatic and rich in composition, since it was done later than the one in St. Petersburg (Bodkin 1939; Sterling 1957; Blunt 1966). Sterling wrote that the St. Petersburg picture's «painterly vision», «elegance of form» and «poetic quality» testify to its earlier execution. Other researchers (Volskaya 1946; Gertz 1947; Glikman 1964; Badt 1969; Wild 1980) believe that the Birmingham picture was the first and we share this opinion. A comparative analysis of the two canvases reveals the tendency of the artist's thought towards achieving a more succinct composition and greater emotional concentration. The compositional schemes of the two works are very similar: their diagonal structure is the same, as are the postures, movement and positioning of the central characters, in short, they both have the same design. It seems most improbable that in striving, quite naturally, for a more perfect execution of the composition, the artist would choose to deliberately complicate and overload it. The opposite would seem far more likely. Furthermore, the compositional density of the Birmingham picture is characteristic of the artist's early works (1627-29), while the colour scheme of the Hermitage painting and its profound poetic qualities are closer to *The Realm of Flora,* known to have been done in 1631.

A similar depiction of a horse appears in Poussin's *St. John Baptizing the People* (Louvre, Paris).

Provenance: before 1766, J.-A.-J. Aved collection, Paris; since 1766, The Hermitage, St. Petersburg.

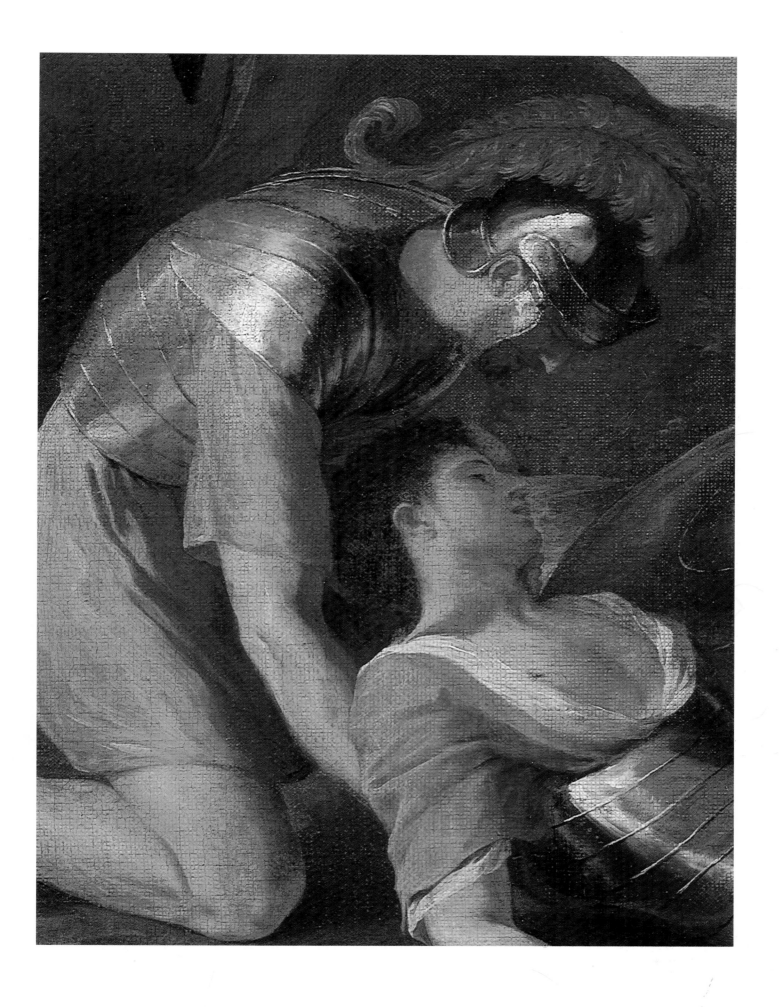

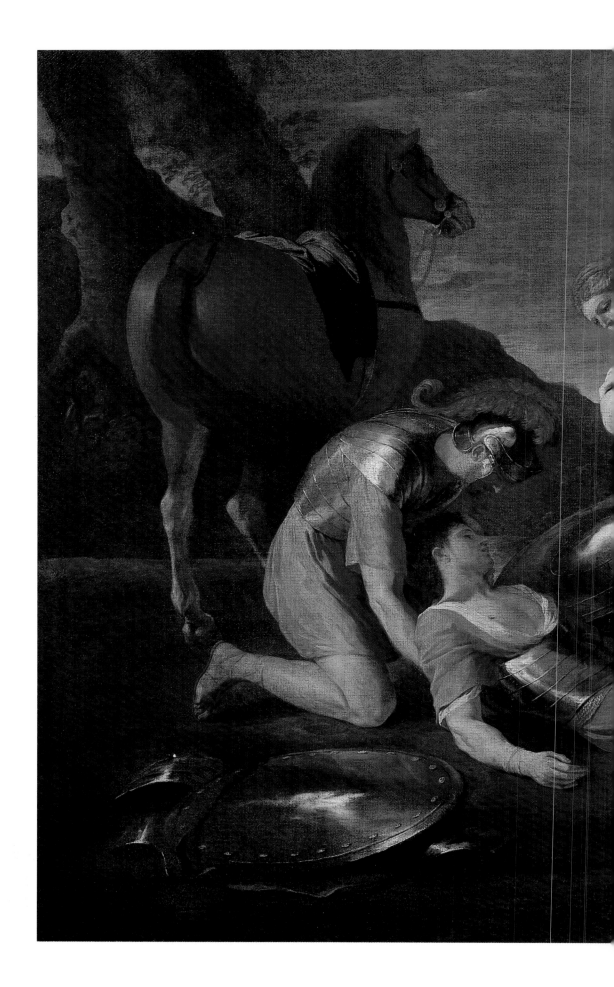

Tancred and Erminia.

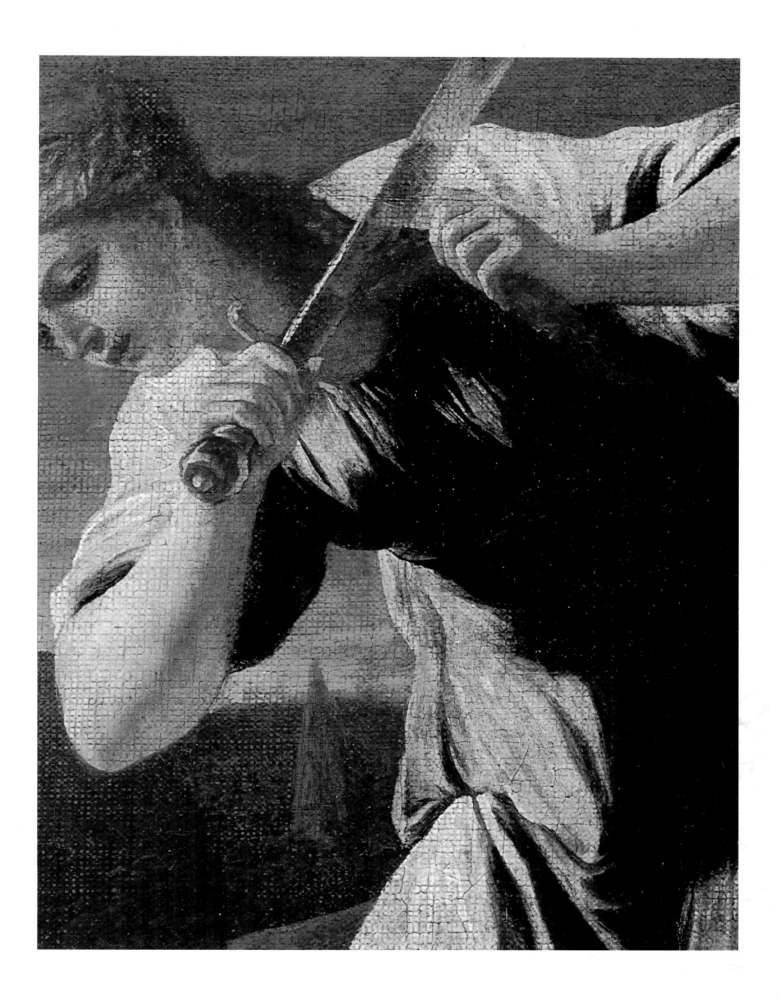

Rinaldo and Armida.

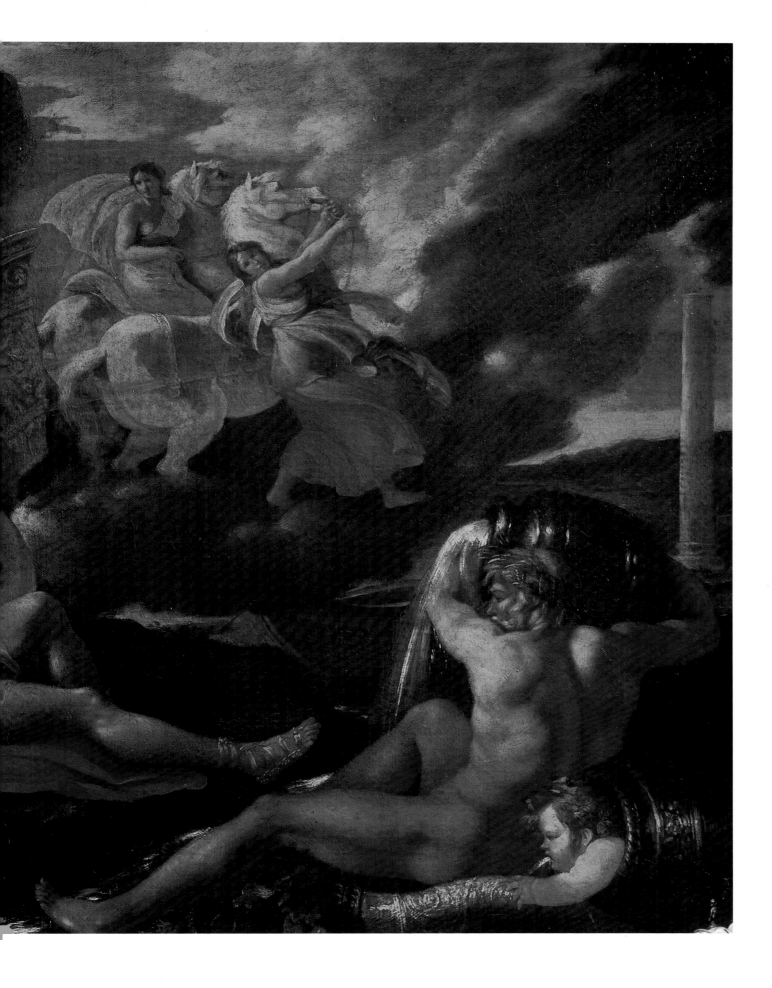

9. RINALDO AND ARMIDA

Oil on canvas, 95 x 133 cm.
The Pushkin Museum of Fine Arts, Moscow, inv. No 2762.
Torquato Tasso, *Jerusalem Delivered*. Canto XIV.

The Hermitage catalogue by Somov (1900) states that the canvas under consideration is a replica of a picture that, according to Félibien, Poussin painted for his friend and fellow artist Jacques Stella in 1637 (Thuillier 1974, No. 102). However, if it is true that an engraving by J. Chasteau (Andresen 1863, No. 409) corresponds to that picture, then one has to admit that it does not coincide with the *Rinaldo and Armida* in the Pushkin Museum of Fine Arts, Moscow. The complex, multifigured composition of the engraving, which has the cupids carrying a sleeping Rinaldo on to Armida's chariot, is from a completely different original.

This episode from Tasso's poem was a special favourite of Poussin's and one that he often used. The best known version of it is in Dulwich College, London (Blunt 1966, No. 202; Thuillier 1974, No. 24). Though it depicts almost the same moment as the painting in the Pushkin Museum does, there is a great deal of difference between the compositions. A third picture on the same theme is in Berlin's Staatliche Museen (inv. No. 486). Smith (1837) mentions that it was transferred to Berlin from the Louvre in 1815. The composition of this painting corresponds to the engraving by J. Chasteau. Blunt (1966, No. 204) thinks that it is the original one Poussin did for Stella. Friedlaender, Grautoff and Thuillier consider it to be an old copy after Poussin. There also existed still another picture, now lost, but thoroughly described by Bellori. Perhaps, what he was writing about was a detailed and skilful drawing, which may be the one in Windsor Castle (25.2 x 36.5 cm, pen and bistre wash).

Most likely, there were many copies made of the picture, one of which, whose high quality was noted by Friedlaender, was in the Pearson collection in Paris. Smith listed in his catalogue a painting of the same subject owned by Count Scaredale in England; this may be the same one Waagen mentioned in connection with Lord Jarborough's collection (England).

The Louvre, Windsor Castle, the British Museum and the Musée des Beaux-Arts et d'Archeologie (Rennes) each have a drawing done on this theme.

None of them, however, corresponds compositionally to the painting in the Pushkin Museum of Fine Arts. There is an old copy of the painting in the collection of I. L. Knuniants, Moscow.

The majority of specialists place the date of the present picture in the first half of the 1630s. Friedlaender suggests 1637. Thuillier, who considers that too late a date, firmly disagrees and refers the painting to the same time as the early battle scenes, *i.e.*, to 1625-26. We are not convinced of this, firstly because the differences between the colour schemes and the compositional treatment are too great and, secondly, because the prevailing intimate and lyrical atmosphere of the painting in the Pushkin Museum places it closer to *Tancred and Erminia* in the Hermitage. Finally, a detailed X-ray analysis done by Yerkhova (1970) shows that *Rinaldo and Armida* was painted after *Nymph and Drinking Satyr*. In view of all this, we suggest the early 1630s as the picture's time of execution. In a recent study of Poussin, Wild (1980) ascribed the *Rinaldo and Armida* in the Pushkin Museum of Fine Arts, along with the one of the same name in Dulwich College, as well as a few other paintings by Poussin to the artist Charles Mellin (c. 1597-1649) who worked in Rome during the same years. However, this reattribution of Poussin's works to a previously virtually unknown artist seems, in general, quite questionable and requires further, more convincing arguments.

Provenance: before 1766, J.-A.-J. Aved collection, Paris; 1766-1930, The Hermitage, St. Petersburg; since 1930, The Pushkin Museum of Fine Arts, Moscow.

74

10. *VENUS, A FAUN AND PUTTI*

Oil on canvas, 72 x 56 cm.
The Hermitage, St.Petersburg, inv. No 1178.

The painting has been variously entitled in the Hermitage inventories and catalogues as *A Satyr Putting a Bacchante on a Goat's Bark* (cat. 1797), *Faun and Bacchante* (inv. 1859), *Bacchanal* (cat. 1863 and 1892), and *Satyr and Bacchante* (cat. 1908, 1958 and 1976).

Yet the woman in the picture has none of the attributes of a bacchante, such as a thyrsus entwined with ivy, tangled or cascading hair, snakes and stag skins, etc. The youth helping her to climb on the goat's back is unlike any of Poussin's satyrs: cf. *Nymph and Satyr* (Gemäldegalerie, Cassel) and *Bacchanal before a Herm* (National Gallery, London), but looks very much like the fauns in *The Nurture of Bacchus* (National Gallery, London) and in *The Triumh of Pan* (S. Morrison collection, England).

Blunt (1967) treats the whole scene as an allegory. He feels its main message is in the struggle between the putto and small satyr, which is symbolic of the conflict between physical and spiritual love (A. Blunt, «Poussin Studies III: The Poussin at Dulwich», *The Burlington Magazine*, 1948, 538, p. 7). Poussin represented a similar scene in *Venus and Mercury* (Dulwich College, London).

Yet, given this interpretation, the message of the allegory is still somewhat obscure. Though it is obvious that elevated love triumphs, as personified by the putto crowned with a golden laurel wreath, it remains unclear what is meant by the presence of the goat (a symbol of base passions and sensuality) together with the putto enticing the woman and another one fighting a satyr.

Blunt (1958) identified the Hermitage painting with the one in the Ruffo collection in Messina (the inventories and documents relating to this collection were first published in 1916) listed as *Venus, Bacchus, a Small Satyr, and Two Putti*. Among other existing documents, there is a letter dated May 22, 1665 from Abraham Bruegel to Antonio Ruffo (published in 1916), in which Bruegel narrated a conversation he had had with Poussin about a picture belonging to Ruffo that depicted «a woman climbing on to a goat», and quoted Poussin as calling this picture «quella veneretta» — «this small Venus» (Ruffo 1916, p. 173).

An interesting idea concerning the subject-matter of the Hermitage painting was put forward by Mezentseva (1983). She thinks that the woman depicted is Venus Pandemos or Venus Epitraghia, that is, Venus on a goat's back. Usually, Venus Pandemos was shown riding a goat in the skies and often accompanied — since her cult was connected with that of Dionysus — by putti or small satyrs. Representations of Venus Pandemos were widely spread in the art of antiquity (many of which have come down to us), as well as during the Middle Ages and the Renaissance.

With his interest in antiquity, Poussin could not have failed to see such representations. His numerous drawings from classical monuments appear as independent, creatively reinterpreted versions and never as exact copies. By not showing Venus Pandemos in flight, Poussin deviates from tradition in this case as well. The traditional depiction would have been considered too much in the spirit of Roman Baroque, a style essentially alien to the artist. For Poussin, antiquity was not the distant past. Fascinated by it, he perceived its myths and heroes as real. All of his bacchanals and mythological scenes are lifelike and ingenuous, with gambolling bacchantes and fauns, dancing maenads, and nymphs sleeping under the shade of trees.

It is as if Poussin himself witnessed the moment when Venus was climbing on the back of the goat. A faun is helping her, holding her arm, a smiling small putto hovers, ready for flight, and impatiently glances back, but Venus's attention is averted by a satyr, who is accompanying her, and a putto, who has attacked him. The face of Venus is sad, which may be explained by the victory of elevated love (represented by the putto crowned with a laurel wreath) over sensual love (whose cult is personified by Venus Pandemos). The picture is filled with shimmering chiaroscuro and sunlight streaming through the leaves of the trees. Bathed in this golden sunlight and fused with it are the figures of Venus and her companions. The light envelops and unites them, thus betraying Poussin's perception of the harmony and inseparable link between man and nature.

The fighting satyr and putto were perhaps introduced because Poussin wished to express his own opinion on the subject. Though the picture features Venus Pandemos, or sensual love, it is elevated love, according to the artist's lofty ideals and aspi-

Venus, a Faun and Putti.

rations, that must be triumphant in the world. The meaning of the fighting putto and satyr is implied in keeping with Poussin's method of conveying the message of the composition indirectly, rather than by imposing it on the viewer. This representation should not be interpreted either in a moral or Christian sense (Blunt 1967).

The figure of this putto, incidentally, was probably not in the picture's original design, but was introduced later, indicating that Poussin decided to express the message precisely this way during the process of painting the scene. It is possible that initially Venus turned back to look only at the small satyr, and that the artist then decided to introduce the motif of a putto and satyr struggling and painted the figure of the second putto over a flower gar-

land, which is still discernible and can be clearly seen when viewed under infrared light. Infrared analysis also shows that the landscape background in this section of the picture was painted anew (it was originally darker behind the fighting putto's back) and the trunk of the tree was wider. In other parts of the picture there is no trace of even the slightest changes.

As for the flower garland, a detail most difficult to explain, it may symbolise Venus's ties with the other world, since on Roman sarcophagi, which Poussin undoubtedly studied, garlands are indirect symbols of the connection between body and soul, *i.e.*, between the corporeal and the spiritual.

Provenance: L. A. Crozat de Thiers collection, Paris; 1822, entered the Hermitage from the collection of General Korsakov.

Nicolas Poussin, *Venus and Mercury*.
Dulwich College, London.

Nicolas Poussin, *Venus and Mercury*.
Detail, Dulwich College, London.

11. CUPIDS AND GENII

Oil on canvas, 95 x 71.5 cm.
The Hermitage, St. Petersburg, inv. No 1187.

The subject of this painting has been variously described in literature and in old Hermitage catalogues: *The Play of Children* (cat. Crozat 1740; livret 1838), *Children and Putti Playing* (cat. 1863; cat. 1892; Thuillier 1974), *Cupids and Genii* (cat. 1908; Grautoff 1814; Magne 1914) and *Putti Playing* (Blunt 1966; Wild 1980).

Seventeenth-and eighteenth-century catalogues and inventories often mention small pictures by Poussin showing playing putti, or «children's bacchanals». Two of his early «children's bacchanals» are known (Incisa della Rocchetta collection, Rome). The Hermitage painting has no concrete subject-matter, but probably its allegorical meaning was prompted by the depictions on Dionysiac sarcophagi and is close to that of Dionysiac mysteries. Blunt thinks that Poussin used this allegory to his idea of life beyond the grave, which is hinted at by the depiction of putti, who «symbolise in their activities the delight prepared for those who in their life have been initiated to the Dionysiac mysteries» (Blunt 1967, p. 122).

The picture is devoted to the theme of fate which depends on the capricious play of cupids and genii amusing themselves by clutching a butterfly and bird, symbols of the human soul and the transience of life. The motif of the vicissitudes and unexpected twists and turns of life is further developed in Poussin's later works.

The picture's attribution to Poussin is traditional. In 1980 it was questioned by Wild, but we can hardly agree with her subjective and verbose comments. The painting is in no way incongruous with Poussin's art of the early 1630s, and the putti are depicted in a way typical of him. X-ray analysis also confirmed its authenticity, revealing the device of outlining the contours of the standing, sitting and flying putti.

Blunt placed the picture between 1630 and 1633. This dating, which is supported by Thuillier, arouses no controversy.

Similar figures of putti occur in a few others of Poussin's works: *The Realm of Flora* has a reclining putto; the seated putto is reminiscent of ones in *Concert of Putti* (Louvre, Paris), *Venus Sleeting* (Gemäldegalerie, Dresden) and *David Victorious* (Prado, Madrid); and the putto looking out from behind the tree is a repetition of one appearing in an earlier work — *Putti with Goat and Mask* (Incisa della Rocchetta collection, Rome).

The Hermitage also has a copy of *Cupids and Genii* (inv. No. 8427, oil on canvas, 95 x 74 cm) that was received from the State Museum Reserve in 1939. The picture's history cannot be accurately traced. The entry in Monconys' travel diary for May 31, 1664 mentions a *Children's Bacchanal* he purchased for 600 écus, which Blunt thinks may be referring to either the one in the della Rocchetta collection, or the one in the Hermitage. Le Maire spoke of a *Children's Bacchanal* by Poussin in 1685. It was kept in the Colbert Hotel, in the collection of the son of Jean-Baptiste Colbert, the Marquis de Seignelay. Le Maire noted that the picture «combines a beautiful colour scheme and brushwork with accurate drawing». This can be fully applied to the Hermitage painting, since the postures of the cupids and genii presented very difficult foreshortening problems brilliantly solved by Poussin. It is possible that the picture later passed on to the Marquis de Seignelay's brother or nephew. In 1740 it is listed as item 229 in the inventory of the Pierre Crozat collection, as well as in the catalogue of the collection of Crozat de Thiers. There is a sketch of it done in the margin of the Crozat (1755) catalogue by Gabriel de Saint-Aubin (Dacier, 1909).

Provenance: L. A. Crozat de Thiers collection Paris; since 1772, The Hermitage, St. Petersburg.

Cupids and Genii.

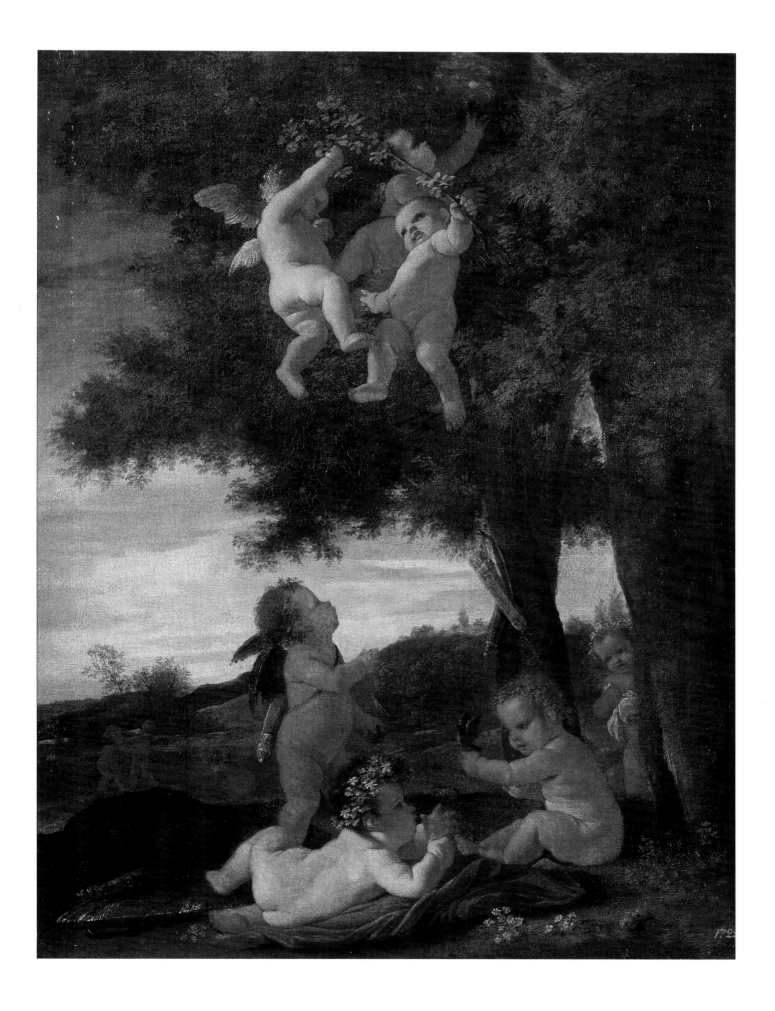

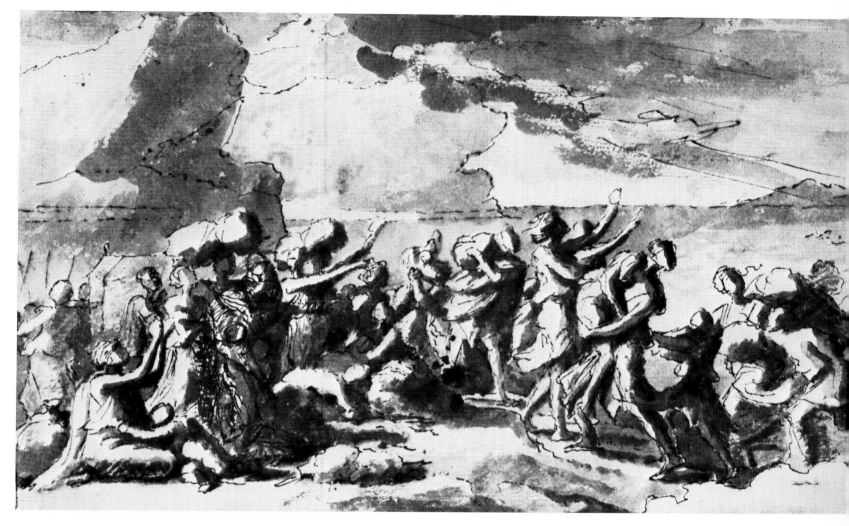

Crossing at the Red Sea.

12. *CROSSING OF THE RED SEA*

Pen and bistre wash, 18.8 x 32.5 cm, relined.
The Hermitage, St. Petersburg, inv. No 14542.
Exodus 14:16-22.

The figure of Moses on the right edge of the drawing is partially cut off.
The drawing is one of the preliminary sketches for the picture *Crossing of the Red Sea* commissioned by Amadeo dal Pozzo and executed between 1634 and 1635 (National Gallery of Victoria, Melbourne; 1960 Paris, No. 37; Blunt 1966, No. 20). The drawing is very different from the painting, which has more figures and a greater dynamism. There are other preliminary drawings to this painting as well: in the Louvre, Paris (Drawings, 1, Nos. 20, 21, pls. 12, 13), in the Hermitage, St. Petersburg, and in Blunt's collection in London (Drawings, 5, p. 66, No. 386, pl. 288, fig. 386).
The present drawing can be dated to 1634-35.

Provenance: J. de Jullienne collection, Paris;
I. I. Betzkoi collection, St. Petersburg (stamped L. 2878a);
Academy of Arts, St. Petersburg; since 1924, The Hermitage, Leningrad-St. Petersburg.

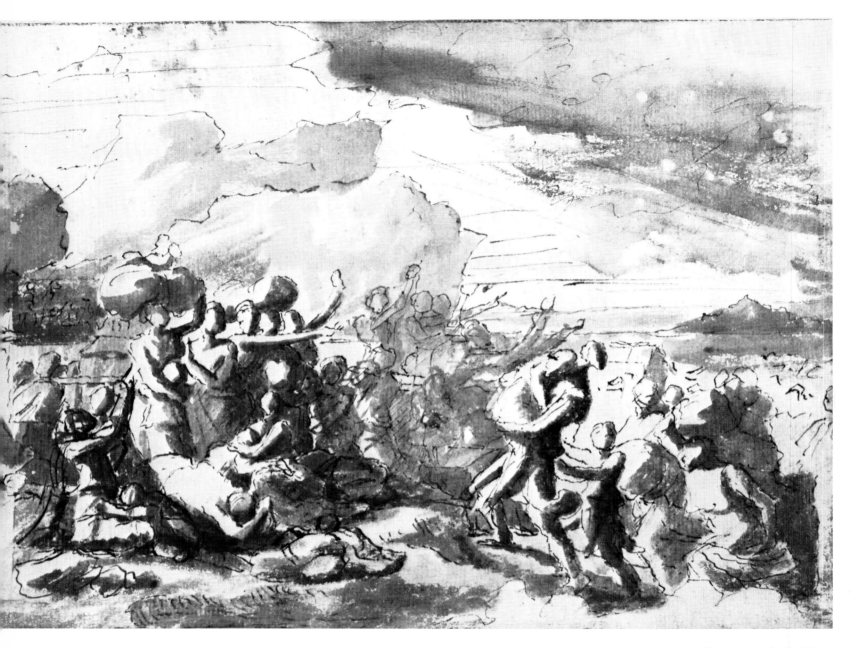

Crossing at the Red Sea.

13. *CROSSING OF THE RED SEA*

Pen and bistre wash and white, 18.5 x 26.5 cm
The Hermitage, St. Petersburg, inv. No 14540.
Exodus 14:16-22.

The drawing is a sketch for the picture of the same
name commissioned by Amadeo dal Pozzo and exe-

cuted between 1634 and 1635 (National Gallery of
Victoria, Melbourne).
It can be dated to the same period.

Provenance: J. de Jullienne collection, Paris;
I. I. Betzkoi collection, St. Petersburg (stamped L. 2878a);
Academy of Arts, St. Petersburg; since 1924, The Hermitage,
Leningrad-St. Petersburg.

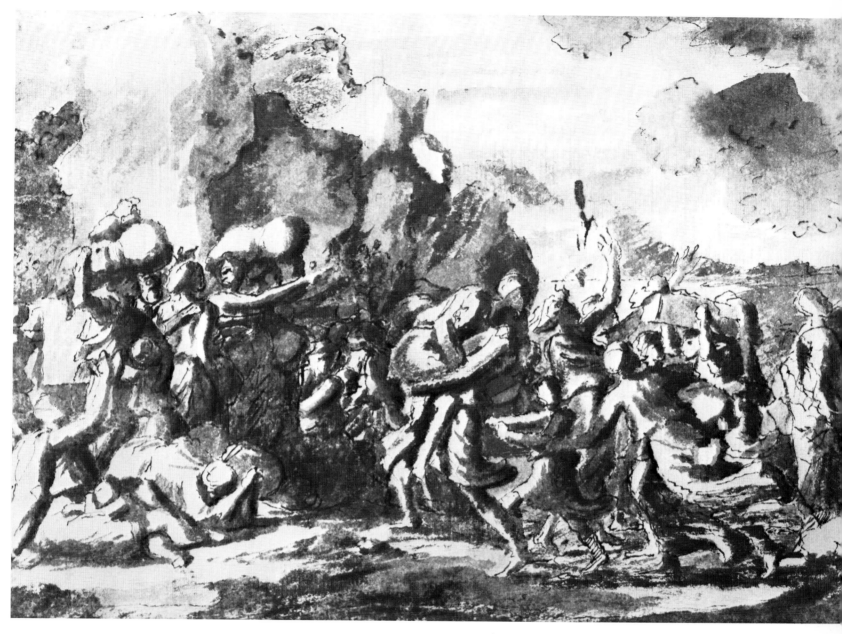

Crossing at the Red Sea.

14. *CROSSING OF THE RED SEA*

Pen and bistre wash and white, 18.5 x 25 cm.
The Hermitage, St. Petersburg, inv. No 14541.
Exodus 14:16-22.

This drawing is a sketch for the picture of the same name commissioned by Amadeo dal Pozzo and executed between 1634 and 1635 (National Gallery of Victoria, Melbourne). The figure of Moses raising a staff near the right edge of the drawing is clearly visible.
A copy of the drawing (Albertina, Vienna) was reproduced as the original by Magne (1914, p. 64). The drawing can be dated to 1634-35.

Provenance: J. de Jullienne collection, Paris;
I. I. Betzkoi collection, St. Petersburg (stamped L. 2878a);
Academy of Arts, St. Petersburg; since 1924, The Hermitage, Leningrad-St. Petersburg.

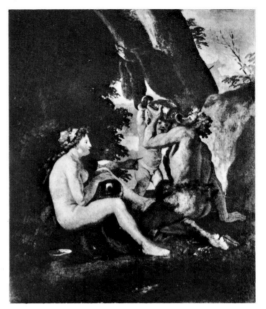

Nicolas Poussin, *Nymph, Satyr, Faun and Cupid*. Gemäldegalerie, Cassel.

Nicolas Poussin, *Satyr and Nymph*. Prado, Madrid.

15. *NYMPH AND DRINKING SATYR*

Oil on canvas, 77.5 x 62.5 cm.
The Pushkin Museum of Fine Arts, Moscow, inv. No 1049.

The painting is done over a thin red primer in pastose strokes, though in a softer and freer manner than the battle scenes. The arms and lower part of the nymph's legs, for example, are done in elongated strokes stressing their slender shape.

The heavy density of the painting's X-ray indicates the extensive use of white lead, a sign of a relatively early date of execution.

The X-ray also showed that the initial composition underwent some changes: the bacchante's figure was a little bit stouter; the skin hanging from the tree, slightly bigger; and there were no short green branches on the right side of the tree-trunk.

The picture was listed in the Crozat catalogue (1755) as *Drinking Satyr and Young Woman with Glass Vessel*, and the Hermitage inventories and catalogues called it *Venus and Satyr*. Some authors refer to it *as Satyr and Bacchante*.

The majority of experts (Grautoff, Jamot, Blunt) place it in the mid-1630s; Thuillier (1974) dates it 1626-27.

The Prado in Madrid has a version that is quite close to the painting in the Pushkin Museum. It was traditionally believed that the one in the Prado was purchased in Rome in 1722-24 from the heirs of Carlo Maratta. Grautoff held Poussin to be the author of both pictures, but Blunt thinks that the one in the Pushkin Museum is the original and the Prado painting, a copy — considering its less fine technique and complete failure to fit the inventory description of the picture purchased from Maratta. Rosenberg, in his catalogue of Poussin's exhibition in Dusseldorf, agrees with Blunt.

Two more replicas of the picture are in the Musée des Beaux-Arts, Besançon (inv. No. 210) and in the National Gallery, Dublin (inv. No. 2519). The latter of these two belonged to the collection of the Dukes of Sutherland in London in the nineteenth century. In 1913 it was bought by Sir Hugh Lane and in 1916, according to his will, was given to the National Gallery. A repetition of the figure of the drinking satyr (depicted drinking from a horn) appears in *The Youth of Bacchus* in the Musée Condé, Chantilly.

Engravings: J. Coelemans, among a series of engravings belonging to the collection of Jean Baptiste Boyer d'Aguilles in 1709.

Provenance: before 1709, collection of J.-B. Boyer d'Aguilles (Chief Royal Prosecutor of Aix); 1709-37, collection of Abbot Louis Lanthier, Aix; 1737-40, collection of Pierre Clozat the Junior, Paris; before 1770, collection of L. A. Crozat de Thiers; 1822-1929, The Hermitage, St. Petersburg; since 1929, The Pushkin Museum of Fine Arts, Moscow.

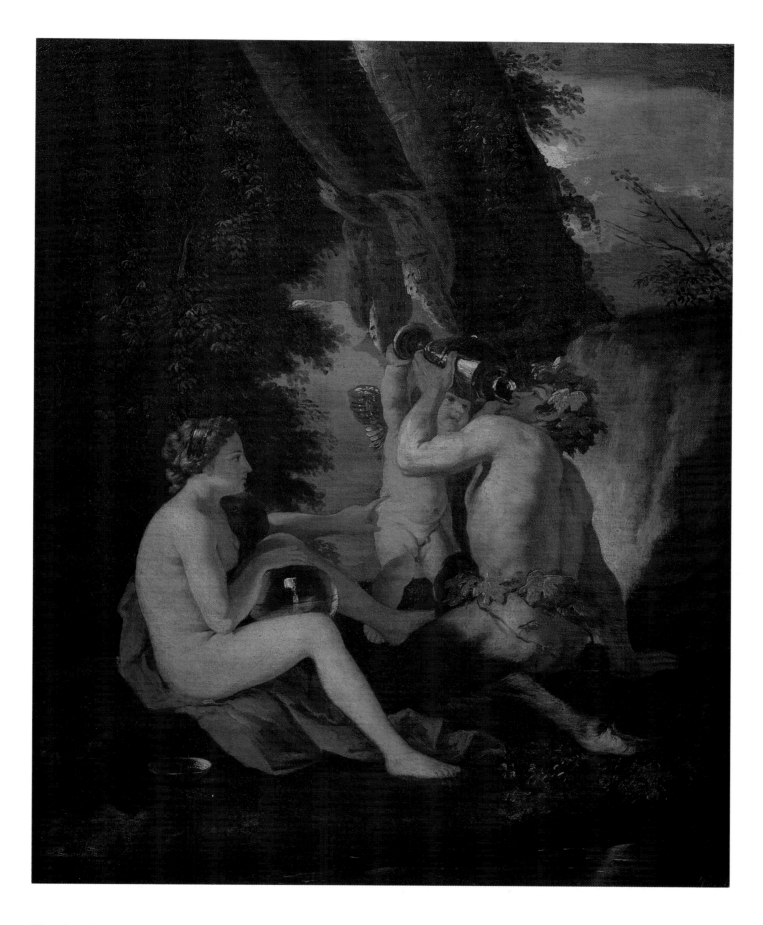

Nymph and Drinking Satyr.

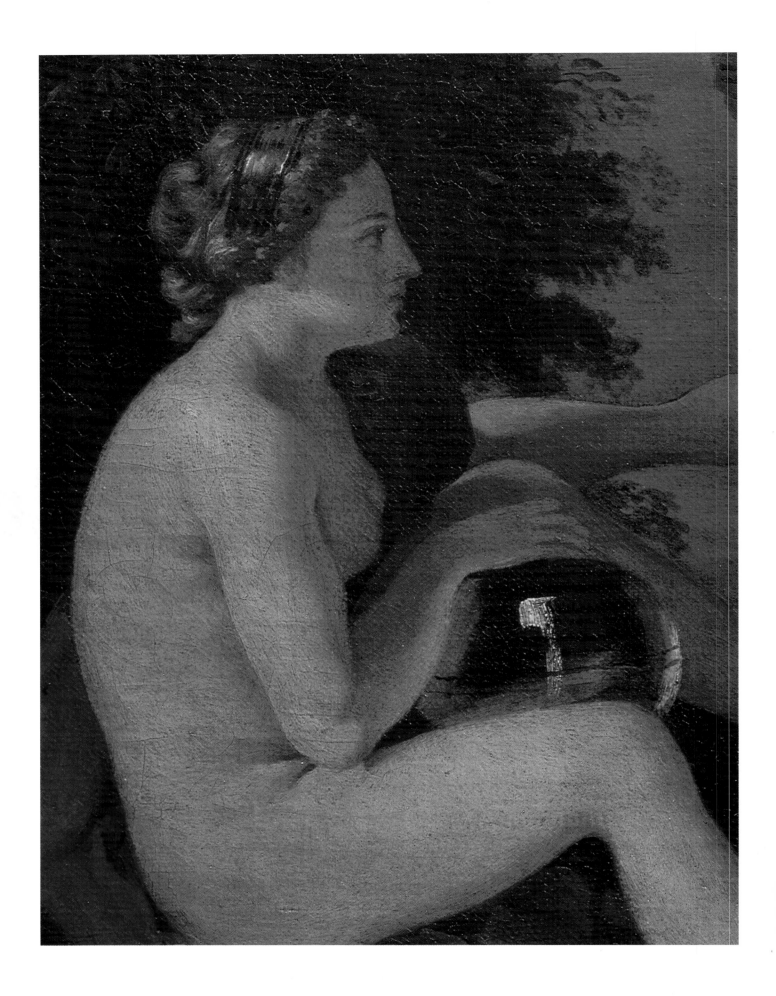

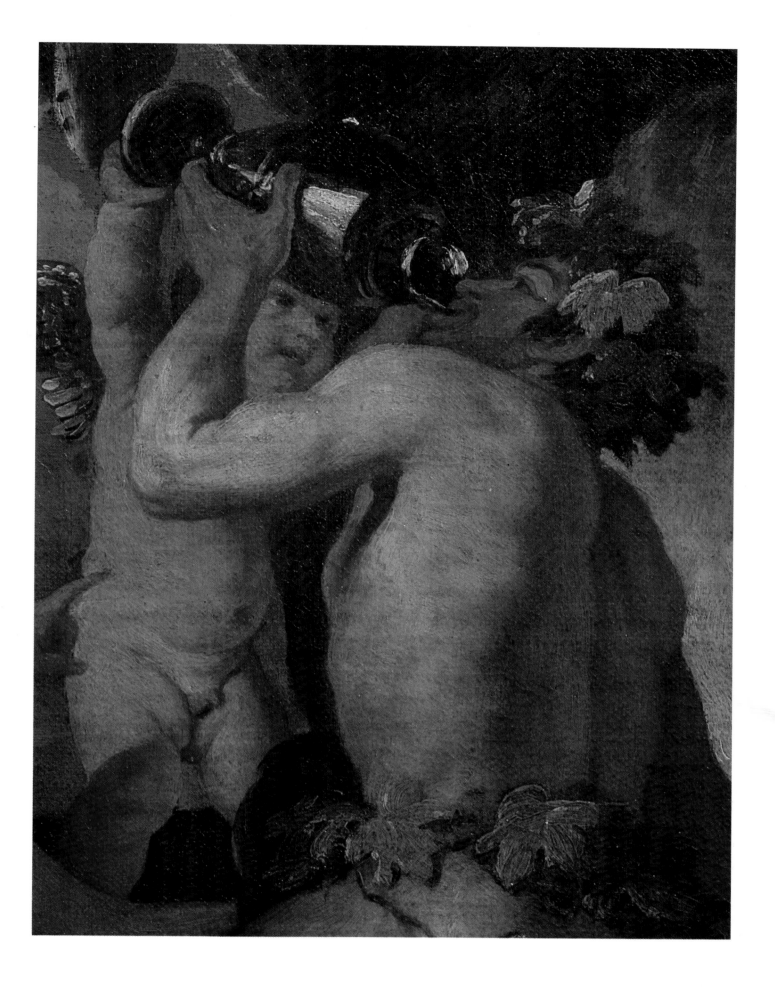

16. PUTTI HUNTING

Oil on canvas, 67.5 x 50 cm.
The Hermitage, St. Petersburg, inv. No 1196.

X-raying reveals that the picture is a fragment of a much larger canvas: the tensioning of the canvas threads can be seen on its left and bottom edges, but not on its right and top ones.

Taken separately, the picture of four putti and two dogs has no subject. It may be that the larger painting showed a hunting scene based on a myth. A lance could be an attribute of various characters (Mars, Rinaldo, Tancred, Adonis), but the presence of hunting dogs and of the small horn that is being blown by a putto suggests that it was a depiction of Adonis before hunting. This opinion is shared by the majority of experts: Smith (1837); Waagen (1864), who considered the picture «a final study for a composition of Venus and Adonis»; Magne (1914); Blunt (1966); and Wild (1980). The idea that the painting is a fragment of a larger one is prompted by its composition and by the size of the putti figures, too big for a canvas of this size. In addition, the figures of the dogs are cut off and the lance rests on the ground outside the picture. Further confirmation of this premise is offered by the testimony of de Brienne mentioning that he himself had a picture of Venus by Poussin cut in order to have just the three cupids that were at the foot of her bed (Colloque 1960, 2, p. 223), since Venus seemed *to* him «too immodest». Another painting by Poussin, *Venus and Mercury* (Dulwich College, London), was also split, with the section showing four cupids playing musical instruments becoming an independent work (Louvre, Paris). Poussin's compositions, in fact, often lend themselves to being divided into individual parts. *The Adoration of the Shepherds* (National Gallery, London) and *The Holy Family* (Devonshire collection, Chatsworth), for example, have groupings of putti moved away from the main characters. The attribution is traditional, although Grautoff (1914), pointing to the figures of the putti, which, in his opinion, are too obese for Poussin's manner, and to a certain inclination of the motif toward genre, made the supposition that the painting may have been done by Gérard de Lairesse. Thuillier (1974), noting that this picture is listed in the 1740 catalogue of the Crozat collection as being done by Chaperon, ascribed it to that artist. Yet the catalogue's attribut-ion, which is over two hundred years old and was changed already in Tronchin's inventory of 1771, does not suffice to refute Poussin's authorship.

Wild (1980), because of the painting's «badly modelled stilted putti» and «sombre background», considers it impossible to ascribe it to Poussin, and attributes it to an «anonyme Puttenbilder». In our opinion, the Hermitage painting, both in terms of composition and artistry, does not run counter to Poussin's style. Furthermore, it complies with his manner of the 1630s, when his rich chiaroscuro and striking lighting effects gave way to more subtly modelled forms without sharp contrasts.

Blunt dates the picture 1630-33, but we hold that it should be placed in the mid-1630s because of its affinities with such works as *Landscape with Juno, Argus and Io* (Staatliche Museen, Bodemuseum, Berlin), *Venus, a Faun and Putti* (Hermitage, St. Petersburg), *Nymph, Satyr, Faun and Cupids* (Gemäldegalerie, Cassel), *Nymph and Drinking Satyr* and *Rinaldo and Armida* (both in the Pushkin Museum of Fine Arts, Moscow). The putto pulling the dog by a chain is almost an exact replica of the putto with an armful of grass in *Apollo and Daphne* (Alte Pinakothek, Munich).

The catalogue of 1892 mentions a study for this picture belonging to the P. Methuen collection, Corsham (Smith 1837, p. 88, No. 165).

The picture is listed as originating from the Crozat collection for the first time in the Hermitage catalogue of 1908 (previously it was merely registered as being purchased during the reign of Catherine II). Magne (1914) wrote that it came from Cardinal Mazarin's collection. Blunt identified it with a picture (No. 934) listed in the 1653 inventory of the Cardinal collection as «Four Nude Putti and Two Dogs by Poussin». An inventory of 1661 gives its dimensions as 24 x 18 inches (61 x 45.7 cm), which are approximately equal to the size of the Hermitage painting (61 x 51 cm). After Mazarin's death the collection was to go to either Hortense Mancini or Filippo Mancini (Blunt 1966).

Provenance: before 1772, L. A. Crozat de Thiers collection, Paris; since 1772, The Hermitage, St. Petersburg.

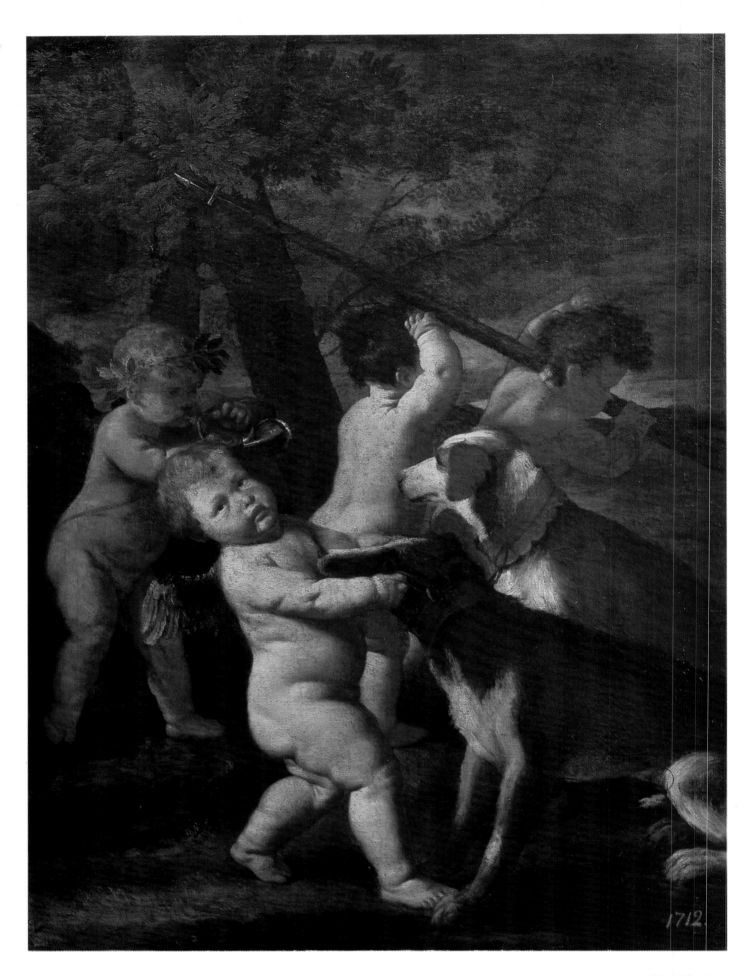

Putti Hunting.

17. CENTAURS DASHING

Pen and bistre, 8.3 x 7.5 cm, relined.
The Hermitage, St. Petersburg, inv. No 6995.

The drawing is a sketch for the composition *The Triumph of Bacchus* dated c. 1636 (Nelson Gallery, Atkins Museum, Kansas City). With slight changes, this grouping is repeated in other preliminary drawings for the same picture (Windsor Castle, England; Nelson Gallery, Atkins Museum, Kallsas City; Blunt 1967, p. 136, figs. 126, 127). By the dynamic movement of the centaurs, vigorous contours and the energetic shading this drawing is close to another one, *Centaur Kidnapping a Nymph* (Musée Bonnat, Bayonne; Drawings, 3, No. 240, pl. 151).

Provenance: K. Cobenzl collection, Brussels (stamped L. 2858b); since 1768, The Hermitage, St. Petersburg (L. 2061).

101

18. *VIEW OF CAMPAGNA DI ROMA*

Bistre wash over black chalk, 15 x 40.5 cm, relined.
The Hermitage, St. Petersburg, inv. No 5082.

Executed in a free manner, this drawing is perhaps a sketch for a painting. An extension on the right indirectly supports this idea. It is datable to the early 1640s by analogy with the painting *View of Campagna di Roma* (O. Reinhart collection, Winterthur; Mahon 1961, p. 119, ill.) which shows the same scenery from a different point. According to Blunt, the drawing may also be related to *Landscape with St. John on Patmos* (Art Institute of Chicago; Blunt 1979, p. 122) dated by the late 1630s (L. Barroero, «Nuove acquisizioni par la cronologia di Poussin», *Bolletino d'Arte,* 1979, 4). Friedlaender (Friedlaender 1966, p. 76, fig. 71), in his last study of Poussin, gives the drawing a name similar to the one accepted by the Hermitage, *Roman Arch in Campagna.* He dates it 1630, which does not seem convincing.

Provenance: K. Cobenzl collection, Brussels (stamped L. 2858b); since 1768, The Hermitage, St. Petersburg (L. 2061).

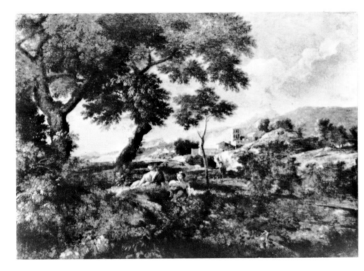

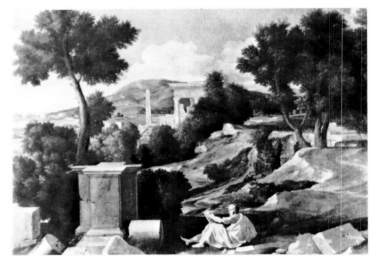

Nicolas Poussin, *View of Campagna di Roma.* Reinhart collection , Winterthur.

Nicolas Poussin, *Landscape with St. John on Patmos.* Art Institute, Chicago.

View of Campagna di Roma.

The Magnanimity of Scipio.

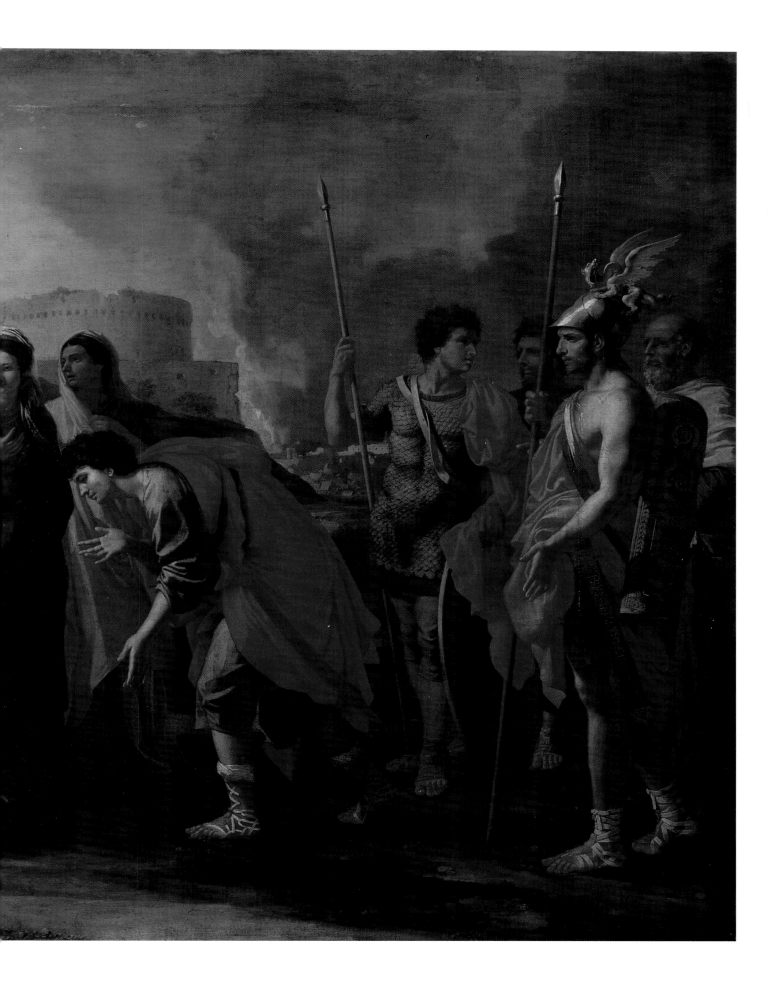

Nicolas Poussin, *The Magnanimity of Scipio.*
Drawing, Musée Condé, Chantilly.

19. *THE MAGNANIMITY OF SCIPIO*

Oil on canvas, 114.5 x 163.5 cm.
The Pushkin Museum of Fine Arts, Moscow, inv. No 1048.
Titus Livius, *Annals,* book XXVI, chapter 50.

Although early written sources mentioning this painting were not known until recently, its authenticity was never questioned. Grautoff dated it 1643, and Mahon and Blunt, 1643-45. Thuillier thought that Poussin painted it shortly after returning to Rome (November 1642). The research done by Liliane Barroero in the archives of Foligno and Rome now makes it possible to determine the exact date of execution and the name of its first owner, Gian Maria Roscioli (1609-1644), Secretary and Chamberlain to Urban VIII.

According to the inventory of the Roscioli collection that Barroero discovered, the picture *Scipio Africanus* was purchased from Poussin for seventy scudi and was already a part of the Roscioli collection in 1640. The dimensions of the painting listed there coincide with the ones of the picture in the Pushkin Museum of Fine Arts (L. Barroero, «Nuove acquisizioni per la cronologia di Poussin», *Bolletino d'Arte,* 1979, October-December).

There are preliminary drawings to the painting in the Musée Condé, Chantilly (Drawings, 2, No. 125) in the collection of Siegfried Schwarz in New York (A. Blunt, *The Drawings of Nicolas Poussin,* 1974, part 5, No. 420) and in the Hermitage. At present, the majority of experts consider the Hermitage drawing to be a copy done by Poussin's studio from the painting.

The Bowdon College Museum in Brunswick, USA, has a copy of *The Magnanimity of Scipio* in the Pushkin Museum of Fine Arts (115 x 155 cm) which was executed by John Smibert in 1728 (*Catalogue. Philadelphia. Painting and Printing to 1776*, Philadelphia, 1971, p. 35). Blunt's catalogue (1966) mentions a 1742 copy of the Moscow painting by Ranelagh Barrett that appeared in the *Notebook* by Georges Vertue (Blunt 1966, p. 129) and another copy that in 1958 was part of the Houermouzios collection, London.

Engravings: 1. C. Dubosc. 1741; 2. F. Legat. 1752 (Aedes Walpolianae, p. 89).

Provenance: early 18th century, Gemäldegalerie, Dusseldorf; Count de Morville collection; c. 1730-79, Robert Walpole collection, Houghton Hall, England; 1779-1927, The Hermitage, St. Petersburg-Leningrad; since 1927, The Pushkin Museum of Fine Arts, Moscow.

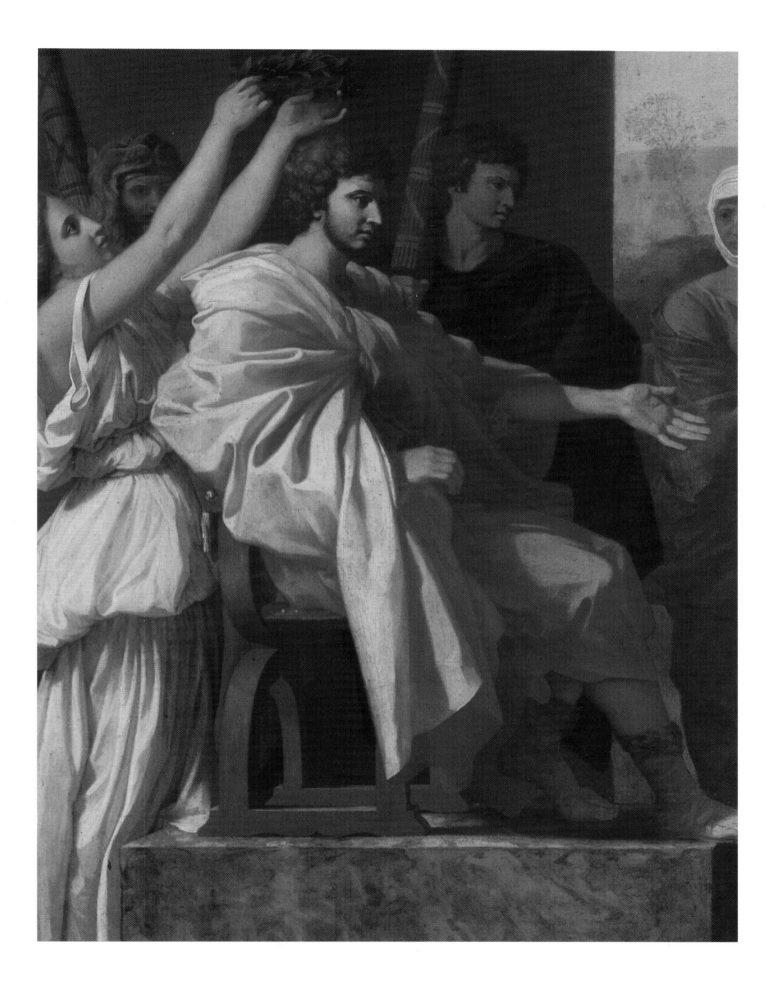

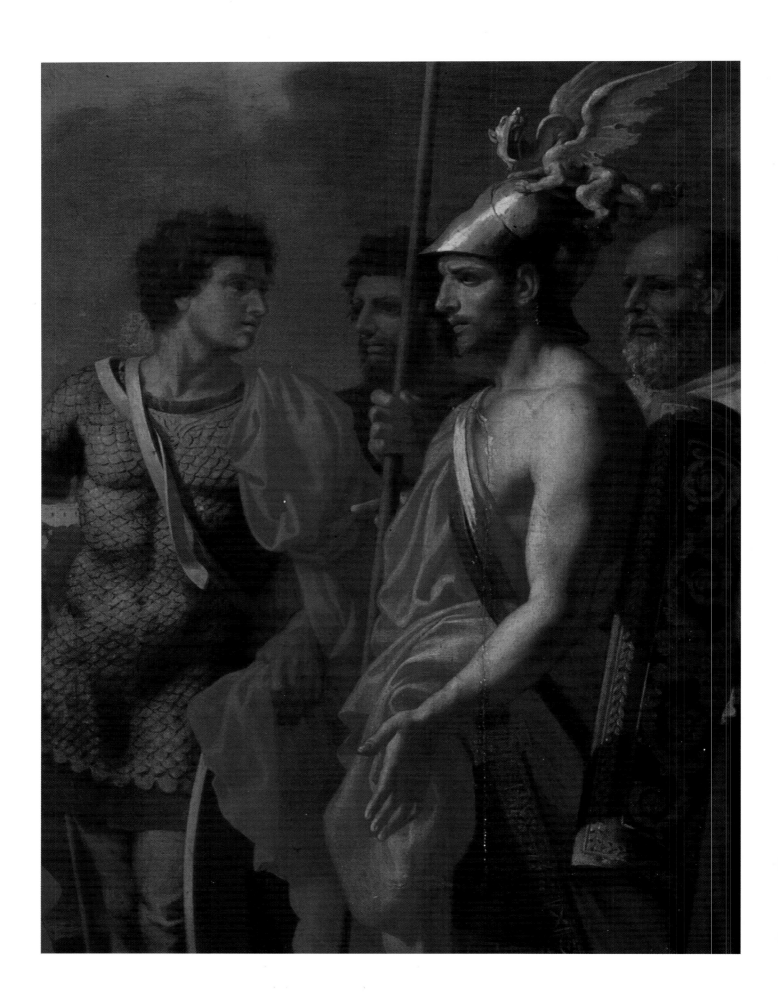

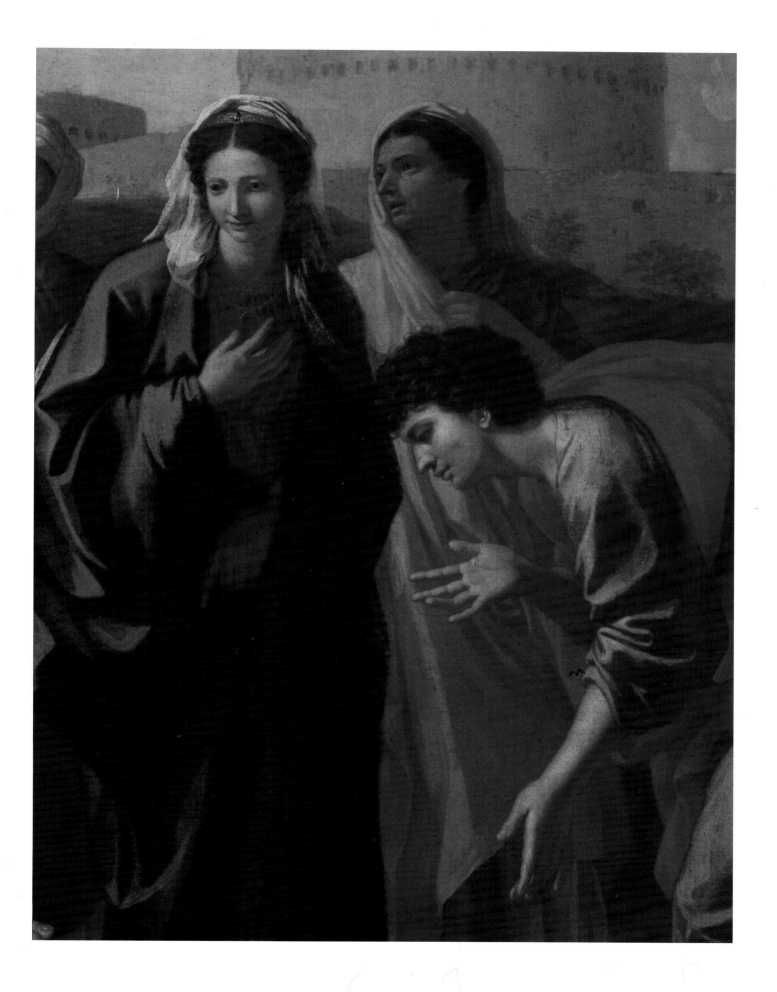

20. *DECORATIVE COMPOSITION WITH ATLANTES*

Pen and bistre wash over pencil, 18 x 11.1 cm, relined.
The Hermitage, St. Petersburg, inv. No 8192.

This design for the decorative painting of the Louvre's Grande Galerie, on which Poussin worked in 1641-42, is the only authenticated drawing for the Louvre ensemble housed in the Hermitage. The elegant finished composition can be referred to the beginning of a cycle of frescoes devoted to a character from ancient mythology, the legendary Hercules. The rich framing of the upper part of the drawing includes depictions of an eagle and lightning bolts, the attributes of Jupiter, the father of Hercules. Below, in a round medallion, Jupiter is shown sending Mercury to Apollo. This sketch, outlined here only in general, was later developed into a separate composition in the Louvre drawing *Jupiter and Mercury* (Drawings, 4, p. 14, A, 71, pl. 185). The Hermitage drawing played a great role in designing the Gallery's decorative compositions. Certain of its elements were used in subsequent sketches for the decoration (Kamenskaya 1971, Nos. A 25, A 26). Some motifs were used by Jean Pesne in his engravings to *The Feats of Hercules* (J. Pesne, *Herculis labores*, Paris, 1678).

Provenance: H. Brühl collection, Dresden; since 1769, The Hermitage, St. Petersburg.

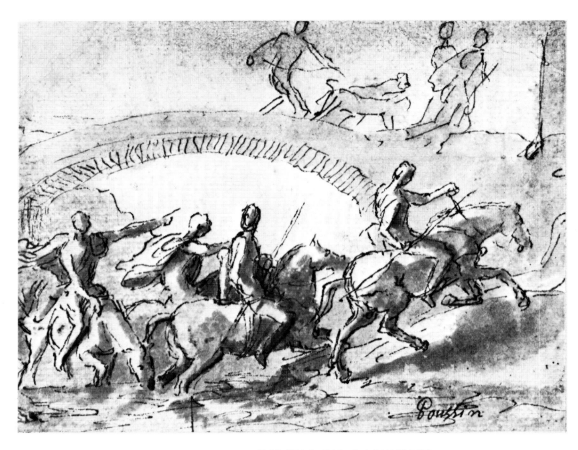

21. *SCENE OF A FLIGHT*

Pen and ink and bistre wash, 11.3 x 14.5 cm, relined.
Inscribed in a later hand, bottom right: *Poussin*.
The Hermitage, St. Petersburg, inv. No 5133.

The man on horseback leading the small unit across a stream resembles a similar figure in a (drawing at the Louvre (Drawings, 2, No. 120, pl. 95).
It is thought that the Louvre drawing depicts Metius Curtius, the leader of the Sabines, fleeing from the Romans. But this interpretation cannot be applied to the Hermitage drawing, since, according to Titus Livius, Metius Curtius «was escaping alone on horseback» (Titus Livius, *Ab urbe condita*). The drawing is a free composition not connected with any particular painting. It testifies to Poussin's ability to forcefully render the psychological state of his characters, as well as his keen eye for aerial perspective. A similar chiaroscuro treatment can be found in the drawing *Camillus and the Teacher from Falerii* (*Windsor* Castle, England; Blunt 1945, No. 190, pl. 37; Drawings, 2, No. 123, pl. 97). Blunt places this drawing in the 1650s.

Provenance: H. Brühl collection, Dresden; since 1769, The Hermitage, St. Petersburg.

22. ESTHER BEFORE AHASUERUS

Oil on canvas, 119 x 155 cm.
The Hermitage, St.Petersburg, inv. No 1755.
Esther 5:1-2.

Poussin departed from the Bible in some details of this painting. Grautoff (1914) noted that the artist, in order to make the composition more balanced, depicted three maids instead of two, and that he replaced the King's splendid vestments with a plain red cloak. Grautoff also pointed out the similarity between Esther's group and the group surrounding the swooning Virgin Mary in Raphael's *Deposition* (Galleria Borghese, Rome).

According to Félibien (1685), Poussin realised this painting for one of his regular customers, Cérisier, a merchant from Lyon, c. the early 1640s but without giving very much more precision about the date. Yet Grautoff dates it after Poussin's return from Paris *i.e.* between 1643 and 1645. However, considering the stylistic affinities of this painting with later paintings such as *The Death of Sapphira* (Louvre, Paris), Blunt and Thuillier assumed it had been executed in the 1655s which seems more realistic to us.

This painting also happens to have been wrongly listed as an eighteenth century painting in catalogues by Smith and Grautoff. It is also mistakenly mentioned as having belonged to Lord Carrisfort's collection, then to De Colonne's who stayed at court in England while a minister of Louis XVI.

In 1717, James Thronhill saw the painting in the home of Philippe, Duke of Orléans, hung next to the set of the *Seven Sacrements*.

A copy of the picture appeared at Christie's, London, on May 8, 1841 (No. 54).

Engravings: 1. Jean Pesne made an engraving of Esther before Ahasuerus while the painting was still in the possession of Cérisier. This engraving has served for the picture's attribution (Andresen 1863, No. 88); 2. F. de Poilly (Andresen 1863, No. 87); 3. F. Cars the Junior (Andresen 1863, No. 89); 4. I. G. (Andresen 1863, No. 90)

Provenance: mid-17th century, Cérisier collection; before 1690, J.-B. Colbert, Marquis de Seinelay, collection; 1690-1707, J.-N. Colbert collection; early 18th century, Philippe, Duke of Orléans collection; 1770, F. de Dufresne collection; since 1774, The Hermitage, St. Petersburg.

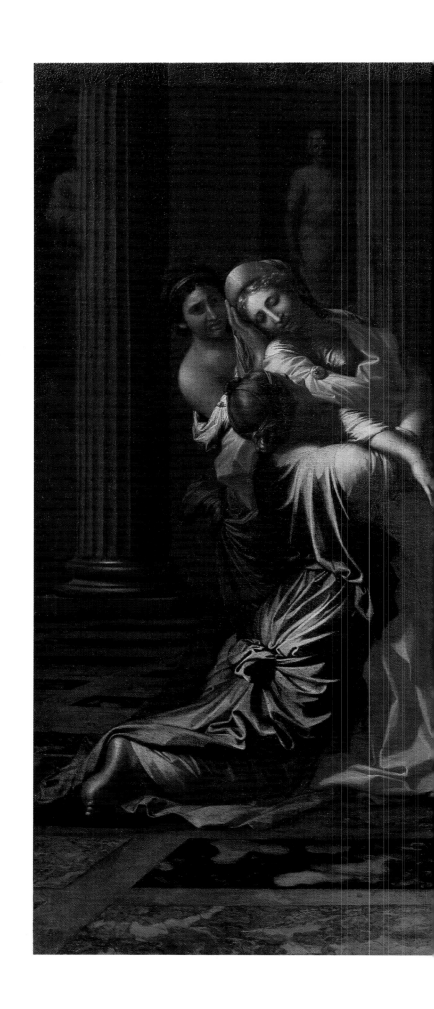

Esther before Ahasuerus.

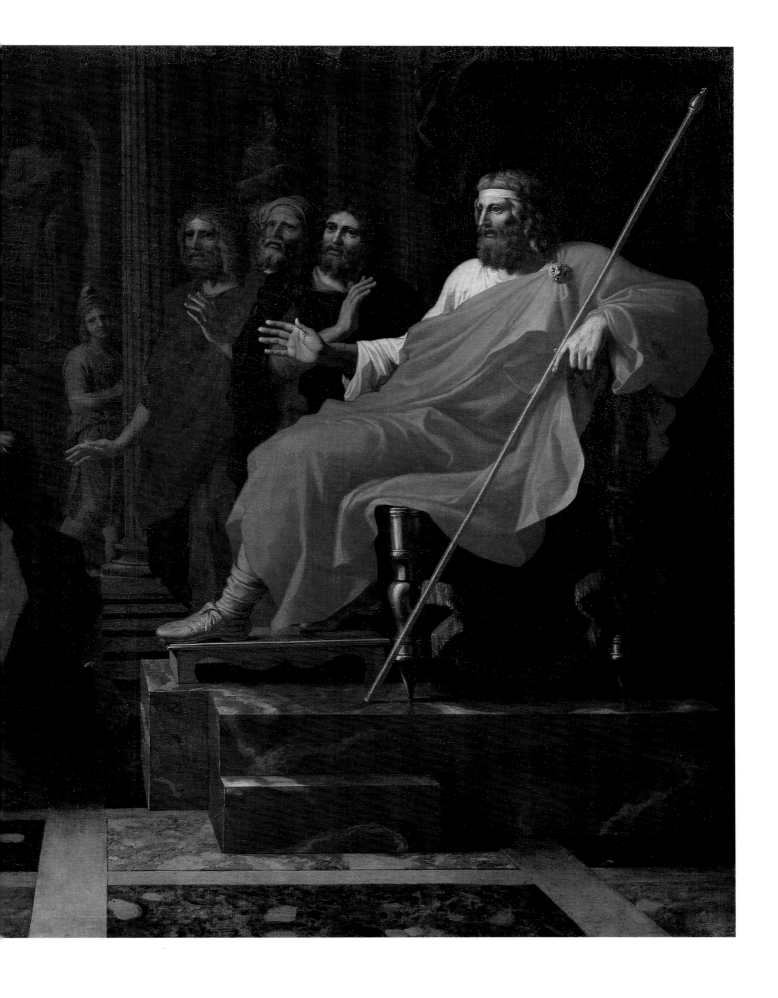

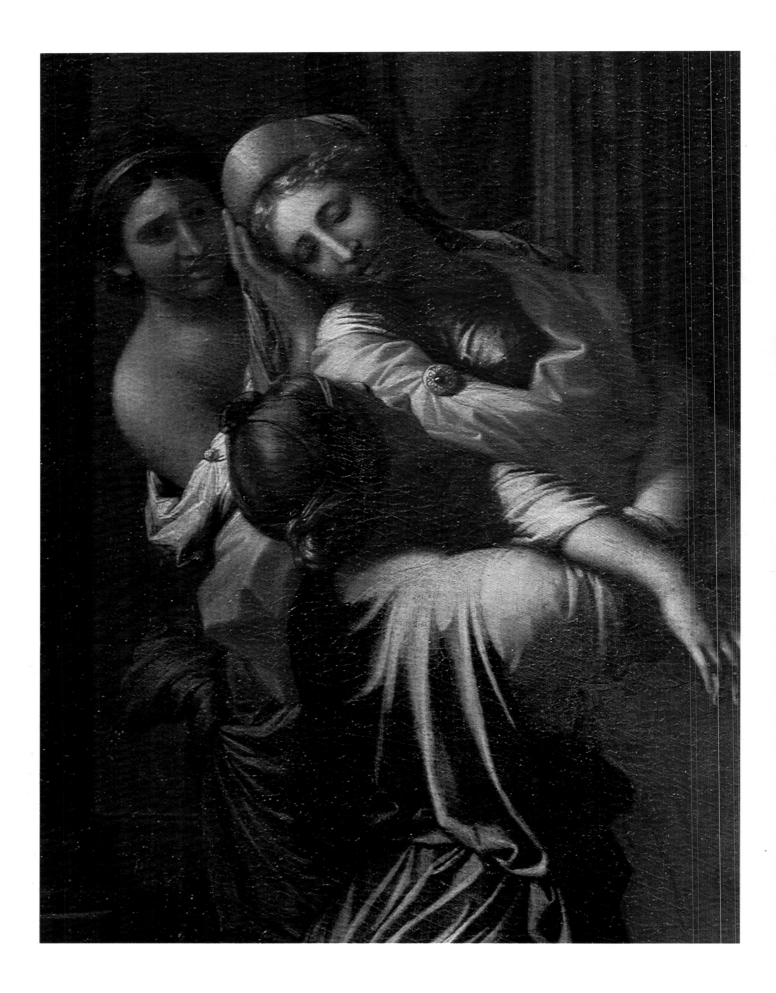

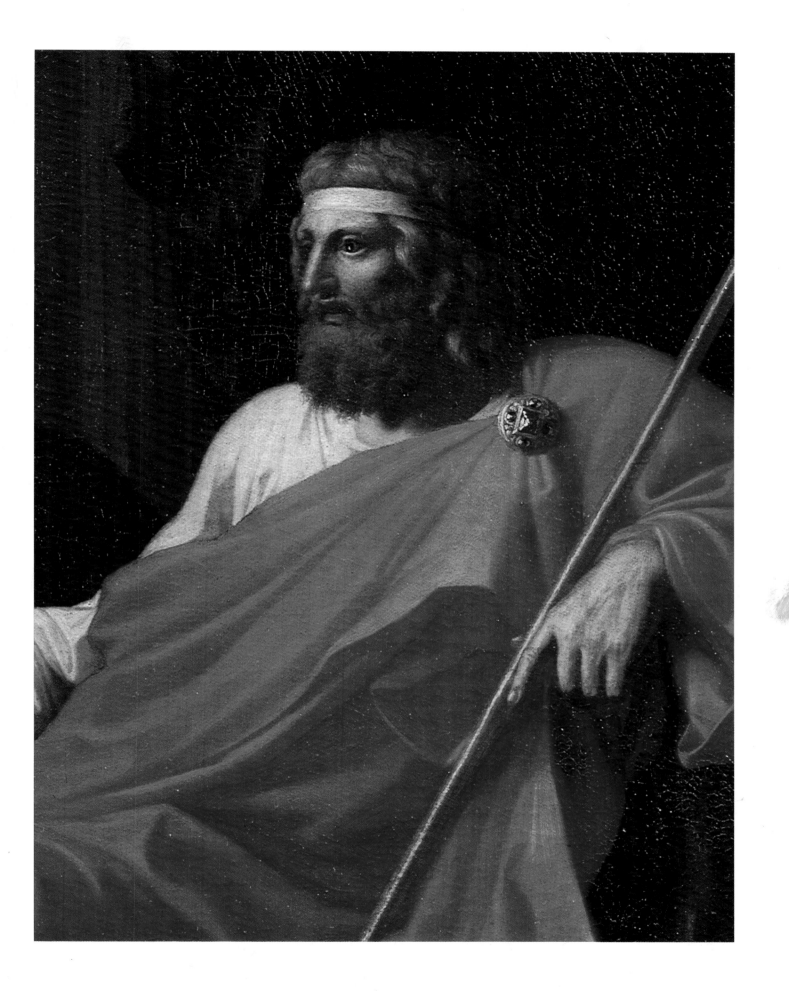

In the drawing, handwritten inscriptions read: *voLumi*, *agape*, and at the bottom *Convito funerale col triclinio Lunare detto Sigma*.

A Feast of the Early Christians
in Catacombs.

23. 24. *A FEAST OF THE EARLY CHRISTIANS IN CATACOMBS*

Pen and bistre wash, 14 x 12 cm, relined.
Inscribed in the artist's own hand,
bottom: *Convito funerale col triclinio Lenare detto Sigma*
(Commemorative funeral feast with a Lunar Triclinium called Sigma);
on the upper right: *agape* and on the upper left: *volumi*.
On the reverse: *Three Figures Standing*, pen and bistre.
The Hermitage, St. Petersburg, inv. No 8133.

A. Bank suggested (orally) that this scene is a traditional depiction of the early Christians in the catacombs engaged in the «feast of love» (*agape*). Two more drawings on the same subject are in the Rosenberg collection, Paris (Drawings, 5, p. 46, Nos. 361, 362, pl. 273, figs. 361, 362). Poussin's having used an edition of engravings by A. Bosio of classical buildings and statues and early Christian paintings (G. Wilpert, *Le pitture delle catacombe romane*, Rome, 1903, pl. 157) rather than having referred to the original works of art, may account for the reserved and careful manner of the drawing.

Poussin's attention in this case was caught by a depiction of a triclinium in a mural in the apse lunette of the catacomb of St. Peter and Marcellin (Rome, 4th century). The artist studied the forms of triclinia from Dutch engravings and other sources as well (A. Blunt, «The Triclinium in Religious Art», *Journal of the Warburgand Courtauld Institute*, 1938-39, 2, p. 271; J. Vanuxem, «Les *tableaux sacrés* de Richeome et l'iconographie de l'Eucharistie chez Poussin», in: Colloque 1960, 1, p. 151). In a letter dated May 30, 1644 Poussin wrote to Chantelou, one of his patrons, that *Penance* (*The Seven Sacraments*, second series) would have the new element of a lunar triclinium (Corr. 1911, p. 272), a remark almost identical to the inscription on the bottom of the Hermitage drawing. Nonetheless, the painting, finished in

119

Three Figures Standing.

1647, shows that the artist returned to his original idea of a rectangular-shaped Roman triclinium.

The drawing can be placed in the mid-1640s, although Blunt dates it to the 1650s (Drawings, 5, p. 46). The composition of the mural is preserved in the drawing, but the figures have been given a greater dynamism. The sketch of the scroll-containing basket labelled *volumi,* in which Poussin carefully repeated the oval of all eight rolls, resembles the one in the fresco *Christ the Teacher among the Apostles* (A. Bosio, *Roma sotterranea...,* Rome, 1632, p. 221).

The drawing on the reverse is based on an ancient relief. The figure carrying an axe is derived from the Altar of Peace (*Ara Pacis*) (S. Reinach, *Répertoire de reliefs grecs et romains,* Paris, 1909, 1, p. 235). The Musée Condé in Chantilly has some similar drawings.

Provenance: H. Brühl collection, Dresden; since 1769, The Hermitage, St. Petersburg.

Passing of the Scroll.

25. 26. *PASSING OF THE SCROLL*

Pen and bistre, 13.5 x 11 cm.
On the reverse: *Scene at a Tripod*, pen and bistre.
The Hermitage, St.Petersburg, inv. No 8134.

In the middle are the initials *SP* (Saint Pierre) and, on the left, half cut off, JC (Jesus Christ). The scene is taken from a relief on an ancient sarcophagus engraved by Bosio (G. Wilpert, I *sarcofagi cristiani antichi, Rome, 1929, 1, pl.* CXXI, 4). The motif of an unrolled scroll rather than keys being passed to Apostle Peter is rare in Christian iconography. Poussin intended to use it in his *Ordination* (1647, National Gallery of Scotland, Edinburgh), as evidenced by another preliminary drawing to that painting in the Louvre (Drawings, 1, No. 96, pl. 62). However, he eventually used the Gospel version.

The depictions of a bust on a column at right and of a head with a Phrygian cap at the top are related with another sarcophagus (A. Bosio, *Roma sotterranea...*, Rome, 1632, p. 63).

On the reverse of the sheet there is an exact copy of the figures in the upper relief of a marble sarcophagus from the cemetery of Lucian Effross (A. Bosio, *Roma sotterranea...*, Rome, 1651, p. 432). The drawing's architectural details are reminiscent of the depictions on the side walls of another sarcophagus (*ibid, p.* 310).

It is not easy to place these drawings chronologically. The use of the scroll-passing motif in a study to the 1647 picture, along with the peculiarities of techniques, suggest that they were done in the mid-1640s.

Provenance: H. Brühl collection, Dresden; since 1769, The Hermitage, St. Petersburg.

Scene at a Tripod.

27. *BAPTISM*

Pen and bistre wash over black chalk, 16.5 x 25.4 cm, relined.
The Hermitage, St. Petersburg, inv. No 5081.
Matthew 3:13-17.

This is a sketch for *Baptism,* a painting from the second series of the *Seven Sacraments,* done for Chantelou in 1646 (Duke of Sutherland collection, Scotland; 1960 Paris, No. 71; Blunt 1966, No. 112). The drawing repeats a motif from the first series of the *Seven Sacraments:* Christ being baptized while standing. In the painting from the second series, however, he is shown kneeling on one leg. Of the few existing sketches to this picture (Drawings, 1, Nos. 77, 79, 80, 82), the one most similar to the Hermitage drawing is in the Louvre (Drawings, 1, No. 83, pl. 54), though it does not have the three contemplating figures to the left of the centre.

The drawing can be dated 1644-45.

Provenance: K. Cobenzl collection, Brussels (stamped L. 2858b); since 1768, The Hermitage, St. Petersburg (L. 2061).

123

Christ in the garden of Gethsemane

28. 29. *CHRIST IN THE GARDEN OF GETHSEMANE (AGONY IN THE GARDEN)*

Pen and bistre, 12.5 x 14 cm.
On the reverse: *Apparition of Christ Resurrected*, pen and bistre.
The Hermitage, St. Petersburg, inv. No 8373.
Matthew 26:34-46.

Windsor Castle (England) has a drawing on the same subject (Blunt 1945, No. 196, pl. 46; Drawings, 1, No. 64, pl. 39). A painting on this theme, that previously belonged to Cassiano dal Pozzo and was mentioned by Sandrart, is lost (J. von Sandrart, *Teutsche Academie der Bau-, Bild- und Mahlerey-Künste,* Munich, 1925, p. 258).
Listed in the Hermitage old inventories as a *Group*

of Male Figures by an unknown master, this drawing may be related to a number of Poussin's authentic works. The tragic scene of the Agony in the Garden reflects the strong feelings such themes evoked in the artist. The drawing's inner tension corresponds to its graphic expression: the lines are nervous, sometimes angular, sometimes round; the pressure of the pen accentuates the three-dimensional quality of the figures; and the intersecting shading, so typical of Poussin, goes in all directions. Poussin's manner is most clearly manifest in the representation of the sleeping apostles. The ways of shading the folds of the robes in the *Agony in the Garden* are identical to those in *Medea Killing Her Children* (Windsor Castle, England; Blunt 1945, No. 217, pl. 60; Drawings, 3, No. 223,

pl. 179), as is the rounded modelling of the bodies. These two compositions also share the technique of applying shadows by means of a continuous, unbroken line. The Hermitage drawing is similar to *The Rape of Europa* (Nationalmuseum, Stockholm; Drawings, 3, No. 168, pl. 138) in terms of shading, which is done quickly, going first from right to left and then immediately in the opposite direction. The figure of Christ, looking as if it were drawn in broken geometricized lines, has many analogies: *The Death of Hippolytus* (Drawings, 3, p. 169, No. 222) *Pyramus and Thisbe* (Drawings, 3, No. 225, pl. 163) and *Scene of a Flight* (Hermitage, St. Petersburg). Though done by simpler graphic means and dominated by straight, rather than intersecting, and slightly broken lines, the sketch on the reverse is equally expressive. The placing of the figures in the lower left corner, which is so rare for Poussin, appears in *Battle Scene* in Stockholm's Nationalmuseum (Drawings, 2, No. 135, pl. 106). The drawing can be dated c. 1646, the same time as the sketch *Carrying the Cross* (Musée des Beaux-Arts, Dijon). Blunt (Drawings, 5, p. 78) places it in the late 1630s.

Provenance: H. Brühl collection, Dresden; since 1769, The Hermitage, St. Petersburg.

Nicolas Poussin, *Christ in the garden of Gethsemane.* Royal Library, Windsor Castle.

Nicolas Poussin, *Battle scene, Drawing.* Nationalmuseum, Stockholm.

125

Apparition of Christ Resurrected.

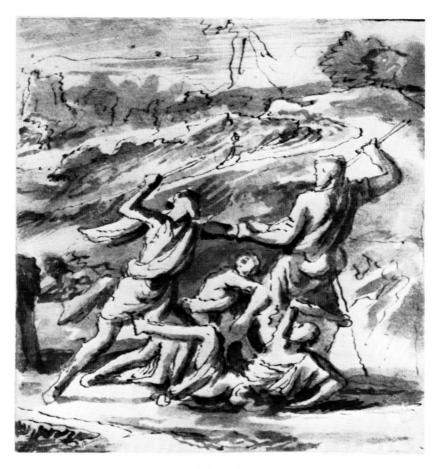

Moses Driving the Sheperds from the Well.

30. *MOSES DRIVING THE SHEPHERDS FROM THE WELL*

Pen and bistre wash, 11.9 x 10.8 cm.
The Pushkin Museum of Fine Arts, Moscow, inv. No 6424.
Exodus 2:16-18.

The drawing, traditionally attributed to Poussin, is a study for Poussin's lost painting, *Moses and the Daughters of Jethro,* datable to 1647-49 (Blunt 1966, pp. 15, 16, No. 17).
There is no mention of Poussin's using this theme in early sources, but indisputable evidence that he did so exists; firstly, a series of nine drawings by Poussin and his studio (Windsor Castle, England; Louvre, Paris; School of Design, Providence; private collection, New York; Pushkin Museum, Moscow) that develop separate motifs and a general composition to the theme (Drawings, 1, Nos. 10-15, A. 3; 5, No. 385; A. Blunt, «Further Newly Identified Drawings by Poussin and His Followers», *Master Drawings,* 1979, 17, No. 2, pp. 119-122, pl. 1);

and, secondly, three identical seventeenth-century engravings on the theme by Antoine Trouvain, Guillaume Vallet and Etienne Gantrel done after a Poussin painting, as an inscription (*N. Poussin pinxit*) appearing on the Trouvain engraving proves (Andresen 1863, Nos. 41-43; reproduced in W. Friedlaender, «Eine neu aufgetauchte Zeichnung zu der Komposition Nicolas Poussins *Moses treibt die Hirten vom Brunnen*», *Belvedere Forum,* 1925, VIII, p. 60; Wildenstein 1955, p. 118, No. 14).
Having analysed the existing drawings, Blunt concluded that Poussin was elaborating two compositional variants of this theme — one, free and animated, and the other more solemn and monumental. The drawing in the Pushkin Museum of Fine Arts is from the final stage of Poussin's work on the subject *Moses and the Daughters of Jethro.* Chronologically, it can be placed between a finished sketch of the entire composition in the Seiden de Cuevas collection (New York), which, in Blunt's opinion, preceded the original in oils (A. Blunt,

«Further Newly Identified Drawings by Poussin and His Followers», *Master Dratings.* 1979, 17, No. 2, p. 121, pl. 1), and a drawing in the Louvre, representing an equally complete, but more spatial and populated version of the same composition (Drawings, 1, No. 15, pl. 9).

In terms of iconography, the grouping of Moses and the shepherds in the Pushkin Museum drawing is almost identical to that in the Louvre one. In the former, however, in the background above the heads of the fighting people, there is a figure of a man walking along the road which is absent in the Louvre drawing, but does appear in the one from the Seiden de Cuevas collection. In addition, the Moscow and New York drawings are done in a similar technique, and both show a sketchy, yet effective use of the pen in combination with brush. The Louvre drawing, on the contrary, is done only with a brush. The detailed character of the Moscow sketch (pointing to its completeness), as well as the depiction of a road, part of a well and mountainous scenery arbitrarily cut off by the edges of the page, suggest, in our opinion, that it is a fragment of a larger composition. It should also be noted that the scale in the Moscow sketch is almost identical to the respective depiction in the drawing from the Seiden de Cuevas collection.

The whole series of drawings on the subject *Moses and the Daughters of Jethro,* including the one from the Pushkin Museum of Fine Arts, can be dated 1647-49.

Provenance: K. Cobenzl collection, Brussels (L. 2858b);
1768-1930, The Hermitage, St. Petersburg-Leningrad;
since 1930, The Pushkin Museum of Fine Arts, Moscow.

Moses Driving the Sheperds from the Well.
Engraving by A. Trouvain from the painting by Poussin.

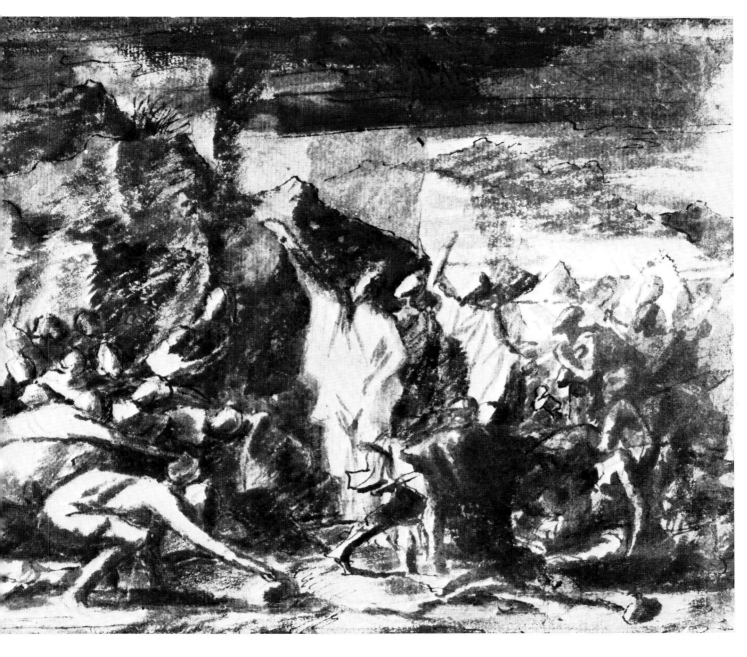

31. MOSES STRIKING THE ROCK

Pen and bistre wash over pencil, and white, 19 x 26 cm.
The Hermitage, St. Petersburg, inv. No 14539.
Exodus 17:5-6.

This is a sketch for the painting *Moses Striking the Rock* (Hermitage, St. Petersburg), which Poussin did for the artist Jacques Stella in 1649. The subject is one Poussin often turned to in different periods of his creative career.

Another *Moses Striking the Rock* (Ellesmere collection, London), commissioned by Melchior Gillier, was painted by the artist in 1636-37. Windsor Castle (England) has a drawing (Blunt 1945, No. 218,

pl. 63; Drawings, 1, No. 28, pl. 17) that is considered to be a sketch for this painting. But, as the date of the Windsor sketch remains unclear, and as certain motifs repeat in both paintings, it is equally possible to connect this drawing with the Hermitage canvas. A comparison of the Hermitage and Windsor drawings shows the evolution of the subject's treatment: both have the figure of Moses in the middle, the rapid motion of the group on the left towards the centre and the similar gestures of the figures quenching their thirst in the foreground. The composition of the Hermitage drawing, however, is more compact, the brightly lit areas anticipate that the light in the painting would come from

129

the left and the figure of Moses is placed in the midst of the crowd rather than separately, on an elevation. The Windsor drawing is thought to be too academic to be among the works by Poussin done around 1637 and should be placed in the late 1640s, the time when the Hermitage painting was executed (Blunt 1945, No. 218; 1960 Paris, No. 220). It is possible that these two sketches are simultaneous versions of the composition.

Provenance: Jean de Jullienne collection, Paris; I. I. Betzkoi collection, St. Petersburg (stamped L. 2878a); Academy of Arts, St. Petersburg; since 1924, The Hermitage, St. Petersburg.

Nicolas Poussin, *Moses Striking the Rock*.
Drawing, Royal Library, Windsor Castle.

32. *MOSES STRIKING THE ROCK*

Pen and bistre wash, 18.5 x 24.5 cm.
On the reverse: sketches for *The Judgement of Solomon*
(Louvre, Paris), pen and bistre, pencil.
The Hermitage, St. Petersburg, inv. No 14539.

Combining two of Poussin's favourite media, pen
and bistre wash, this sketch was done for the paint-
ing *Moses Striking the Rock* (Hermitage, St. Peters-
burg). The final placement of Moses was determi-
ned in this drawing, and the group with the woman
and child and dead young woman (partially cut off)

was elaborated in detail and later introduced into
the picture without any changes.
The drawing can be dated c. 1649.
There is a preliminary drawing to the Hermitage
painting, similar and rather finished, in the Louvre
(Drawings, 1, p. 13, No. 26, pl. 16), and a rough
sketch to it in the Nationalmuseum, Stockholm
(Drawings, 1, No. 26, pl. 14).
The reverse has four quick sketches for the Louvre
painting *The Judgement of Solomon* (1 Kings 3:
16-28) done for Pointel in 1649 (1960 Paris, No.
87; Blunt 1966, No. 35). They represent the art-

131

ist's first attempts to find the future composition, which was later developed in a drawing from the École des Beaux-Arts collection in Paris (Drawings, 1, No. 32, pl. 20; 1960 Paris, No. 218).

Three of the drawings outline a dramatic scene: a woman stretching out her arms towards Solomon as an executioner lifts a sword over the child; the forth one has an expressively postured woman with a dead child on her lap, which, though reappearing in the Paris drawing, was changed in the picture. The Louvre also has a preliminary drawing to *The Judgement of Solomon,* but it is in poor condition (Drawings, 1, No. 33, pl. 19).

Provenance: Jean de Jullienne collection, Paris; I. I. Betzkoi collection, St. Petersburg (stamped L. 2878a); Academy of Arts, St. Petersburg; since 1924, The Hermitage, St. Petersburg.

Nicolas Poussin, *Moses Striking the Rock.*
Drawing, Nationalmuseum, Stockholm.

33. *MOSES STRIKING THE ROCK*

Oil on canvas, 122 x 192 cm.
The Hermitage, St.Petersburg, inv. No 1177.
Exodus 17:5-6.

Poussin turned repeatedly to the Biblical story of Moses, resulting, according to Blunt, in a series of not less than eighteen paintings.

Certain aspects of the interpretation given the scene in the Hermitage version were rejected by Jacques Stella, who commissioned the painting, as well as by some of Poussin's contemporaries. The subject of the dispute concerned a rock split in half with a stream of water profusely pouring out of the crack-details not given in the Bible. In a letter written in September 1649 to Jacques Stella (Corr. 1911, pp. 406, 407) Poussin, saying he was educated enough to interpret things as he perceived them, defended his right to do so. Considering that the artist always thoroughly studied a literary source, it can be stated with assurance that this case was no exception. Poussin did not only refer to the text of the Bible; it is quite possible that he was familiar with the Latin translation of *Jewish History* by Joseph Flavius, where the episode in question is described in greater detail: «Moses hit the rock with his staff and the same instant it broke into two parts and the purest water ran from it in great profusion» (quoted from: *Histoire des Juifs, écrite par Flavias Josèphe, sous le titre des Antiquités Judaïques,* Amsterdam, MDCC, p. 65). This description could have served as a source for the Hermitage painting. *Moses Striking the Rock* is devoted to the theme of suffering and salvation. Emphasised by the red of his robe, the figure of Moses, his posture symbolising creative willpower, dominates the left side of the picture. Surrounding him are his grateful followers, amazed and full of admiration. The thirsty people have been placed on the right and are rushing towards the life-giving stream. The most interesting figure among this group is the young woman passing a vessel towards the spring and at the same time consoling those who are too weak to approach it. The image of this woman personified such noble traits of human nature as mercy and concern for one's fellow man, which Poussin believed should be preserved even in the time of severest trial.

The preliminary stage of the quest for the most effective composition is reflected in a few existing drawings, two of which are in the Hermitage, one in the Louvre and one more in the Nationalmusem, Stockholm.

A version of the composition on the same theme belongs to the Duke of Sutherland's collection (on loan to the National Gallery of Scotland, Edinburgh).

Poussin's contemporaries: Bellori, Félibien, Loménie de Brienne and Baldinucci, as is evidenced by their own statements, thought highly of the painting's artistic merits. Further evidence of the picture's fame is provided by the great number of copies and engravings made from it. Blunt mentions nine copies: 1. H. Walker collection, Brookman Park; 2. Private collection, Dublin; 3. Private collection, Edinburgh; 4. Private collection, New York; 5. Private collection, Washington; 6. One made by Stella when the picture was kept in his collection; 7. One mentioned in 1742 as being part of R. Barrett's collection; 8. Convent of the Blancs-Manteaux, Paris, confiscated in 1790; 9. P. Norton collection, Manchester exhibition (1857).

Engravings: 1. C1. Bouzonnet-Stella (Andresen 1863, No. 57; Wildenstein 1955, No. 19); 2. Anonymous, published by E. Gantrel (Andresen 1863, No. 58); 3. J.-B. Michel (Andresen 1863, No. 59); 4. Anonymous, published by Poilly (Andresen 1863, No. 60); 5. Anonymous, published by Audran (Andresen 1863, No. 61); 6. G. Kilian (Andresen 1863, No. 62)

Provenance: 1649, owned by Jacques Stella, then his niece Claudine Bouzonnet-Stella, who left it to M.-A. Molandier; 1697, sold at an auction; c. 1733, Robert Walpole collection, Houghton Hall, England; since 1779, The Hermitage, St. Petersburg.

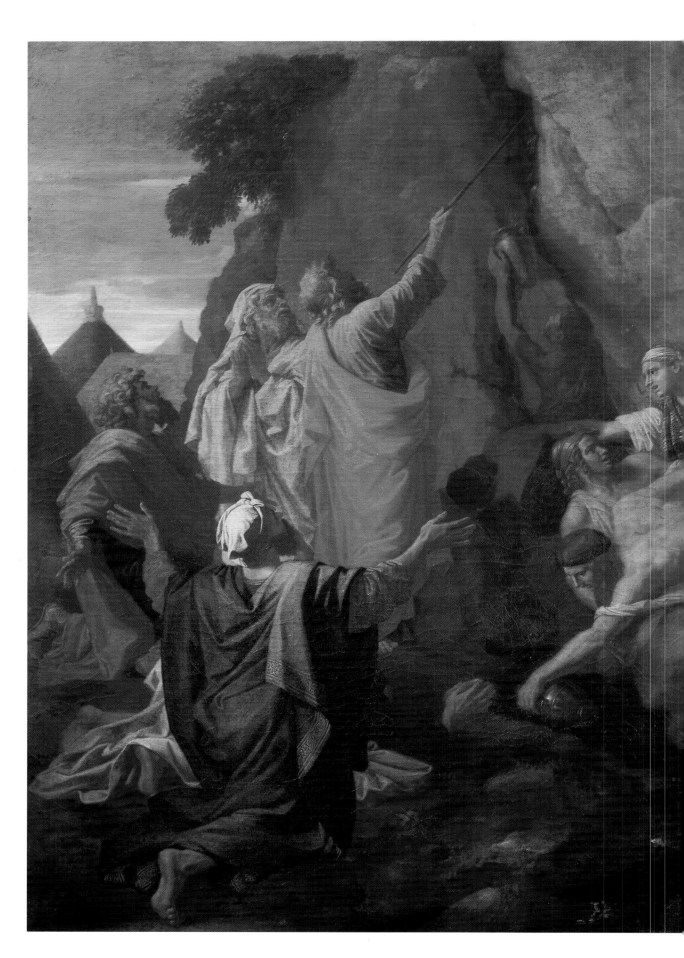

Moses Striking the Rock.

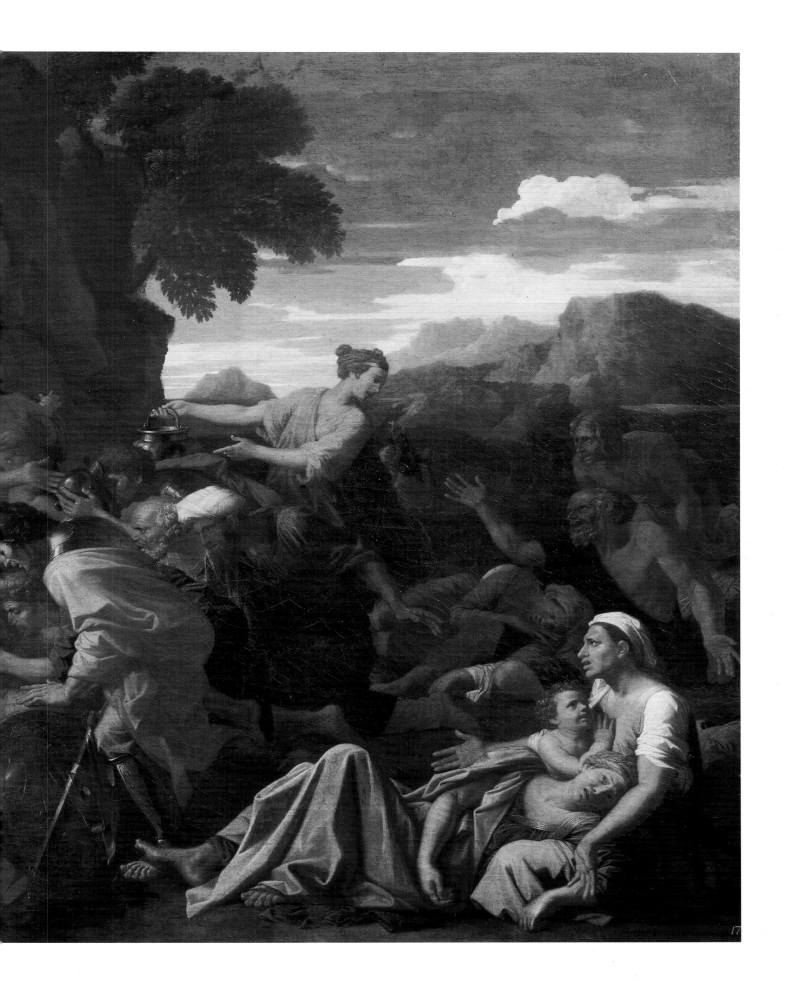

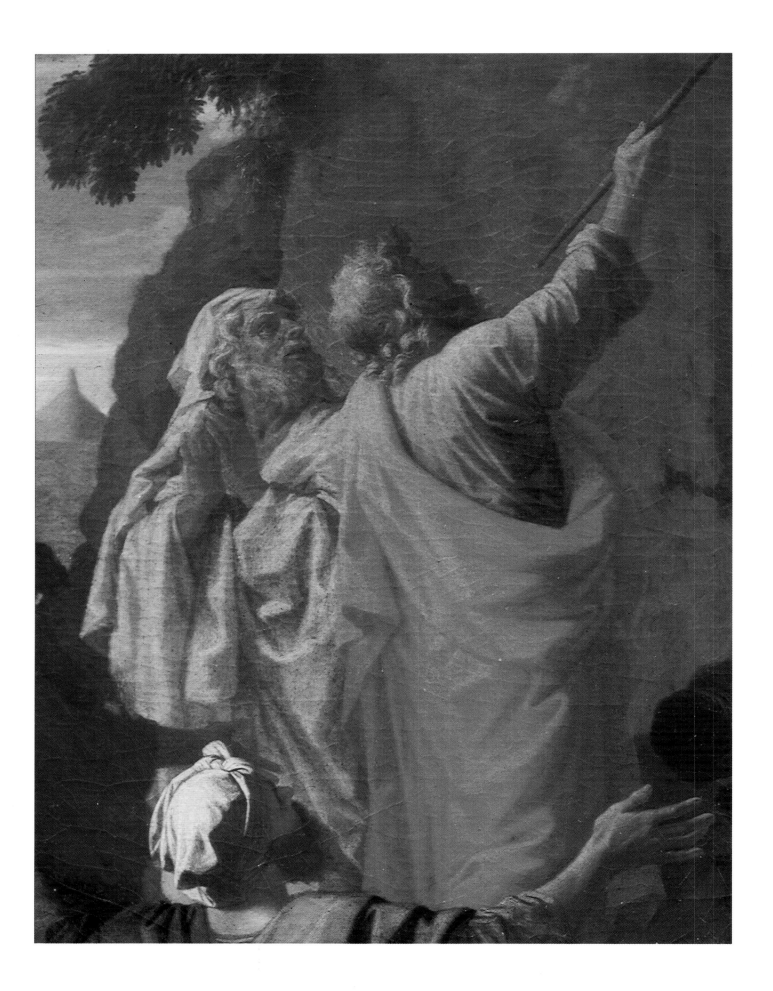

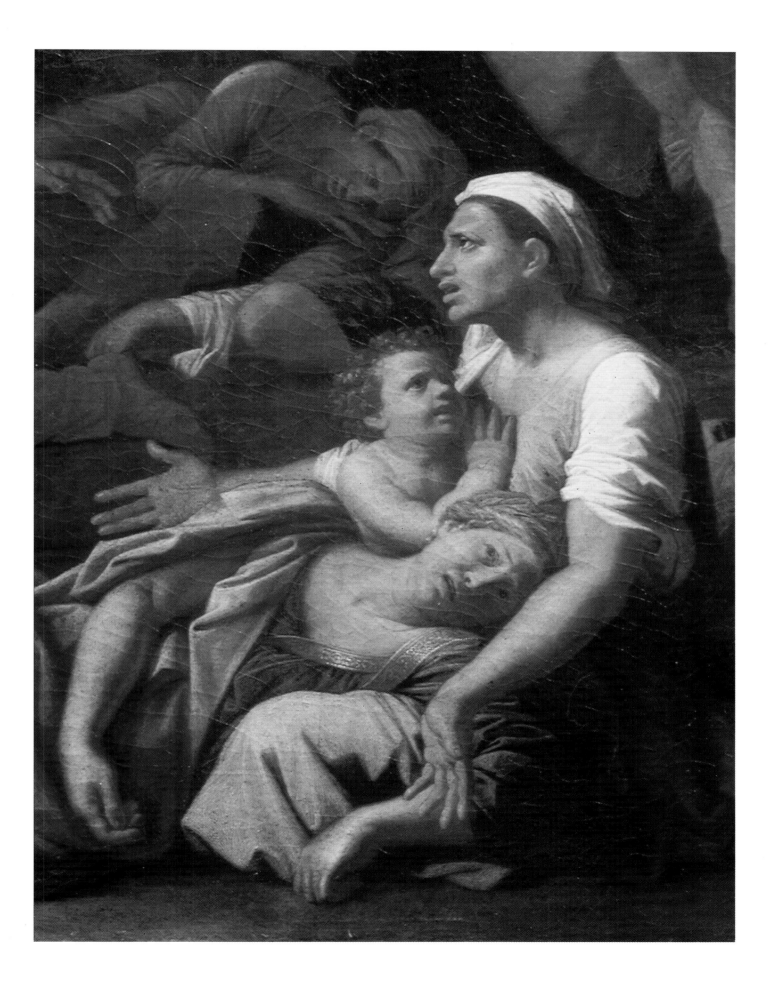

34. CERES SEEKING PROSERPINA

Pen and bistre wash, 16.3 x 22.8 cm, relined.
Inscribed in pencil on the bottom:
the number *469* on the left and the name *Romano* on the right.
The Pushkin Museum of Fine Arts, Moscow, inv. No 6712.
Ovid, *Fasti* 4:393-620.

Ascribed to Giulio Romano when it was acquired by the museum, the drawing was reattributed to Poussin by Maiskaya (1977), and this was confirmed by Blunt in a letter dated November 25, 1981. The drawing is one of a large series done from classical monuments and shows a front of a relief on a Roman sarcophagus acquired in the mid-seventeenth century by the Rospigliosi and now in Palazzo Rospigliosi, Casino del Aurora, Rome (P. P. Bober and R. Rubinstein, *Renaissance Artists and Antique Sculpture,* London, 1986, p. 56, No. 9, pl. 9i). The relief was engraved and reproduced in the edition *Galleria Giustiniana del Marchese Vincenzo Giastiniani, vol.* 2, Rome, s.a., pl. 73; see also [P. S. Bartoli] *Admiranda romanorum antiquitatum, ad veteris sculpturae vestigia... Pietro Sancti Bartolo delineata incisa... Pietro Bellori illustrata,* Rome, 1693, pls. 53, 54. Like many of Poussin's drawings from classical monuments, this one may have been done not from the sarcophagus, but after the illustrated inventory of the Marquis's collection whose first volume was published in 1637, followed, a few years later, by a second one. A comparison of the Moscow drawing with the original displays the characteristic liberties taken by Poussin when copying a classical monument, *i.e.,* Ceres's long torch is turned into a vessel-like object; the overturned basket of flowers at the bottom of that tree is placed between the figures of Diana and Venus; and the chariot, originally adorned with a lion's head, is decorated with a woven ornament.
A drawing (Musée Condé, Chantilly) from the same relief (sarcophagus with the story of Proserpina) is closer to Bartoli's engraving. Done by one of Poussin's followers, it was introduced into a catalogue by Blunt as a «possible copy from the lost original» (H. Malo, *Chantilly, Musée Condé, 102 dessins de N. Poussin,* Paris, 1933, No. 77; Drawings, 5, p. 52, No. A. 156 repr. in Blunt, 1974, pl. 17). Tracing in the Chantilly drawing some reminiscences of Poussin's style of the late 1640s, Blunt made the assumption that the «lost original» goes back

to the same period. After seeing a photograph of the Pushkin Museum drawing, he revised that to a later date: some time in the 1650s. Keeping in mind all the difficulties of chronologically placing Poussin's drawings from the antiques due to their lack of stylistic evolution (Blunt 1979, p. 147), we, nonetheless, are inclined to admit that the drawing has an earlier date. Its high artistic merits, luminosity and boldness of line allow us to refer it to the second half of the 1640s, a period following the publication of the second volume of *Galleria Giustiniana.*
A motif from the same sarcophagus relief with the story of Proserpina was developed in another of Poussin's drawings of the late 1640s, a dramatic composition *The Rape of Proserpina* from the M. Robert Lebel collection in Paris (Blunt 1979, p. 122, footnote 10, pl. 2). Though the Paris drawing is undoubtedly inspired by a different episode of the relief (P. S. Bartoli, *op. cit.,* pl. 53), it bears, in spite of the different aims set by the artist, a certain affinity with the Moscow one, as its dimensions (16.8 x 25 cm) indirectly show.
Blunt also feels that the representations of the snakes driving Ceres's chariot were further developed in a drawing from the Musée Bonnat, Bayonne (Drawings, 5, pp. 41, 42, No. 345, pl. 265; Blunt 1976, p. 135).

Provenance: Princes Youssoupov collection, St. Petersburg; 1925-30, The Hermitage, Leningrad-St. Petersburg; since 1930, The Pushkin Museum of Fine Arts, Moscow.

Ceres Seeking Proserpina.

140

35. LANDSCAPE WITH POLYPHEMUS

Oil on canvas, 150 x 198 cm.
The Hermitage, St.Petersburg, inv. No 1186.
Ovid, *Metamorphoses*, XIII, 760-856.

This was a favourite subject for many Renaissance and seventeenth-century artists. The most famous examples are Raphael's fresco *Triumph of Galatea* in Villa Farnesina and the two frescoes by Annibale Carracci in Palazzo Farnese, *Polyphemus and Galatea* and *Anger of Polyphemus*, sources of numerous imitations. As for Poussin, he was attracted by a different episode from the story, the song of Polyphemus. Of the many who have offered interpretations, Blunt (1967) suggested the possibility of the painting being an allegory depicting different historical epochs: Polyphemus symbolises the time preceding the discovery of crop-growing, while, closer to the viewer, are figures cultivating land and shepherding flocks; nymphs and satyrs personify nature's hidden forces. Another interpretation was given by Kozhina (1983). Insisting on the special significance of the tragic outcome, which, though not present in the picture, is inevitable according to the plot, she draws an analogy between the *Landscape with Polyphemus* and some other works by Poussin — *Landscape with Orpheus and Eurydice* (Louvre, Paris) and *Landscape with the Body of Phocion Carried out of Athens* (Earl of Plymouth collection, Oakly Park, Shropshire) — stressing the similarity of their messages, *i.e.*, the contraposition of the individual catastrophe and the eternity of nature.

Landscape with Polyphemus is traditionally connected with *Landscape with Hercules* (Pushkin Museum of Fine Arts, Moscow). They were purchased at the same time from the Marquis de Conflans and have similar dimensions. They were also listed as companion pieces in the catalogue of 1916 and the Hermitage catalogue of paintings of 1958, and considered a pair by such experts on Poussin as Smith (1837), Magne (1914), Friedlaender (1914) and Grautoff (1914). Alpatov (1965), on the other hand, thought that what brought them together were formal affinities, rather than similarity of content. The controversy surrounding the problem increased after both paintings were displayed in the Louvre in 1960 and compared with other Poussin landscapes. The first thing to be questioned were the dates. Disregarding Félibien's

information that *Landscape with Polyphemus* was painted by the artist for Pointel in 1649, Mahon (1961), on the basis of its stylistic similarity with *Landscape with Orion* (Metropolitan Museum of Art, New York), suggested a new date, 1658. This date was refuted by both Thuillier and Blunt. Blunt (1960) supported the former date of 1649, yet placed *Landscape with Hercules* in 1655. All the experts admit that the pictures may comprise a set, but were executed at different times. In 1969 Hans Willem van Helsdingen published an article in which he tried to prove that the St. Petersburg and Moscow paintings make up a pair. Kozhina (1983) rejects this supposition. She refers to the inventory of paintings belonging to the art lover and banker Pointel, mentioned by Félibien as the commissioner and first owner of *Landscape with Polyphemus*, in which there is no record of the *Landscape with Hercules*. Kozhina's attempt to find another picture that may have made up a set with the Hermitage canvas is of interest; pointing to the coincidence of their messages, she suggests that this could be *Landscape with Orpheus and Eurydice* (Louvre, Paris), which was painted around 1650 (*i.e.*, shortly after *Landscape with Polyphemus*) and as is shown by the recently published inventory of the Pointel collection (Thuillier, Mignot 1978), initially had similar dimensions (150 x 200 cm).

The story of Count Dmitry Golitsyn's purchase of *Landscape with Polyphemus* and *Landscape with Hercules* for Catherine the Great from the Marquis de Conflans is given in a letter dated July 17, 1772, from Denis Diderot to François Tronchin. Describing the picture, Diderot mentioned Acis and Galatea as being among the characters portrayed. Later this remark was more or less forgotten and for a long time all the figures in the foreground were considered to be satyrs and nymphs. The supposition that depicted among them may be Galatea, to whom Polyphemus addressed his song, and her beloved Acis was made by Friedlaender (1965). He thinks that Galatea is the central figure of the group hiding behind a rock, whose unusual bluish hair shows her descent from Nereus, a god of the sea.

Windsor Castle (England) has a drawing representing another compositional variant of three nymphs sitting by the side of a stream. There is an old copy of *Landscape with Polyphemus* in the Prado,

Madrid (inv. No. 2322). Mabilleau (1895) considered it to be a sketch for the Hermitage painting, and the Prado catalogue of 1942 listed it as the original from which a bigger replica belonging to the Hermitage was done. Blunt (1966) mentioned seven more copies that appeared at different auctions. *Landscape with Polyphemus* was engraved by E. Baudet at the end of the seventeenth century (Andresen 1863, No. 440; Wildenstein 1955, No. 178).

Provenance: before 1772, Marquis de Conflans collection; since 1772, The Hermitage, St. Petersburg.

Landscape with Polyphemus.
Engraving by Etienne Baudet from the painting by Poussin.

Nicolas Poussin, *Landscape with Orion*. Metropolitan Museum of Art, New York.

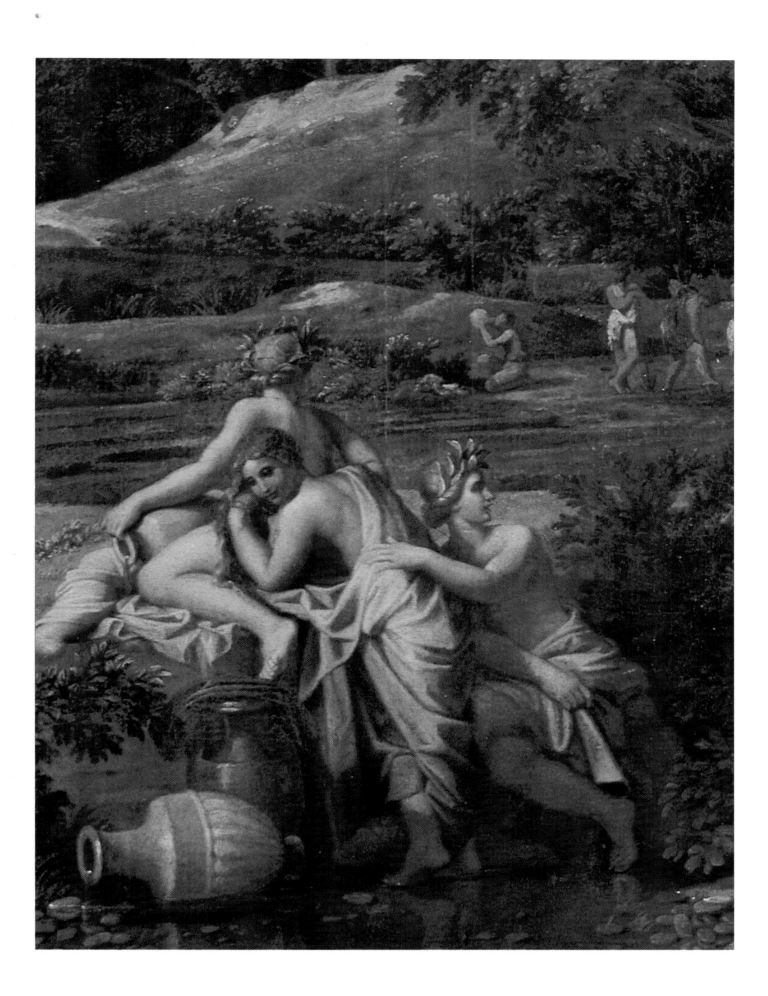

Landscape with Polyphemus.

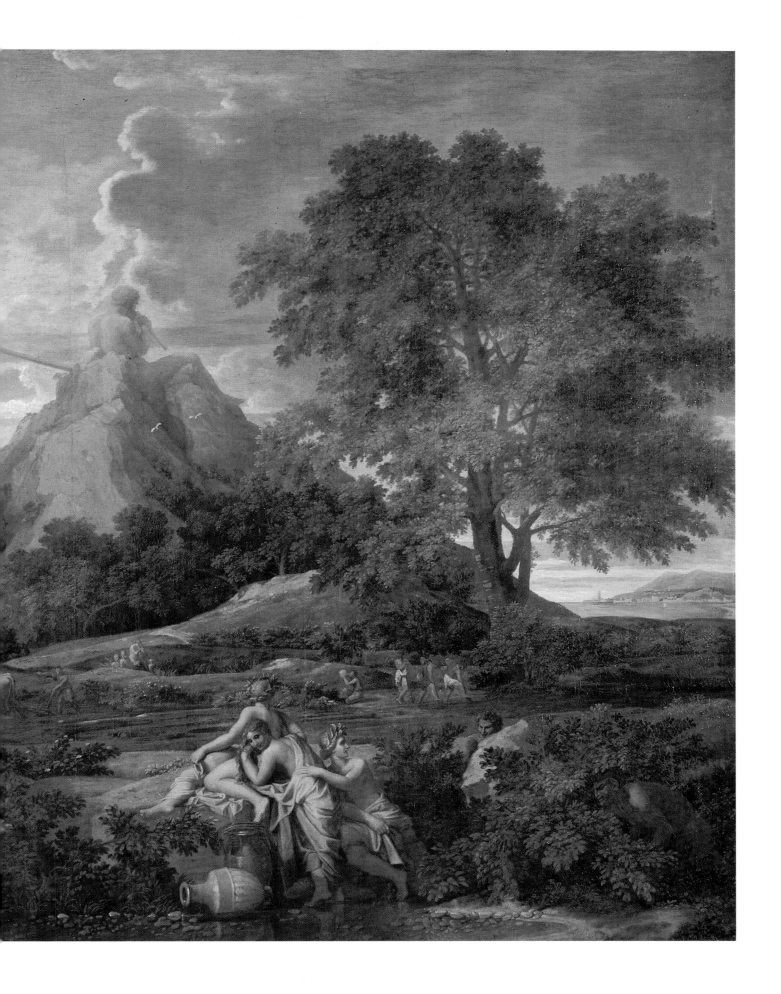

Landscape with Hercules.

36. LANDSCAPE WITH HERCULES

Oil on canvas, 156 x 202 cm.
The Pushkin Museum of Fine Arts, Moscow, inv. No 2763.
Virgil, *Aeneid*, XIII, 190-270.

Hercules, having single-handedly defeated the giant Cacus, throws him off the Aventine Hill, one of the seven hills on and about which the city of Rome was later built. The victory of Hercules symbolises the triumph of good over evil.

The history of *Landscape with Hercules*, which all art researchers consider to be Poussin's summit, remains unclear. Strangely enough, the picture was never engraved or mentioned in any written source. The painting entered the Hermitage in 1772. It was bought by Diderot for Catherine the Great from the Marquis de Conflans in Paris, together with *Landscape with Polyphemus*.

The pictures' dimensions, theme and composition for a long time supported the idea that they were companion pieces. However, following a more detailed analysis carried out in connection with the Tercentenary of Poussin's Death, this traditional opinion was questioned.

According to Félibien, *Landscape with Polyphemus* was done in 1649 for the Parisian banker Pointel, but there was no *Landscape with Hercules* in his collection, as evidenced by the inventory made after Pointel's death. Moreover, both landscapes — as has been established by Mahon (1961) and later confirmed by Blunt, Thuillier and many other art historians — refer, stylistically, to different periods of Poussin's career. Even if we assume that *Landscape with Polyphemus* was painted in 1650-51, the Moscow picture should be dated by 8-10 years later. The arrangement of the first landscape, which is permeated with an idyllic serenity, is remarkable for its clarity, symmetry and well-balanced parts. On the contrary, *Landscape with Hercules* emanates inquietude and alarm; the symmetry is broken and all the forms seem to be invested with a pulsating inner rhythm. Instead of the division of space into clear-cut planes, characteristic of *Landscape with Polyphemus*, we see here a complete fusion of all the component parts of the picture with its space unfolding depthwise along the diagonal. The brushstroke itself changes too, approximating in character the paintings of the artist's last years (the *Four Seasons* series, 1660-64). All this, however, does not allow us to totally exclude some points of simi-larity between two famous works. Their different dates cannot serve as a definitive proof of their independent status. We can assume that the artist may have realized his concept in a pendant several years after the execution of the first picture. In any case, the splendid and mysterious canvas by Poussin still awaits further research.

Provenance: before 1772, Marquis de Conflans collection, Paris; 1772-1930, The Hermitage, St. Petersburg-Leningrad; since 1930, The Pushkin Museum of Fine Arts, Moscow.

37. ACHILLES ON THE ISLAND OF SCYROS

Pen and bistre over pencil, 16 x 20.2 cm, relined.
Inscribed in a later hand, bottom right: *Poussin*.
The Hermitage, St. Petersburg, inv. No 5140.
Ovid, *Metamorphoses*, XIII, 162.

This is a preliminary drawing for the painting *Achilles and the Daughters of Lycomedes* done by Poussin in 1656 for Charles III, Duc de Créqui, the French ambassador in Rome (Museum of Fine Arts of Virginia, Richmond; 1960 Paris, No. 111; Blunt 1966, No. 127).

The characters in the drawing are placed slightly differently than they are in the painting.

This drawing differs from the similarly entitled piece (Pl. 38) by greater expression. This is first of all manifest in its dynamic composition: in the drawing of 1650 the composition is enclosed and the characters are moving towards the centre. In addition, Poussin shifted the figure of Deidamia to the right foreground, and her frightened gesture caused by Achilles's unexpected behaviour reveals clearly the substance of the subject. The line also changes, becoming quivering and nervous.

Provenance: H. Brühl collection, Dresden; since 1769, The Hermitage, St. Petersburg.

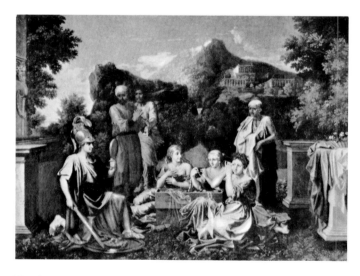

Nicolas Poussin, *Achilles and the Daughters of Lycomedes*. Museum of Fine Arts, Boston.

Achilles on the Island of Scyros.

38. ACHILLES ON THE ISLAND OF SCYROS

Pen and bistre over pencil, 15.3 x 19.4 cm.
Inscribed in a later hand, bottom right: *Poussin.*
The Hermitage, St. Petersburg, inv. No 5136.
Ovid, *Metamorphoses.* XIII, 162.

The drawing is a sketch for the picture *Achilles and the Daughters of Lycomedes* (Museum of Fine Arts, Boston; Blunt 1966, No. 126), dated c. 1650. The Boston painting differs considerably from the Hermitage drawing: the main figures, Achilles and Deidamia, are placed closer to the foreground, and the hero is pulling out his sword from its sheath while kneeling on one knee rather than standing as in the drawing.

The reverse carries a text, which, judging by the handwriting, is a fragment of a draft of a letter written by Poussin around the 1650s, and which is further proof of the drawing's authenticity (Drawings, 2, No. 104, pl. 83) and the date of execution. Cut off on all four sides, the letter has neither an address nor a date, and is not connected with the drawing's theme. Its content is close to a letter dated August 29, 1650 to Chantelou (Corr. 1911, p. 481): Poussin tells of his intention to write a treatise on the theory of painting and mentions a letter he received that praised and honoured him. On the basis of this passage, which is not very clear, Blunt decided that Poussin's addressée was not Chantelou, but another correspondent Roland Fréart de Chambray (Blunt 1977, No. 126), the French translator of Leonardo's *Treatise on Painting* and the author of a preface to it containing high-flown praise of Poussin. According to Blunt, Chambray sent his text to the artist a year before it was published in 1651. This explains the last line of the letter that previously seemed so incongruous: «Figures done some time ago [by me] for Leonardo's book...» (here the text of the letter is cut off).

It is this fragment of Poussin's letter, as well as a link with the painting, that help date the Hermitage drawing c. 1650.

Provenance: H. Brühl collection, Dresden; since 1769, The Hermitage, St. Petersburg.

Achilles on the Island of Scyros.

39. *MUCIUS SCAEVOLA BEFORE PORSENA*

Pen and bistre, 13.2 x 14 cm, relined.
Inscribed in a later hand, bottom right: *Poussin*.
The Hermitage, St. Petersburg, inv. No 5146.
Plutarch, *Lives*, 6, 17.

The drawing was perhaps inspired by Raphael's ceiling painting in the Stanza della Segnatura (Vatican, Rome) where this subject also occurs. Blunt links Poussin's turning to the themes of civic valour in his late period with his interest in the philosophy of the stoics. The drawing's manner, its minute detail and the placement of such a multifigured composition on a small sheet prompt its later date, the second half of the 1650s.

Provenance: H. Brühl collection, Dresden; since 1769, The Hermitage, St. Petersburg.

156

40. *VICTORY AND FAME*

Pen and bistre, 15.4 x 10.8 cm.
The Pushkin Museum of Fine Arts, Moscow, inv. No 6426.

The attribution to Poussin is traditional. It is the second known drawing by the artist that develops the theme of *Victory and Fame;* the first belongs to Stadelsches Kunstinstitut in Frankfurt am Main, a copy of which is kept in the Cabinet de Dessins of the Louvre (Drawings, 2, No. 152).

The Moscow drawing, whose dimensions are larger than those of the Frankfurt one, represents a different and perhaps an earlier version of the composition. Unlike the Frankfurt drawing, wherein the winged figure of Victory is shown standing up, the one in Moscow shows her sitting, with a different position of hands, and holding a tablet with writing on it. The figure of trumpeting Fame in the Moscow drawing is depicted in profile, rather than a three-quarter view as in the Frankfurt one. Instead

of a winged putto leaning on an urn in the lower right corner, the Moscow drawing has another tablet with writing on it, while the winged putto is seen inside a sarcophagus behind Victory.

Blunt pointed out that the figure of Victory in the Frankfurt drawing harks back to Roman prototypes (S. Reinach, *Repertoire de la statuaire grecque et romaine,* vol. 1, Paris, 1908, p. 348). The impact of classic sculpture also determines the iconography and compositional structure of the Moscow drawing. Mentioning the similarity between the posture of Victory in the Frankfurt drawing and the figures on the frontispieces of the books by Virgil and Horace, done by Poussin during his second stay in Paris, Blunt, on the basis of stylistic traits (trembling line), refers it to a later date, c. 1650.

Provenance: K. Cobenzl collection, Brussels (L. 2858b); 1768-1930, The Hermitage, St. Petersburg (L. 2061); since 1930, The Pushkin Museum of Fine Arts, Moscow.

41. 42. *THE HOLY FAMILY UNDER THE TREES*

Pen and bistre, 12.8 x 16.5 cm.
Inscribed in a later hand, bottom left: *Poussin.*
On the reverse: *Hercules Shooting Birds,* pen and bistre.
The Hermitage, St. Petersburg, inv. No 5152.

The distribution of the figures, their postures and the presence of trees in the background are similar to those in the painting *The Holy Family with St. John and St. Elizabeth in a Landscape* (Louvre, Paris), which in the catalogue of the Poussin exhibition in Paris (1960 Paris, No. 104) is dated 1653-54. The group of children resemble those on the right side of the picture *The Holy Family with Ten Figures* done for Pointel in 1649 (National Gallery of Ireland, Dublin; T. Bodkin, «Nicolas Poussin in the National Gallery, Dublin», *The Burlington Magazine,* 1932, 1, p. 174; Blunt 1966, No. 59; 1960 Paris, No. 86). The technique of the Hermitage

drawing is analogous with that of the sketch to the painting *The Holy Family with a Basin* (Fogg Art Museum, Harvard University, Cambridge, Mass.; Drawings, 1, No. 655, pl. 34; 1960 Paris, No. 101; Blunt 1966, No. 34).

The sketch on the reverse is close in subject-matter to those for the painting of the Grande Galerie of the Louvre (1641-42). A drawing for the Grande Galerie depicts Hercules poised to shoot an arrow at iron-clawed birds flying over his head (Drawings, 4, A 95, pl. 192). The later version of this theme depicted in the Hermitage drawing has some features in common with the sketches on the reverse of a copy of *The Ecstasy of St. Paul* in the Louvre (Drawings, 1, p. 38, A17, pl. 71). This quick yet extremely expressive drawing can be dated c. 1650, judging by the broken line, which was characteristic of the artist's technique at the time.

Provenance: H. Brühl collection, Dresden; since 1769, The Hermitage, St. Petersburg.

43. *THE HOLY FAMILY*

Pen and bistre, 11 x 9 cm, relined.
Inscribed in a later hand, bottom right: *Poussin.*
The Hermitage, St. Petersburg, inv. No 5132.

The composition's diagonal structure, the charac-
ters' free postures and the figure of St. Joseph are
reminiscent of Poussin's early works on the theme
of *The Holy Family.* Its manner, however, testifies
to a later date of execution.

Provenance: H. Brühl collection, Dresden; since 1769,
The Hermitage, St. Petersburg.

160

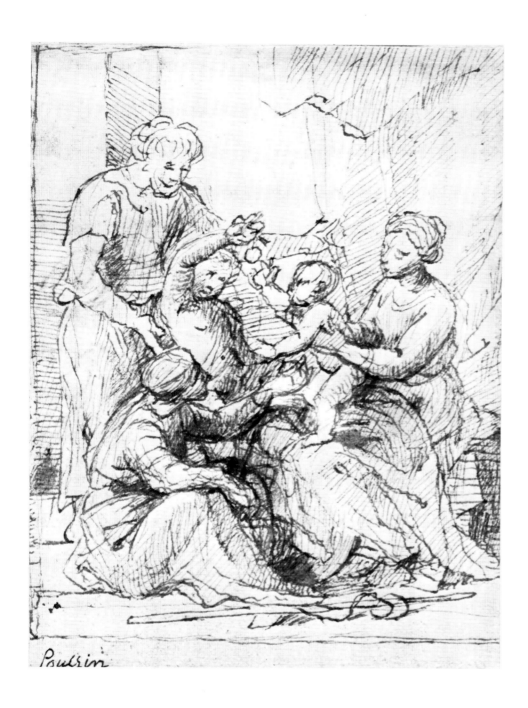

44. *THE HOLY FAMILY WITH A APPLE*

Pen and bistre, 17.2 x 12.5 cm, relined.
Inscribed in a later hand, bottom left: *Poussin*.
The Hermitage, St. Petersburg, inv. No 5151.

The drawing's shading is quite varied and much more thoroughly done than in other versions of the same theme.
On the grounds of style, the drawing may be dated to the mid-1650s.

Provenance: H. Brühl collection, Dresden; since 1769, The Hermitage, St. Petersburg.

45. THE HOLY FAMILY WITH ST. ELISABETH AND ST. JOHN THE BAPTIST

Oil on canvas, 174 x 134 cm.
The Hermitage, St. Petersburg, inv. No 1213.

On the basis of the artist's letters to Chantelou, the painting is dated 1655.

Blunt considered the style of the picture typical of Poussin's late period, while Friedlaender (1966) emphasised Raphael's unquestionable influence, mostly manifested in the strict composition. Thuillier (1974), on the other hand, stressed that it was precisely at this time that Poussin started moving away from Raphael's influence in a search for more monumental expressive means. It is true that even in comparison with *The Holy Family with St. John* (John and Mable Ringling Museum, Sarasota, Florida) painted a little earlier, the Hermitage canvas is more balanced, serene and grand. These traits were in tune with Poussin's style in the second half of the 1650s.

In 1914 Friedlaender identified the Hermitage painting as the *Grande Vierge*, or the so-called *Madonna Chantelou*. This view was questioned that same year by Grautoff, but was later accepted by all the experts.

The picture was commissioned by Chantelou back in 1647. It was finished and sent to Poussin's patron in 1655. Poussin and Chantelou corresponded over all those years and constantly referred to the work on the picture (Corr. 1911).

In the first letter, dated December 22, 1647, Poussin wrote that he wanted to «rack his brains» in order to come up with a new interpretation of the theme. In the letters of 1648-49 the artist mentioned that he had not forgotten his promise concerning a Madonna and was going to start work on it as soon as possible, but that he was always forced to postpone the plan either because he was too busy (letters of March 23, 1648; February 7, 1649; October 8, 1649; December 3, 1651) or because of events in France (letters of May 2 and 24, 1649; November 10, 1652). He also said that he wanted to think over and paint the best possible picture for his friend using all his abilities and talent (letters of August 2 and December 19, 1648), and that he was looking for the «idea of representation» (November 22, 1648). A letter dated January 17,

The Holy Family. Engraving by A. Voet from the painting by Poussin.

162

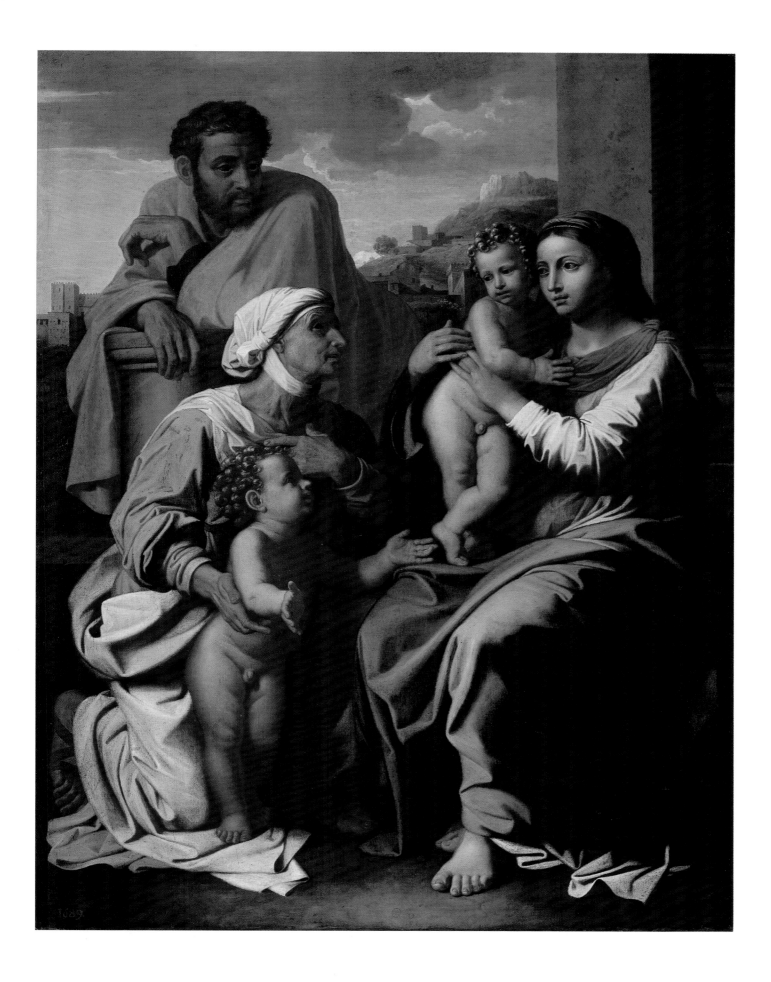

1649 informed Chantelou that he had arrived at the picture's composition, but something must have intervened, because four years later (February 16, 1653) he wrote saying that he «had found the idea of the Virgin» (most likely, a new one), and in May of the same year — that he had definitely settled on this idea. Finally, on June 26, 1655, Poussin wrote announcing that the picture had been sent and asked Chantelou to let him know his opinion of it.

A version of the same theme that can be considered the closest to the Hermitage painting is *The Holy Family with St. John* (John and Mable Ringling Museum, Sarasota, Florida). This is the very picture mentioned by Poussin in a letter of August 29, 1655 to Chantelou. It embodies Poussin's idea of the Grande Madonna and, like the Hermitage painting, reveals the strong influence of Raphael. The schemes of both pictures are similar, yet the composition of the Hermitage one is more complete and has greater integrity. For Poussin, the traditional Gospel subject of the Holy Family was more like a generalisation, not so much expressing religious feelings, but symbolising people's spiritual closeness and affinity. In spite of the images' special grandeur, the painting is above all a representation of a family of people united by love.

The Hermitage has two preliminary drawings: one to this painting and one to the painting in the Sarasota museum. In these drawings the «quests for the idea» of the composition can be traced. The first one (inv. No. 5131) is placed approximately in the second half of the 1650s, the other (inv. No. 5142) in the mid-1650s.

Blunt mentioned three copies with a similar composition, wherein the analogous figures are placed in a landscape: 1. Formerly in the Liechtenstein collection, Vienna (Grautoff 1914, 1, p. 271; 2, p. 282); then Christie's, London, 2.2. 1945, lot 82; Sotheby's, London, 17.12.1947, lot 90; 2. Christie's, London, 18.1.1887, lot 866; Christie's, London, 29.1.1960, lot 56; 3. Private collection, London.

Engravings: 1. Fr. Poilly (Andresen 1863, No. 129; Wildenstein 1955, No. 50); 2. A. Voet (Andresen 1863, No. 130; Wildenstein 1955, No. 49).

Provenance: 1655, owned by Chantelou, Paris; 1720, possibly Count Fraula collection, Brussels; 1738, De Vos sale, Brussels; c. 1739, purchased in Paris through Lord Waldegrave for Robert Walpole; 1779, purchased for the Hermitage from the Robert Walpole collection, Houghton Hall (England).

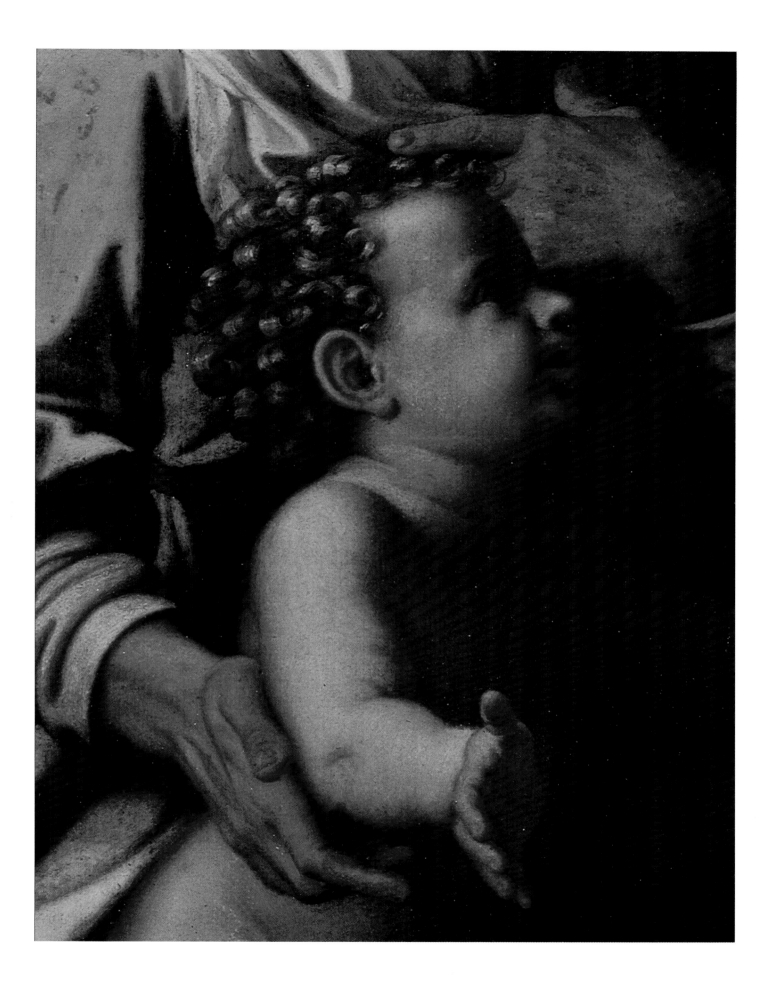

46. THE HOLY FAMILY WITH ST. JOHN AND ST. ELISABETH

Pen and bistre, 14.3 x 11 cm, relined.
Inscribed in a letter hand, bottom right: *Poussin*.
The Hermitage, St. Petersburg, inv. No 5142.

This is a sketch for the painting *The Holy Family with St. Elizabeth and St. John the Baptist* finished in 1655 (Hermitage, St. Petersburg).
Beginning in 1647 the artist often mentioned this picture in his letters. When searching for a scheme that would suit him, Poussin first «got into the mood», and then «finally found the idea» (*j'ai trouvé la pensée*) (Corr. 1911, pp. 376, 428, 433), which usually meant that the new composition was fixed in a drawing. This remark of Poussin's could just as well have been made in reference to this drawing, as its placement of figures almost exactly coincides with the picture. A somewhat dry and reserved style of pen shading and a strict, bold composition give further support for dating the drawing to the mid-1650s. In a way, this drawing marked the culmination of *The Holy Family* theme so prominent in Poussin's graphic art for more than twenty years.

Provenance: H. Brühl collection, Dresden; since 1769, The Hermitage, St. Petersburg.

47. THE HOLY FAMILY
AGAINST A WINDOW

Pen and bistre, 14.4 x 10,3 cm, relined.
Inscribed in a letter hand, bottom right: *Poussin.*
The Hermitage, St. Petersburg, inv. No 5131.

The part of the drawing on the left that shows
St. Joseph and St. Elizabeth is reminiscent of the
painting *The Holy Family with St. Elizabeth and
St. John the Baptist* (1655, Hermitage, St. Peters-
burg). Its right part corresponds to a group in the
picture *The Holy Family with Ten Figures* (Natio-
nal Gallery of Ireland, Dublin; T. Bodkin, «Nicolas

Poussin in the National Gallery, Dublin», *The Bur-
lington Magazine,* 1932, 1, p. 174; Blunt 1966,
No. 59), painted in 1649, the same year as *Moses
Striking the Rock, Landscape with Polyphemus,
The Judgement of Solomon,* the first self-portrait,
etc.
Yet the technique of drawing, the type of shading
and the «mask-like» ovals of the faces of St.
Joseph and Mary suggest that the drawing was
done later, *i.e.,* around the second half of the
1650s.

Provenance: H. Brühl collection, Dresden; since 1769,
The Hermitage, St. Petersburg.

48. *THE CONVERSION OF SAUL*

Pen and bistre, 12.5 x 9 cm.
Inscribed in a letter hand, bottom left: *Poussin*.
The Hermitage, St. Petersburg, inv. No 5134.
Acts 9:3-5.

Though Poussin repeatedly told Chantelou in his letters of 1649-50 that he intended to paint a picture on the theme of Saul's Conversion, there are no existing preliminary works from this period. The idea of doing a painting on this subject again arose in 1657-58 (Corr. 1911, pp. 442, 447, 458), which resulted in widely different sketches.

The present drawing may be considered the earliest version of the composition. It is also stylistically close to the right side of a sketch on the same subject in the collection of E. Shilling, England (1960 Paris, No. 234). The most likely date of execution is c. 1657-58.

Provenance: H. Brühl collection, Dresden; since 1769, The Hermitage, St. Petersburg.

170

49. *THE CONVERSION OF SAUL*

Pen and bistre, 11 x 18.2 cm, relined.
The Hermitage, St. Petersburg, inv. No 8050.
Acts 9:3-5.

In the middle part of the sketch some figures are drawn over others. Depicted are the barely discernible figure of the Apostle, who has been thrown from a rearing horse; captives being beaten by soldiers in the background, amidst kicking horses; and on the left, near the edge of the sheet, a large figure of a warrlor.
The drawing is done with a quick, broken line in the style typical of the artist's late works. The closest analogy to the Hermitage drawing *is The Conversion of Saul* in the collection of E. Shilling, England (1960 Paris, No. 234).
It can be dated 1656-57.

Provenance: H. Brühl collection, Dresden; since 1769, The Hermitage, St. Petersburg.

50. *PARIS AND ŒNONE*

Pen and bistre and pencil, 16.3 x 21.3 cm, relined.
Inscribed in a later hand, bottom left: *Poussin.*
The Hermitage, St. Petersburg, inv. No 5129.
Ovid, *Heroid.* 5.

The catalogue by Friedlaender and Blunt (Drawings 3, p. 41, No. A 65) interpreted the drawing's theme as the scene with Paris and Oenone. A drawing of a similar composition in the Nationalmuseum, Stockholm, previously entitled *Medoro and Angelica, is* now also thought to depict the meeting of Paris and Oenone (Drawings, 3, p. 40, pl. 183, No. B 25). In the above mentioned catalogue the Hermitage drawing is listed as a copy (Drawings, 3, p. 41, No. A 65, pl. 180), but the outlines of the head of Paris, the landscape background and some other details of the drawing reveal a search for forms that never occurs in copies. The sketch was initially done in pencil and the pen lines do not always coincide with preliminary ones — a characteristic feature of Poussin's graphic works. A broken, as if trembling line, common to Poussin's late style, suggests that the drawing was done in the mid- or late 1650s.

John Shearman who saw the Hermitage drawing in 1965, also paid attention to the peculiarities of its technique that speak of Poussin's own hand, and agreed that the drawing should be considered his authentic work.

Provenance: H. Brühl collection, Dresden; since 1769, The Hermitage, St. Petersburg.

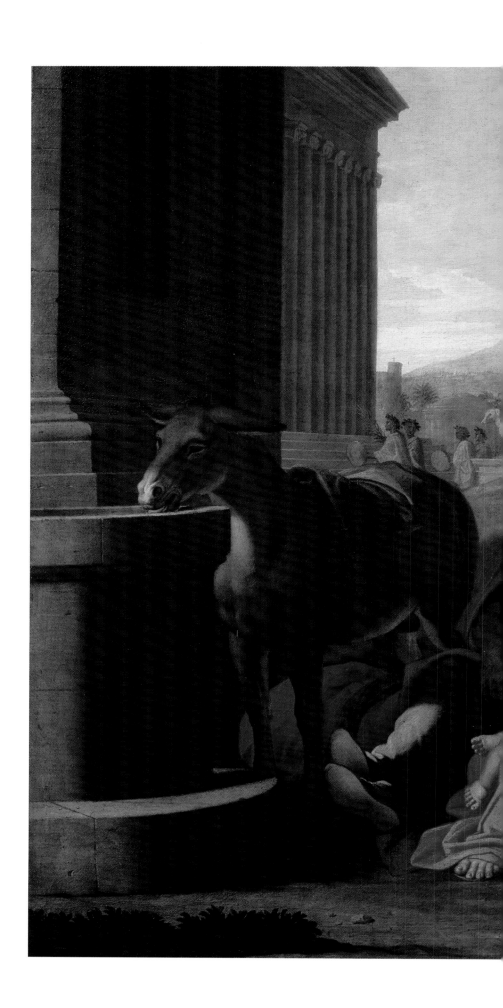

The Holy Family in Egypt.

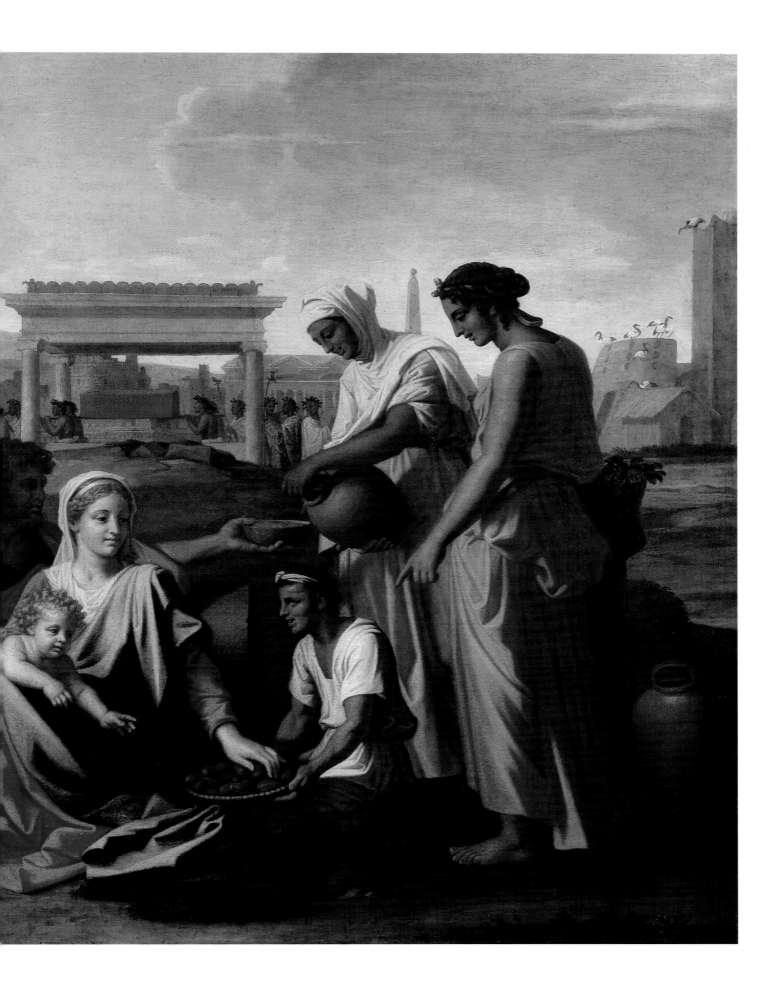

51. *THE HOLY FAMILY IN EGYPT*

Oil on canvas, 105 x 145cm.
The Hermitage, St. Petersburg, inv. No 6741.
Matthew 2:13-14.

In addition to the theme's principal source there exists an apocryphal story after pseudo-Matthew, which was often depicted in seventeenth-century works of art as follows: Joseph and Mary with the infant Jesus surrounded by angels who brought them fruit and flowers. The scene in the Hermitage picture is presented in a different way: the Holy Family is sitting near a stone building, and a kneeling youth on Mary's right is offering her food from a bowl while one of the two women behind them is pouring water from a vessel into a cup held in Joseph's outstretched hand. In the distance is a procession of priests and a tower with ibises, the sacred birds of Egypt. In his letters to Chantelou Poussin referred to the picture as *Madonna in Egypt* or *Egyptian Madonna.* When the artist sent the completed picture to his patron, he enclosed with it a letter stating that all the unusual details, that is, the procession of priests carrying a chest with the remains of the God Serapis to the Temple, the dwelling of ibises and the tower with a concave roof for collecting dew, were not his invention, but had been prompted by an ancient mosaic from the Temple of Fortuna in Palestrina. This mosaic, discovered shortly before the painting's execution at the excavations under the Colonna Palace, was kept in the collection of Cardinal Francesco Barberini beginning in 1650, where Poussin was able to see both the original mosaic and watercolour copies done from it. The copies, now in the Royal Library (Windsor Castle, England), were made for Cassiano dal Pozzo. Their comparison with *The Holy Family in Egypt* at the Hermitage shows that the artist borrowed from the classical composition those details which gave concrete attributes to the location and which introduced an Egyptian colouring. In the above mentioned letter Poussin wrote: «I introduced all these details in order to enliven the picture with novelty and variety, and to show that the Madonna represented is in Egypt» (Corr. 1911, pp. 448, 449).
According to Charles Dempsey (1963), it may have been Poussin who was the first to connect the scenes of the ancient mosaic with the Egyptian myth of the God Serapis. This supposition is backed by Bellori's testimony, who said that when Poussin was working on the subject of a painting he studied all the pertinent sources available.
There are different opinions as to Poussin's unusual and completely new treatment of the present subject. Dempsey thinks that the friendly encounter between the pagan Egyptians and the family of Christ embodied the idea of the unification of the worlds of old paganism and new Christianity. Kozhina (*Gemälde aus der Ermitage und dem Puschkin-Museum,* Vienna 1981, pp. 94-97) interpreted this as an expression of the circumstances of the artist's private life. In Italy, where he spent the greater part of his life, the attitude to Frenchmen was often hostile, which, as is shown by his letters and the testimonies of contemporaries, was felt by Poussin. It is not unreasonable to conclude that the themes of *The Holy Family in Egypt* and of his next picture *Christ and the Woman of Samaria,* also done for Chantelou, were partially dealing with the problem of the interaction of people of different nationalities and beliefs. By showing the triumph of good over human discord, the artist strove to arrive at the ideal and harmonious solution to this problem.
There is a preliminary drawing to the Hermitage painting in the Musée Condé, Chantilly. A copy of the picture belongs to a private collection (Worcestershire, England).

Engravings: 1. J. Dughet (Andresen 1863, No. 157; Wildenstein 1955, No. 59); 2. F. Chauveau, 1667 (Andresen 1863, No. 158); 3. Anonymous published by E.Gantrel (Andresen 1863, No. 159); 4. Anonymous published by Quenault (Andresen 1863, No. 160).

Provenance: 1658, owned by Chantelou, Paris; 1800, Count A. Stroganov collection, St. Petersburg; 1931, entered the Hermitage from the Stroganov Palace Museum, Leningrad-St. Petersburg.

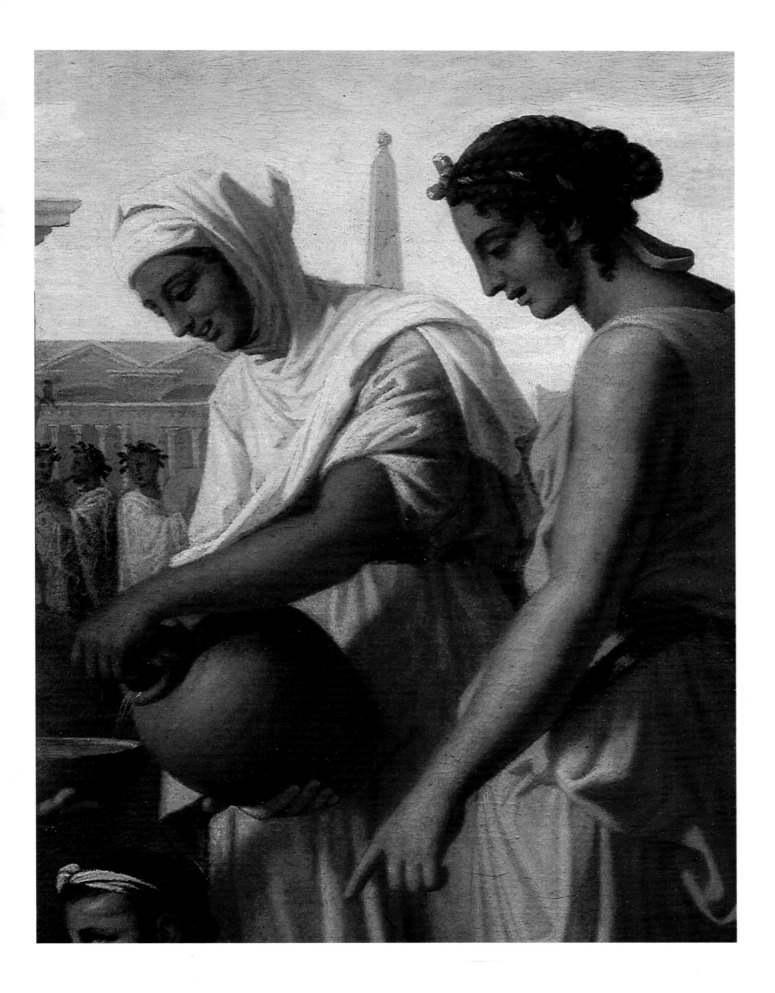

52. *LANDSCAPE WITH THE TEMPTATION OF CHRIST*

Pen and bistre over black chalk, 19.5 x 25.5 cm, relined.
The Hermitage, St. Petersburg, inv. No 7144.
Matthew 4:1-11.

The landscape's attribution to Poussin was first stated by Alexander Benois. At a 1926 exhibition it was displayed as «an unknown subject» by Poussin. Later Irena Linnik suggested (orally) that it was a scene from the Temptation of Christ. Without denying that that version was a possibility, Shearman put forward the supposition (Drawings, 4, p. 52, No. 291, pl. 222, fig. 291) that the drawing depicted Antonius and Paul in the desert. Yet the hermits' usual attribute, a raven, is absent. The scene's emotional intensity speaks of the subject's importance and supports Linnik's interpretation. The free lines in black chalk, not always followed by the quick nervous lines of the pen, and the figures' «trembling» contours are typical of the artist's late style.
The drawing can be dated to the late 1650s-early 1660s.

Provenance: K. Cobenzl collection Brussels (stamped L. 2858b); since 1768, The Hermitage, St. Petersburg (L. 2061).

181

53. *APOLLO AND DAPHNE*

Pen and bistre, 13.5 x 18.5 cm, relined.
Inscribed in a later hand, bottom right: *Poussin*.
The Hermitage, St. Petersburg, inv. No 5138.
Ovid, *Metamorphoses*, 1, 452-567.

The catalogue by Friedlaender and Blunt (Drawings, 3, p. 19) describes this drawing as a sketch for the Louvre painting *Apollo and Daphne* which remained unfinished because of Poussin's death. The Hermitage drawing shows the initial version of the composition.

Provenance: H. Brühl collection, Dresden; since 1769, The Hermitage, St. Petersburg.

54. *APOLLO AND DAPHNE*

Pen and bistre, 12.5 x 15.2 cm, relined.
Inscribed on the framing cartouche by Alexander Benois: *Poussin.*
The Hermitage, St. Petersburg, inv. No 7007.
Ovid, *Metamorphoses.* 1, 452-567.

Friedlaender and Blunt (Drawings, 3, No. 176), proceeding from the depiction of Apollo, considered the drawing to be a preparatory one for the Louvre painting of the same title. On one side it shows a group of nymphs and on the other, the group of Apollo and Mercury, which are present in all versions. The centre is left unfilled. The figure of Daphne only appears in a large compositional sketch at the Louvre (Drawings, 3, p. 18, No. 174, pl. 142; 1960 Paris, No. 237), which is very close

to the painting. A cupid hiding behind the nymphs occurs for the first time in the bottom right of the Hermitage drawing. Poussin was probably illustrating the first episode of Apollo's «encounter» with Cupid, where the God of the Sun, revelling in his victory over Python, laughs at Cupid, who shoots at the offender an arrow that «inspires love».
In the Louvre drawing Cupid is placed in the same group with Apollo, directing his «arrow of revenge emitting love» at Daphne. Counter to the tradition, Poussin united the final episode with the preceding one: the same drawing shows Daphne turning into a laurel tree.
The drawing was most likely executed in the 1660s.

Provenance: K. Cobenzl collection, Brussels (stamped L. 2858b); since 1768, The Hermitage, St. Petersburg (L. 2061).

55. STUDIES OF HEADS

Pen and bistre, 9 x 10 cm, relined.
Inscribed, bottom left: *R.D. Urbino.*
The Hermitage, St. Petersburg, inv. No 5293.

The drawing has always attracted special attention because of its high level of execution. The old inventories of the Hermitage listed it as belonging to the Raphael school. This was not the only attribution suggested: some specialists considered it to be the work of Raphael himself, and it was engraved as such in the eighteenth century. According to G. Shearman, the drawing was done by Poussin from the heads in the *Healing of the Crippled Beggar by the Temple's Beautiful Gate*, the famous series of Raphael's cartoons for the tapestries. Since the cartoons were sent to weavers in Brussels as soon as they were ready in 1515-16 and later, though changing hands several times, were never in either France or Italy, Poussin could not have seen the originals. The artist could have been familiar with them from engravings, or from the exhibition of tapestries in the Galleria degli Arizzi in the Vatican. Much more likely is that these sketches derived from Raphael's free preliminary drawings and were given Poussin's own interpretation. Shearman's hypothesis was supported by Blunt (Drawings, 5, p. 47, No. 365, pl. 275, fig. 365). The drawing is done on *papier vergé*, which was commonly used by Poussin. The drawing was engraved by M. Oesterreich in the engraved edition of Brühl's collection (M. Oesterreich, *Recueil de quelques dessins de plusieurs maîtres habiles tirés du Cabinet de S. E. Mr. Le Premier Ministre Comte Brühl*, Dresden, 1752) with the inscription: *Rafaello Sanzio d'urbino delineat. Malteus Oesterreich fecit 1750. Dans le Cabinet de S.E.M. et Prem. ministre Comte Brühl.*

Provenance: H. Brühl collection, Dresden; since 1769, The Hermitage, St. Petersburg.

THE STATE HERMITAGE in St. Petersburg and the Pushkin Museum of Fine Arts in Moscow, the two major museums in the Russia have between them fifteen paintings and forty-one drawings by the great French artist Nicolas Poussin, all of which are reproduced in this book. In describing how the collection of Poussin's works in Russia was formed, we shall, in fact, be dealing only with the history of the St. Petersburg collection, since from 1927 to 1930 the Hermitage contributed all five of the paintings by Poussin that the Moscow museum now has. They were: *Joshua's Victory over the Amorites,* which is one of a pair; *Rinaldo and Armida,* based on the poem *Jerusalem Delivered* by Torquato Tasso; *Nymph and Drinking Satyr,* which is close in subject-matter and date of execution to the Hermitage *Venus, a Faun and Putti; The Magnanimity of Scipio,* and, finally, *Landscape with Hercules* from the artist's late period. Thus, both museums possess collections fully representative of Poussin's major periods and thematic range.

All of the paintings arrived in Russia over a very short period of time, less than twenty years, from about 1763 — the year when the Hermitage's Picture Gallery was established — till 1779, with the purchase of three paintings from the collection of Robert Walpole. During the nineteenth century the Hermitage did not buy a single work by Poussin; *The Holy Family in Egypt,* which entered it in 1931 through the State Museum Reserve, had been in Russia since the late eighteenth century in the collection of Count Stroganov. *Joshua's Victory over the Amalekites* and *Joshua's Victory over the Amorites* were two of the earliest acquisitions. Exactly when they first appeared in the Picture Gallery and from where is not known. Some data indicate that at the end of the seventeenth century they were part of the collection belonging to Duke Anne-Jules de Noailles, Marshal of France. There is no trace of them after that, and where they were in the first half of the eighteenth century can only be guessed at. It is generally believed that these two paintings came into the possession of the

Picture Gallery some time between 1763, when it was established, and 1774, when they were already listed in the inventory begun in 1773.

In purchasing paintings for her gallery Catherine the Great relied on the advice of experts, such as the French philosopher Denis Diderot and Prince Dmitry Golitsyn, one of the most educated Russians of his day and Catherine's ambassador to Paris from 1762 to 1768. Prince Golitsyn's first acquisitions were made at the sale of the collection belonging to the artist Jacques-André Joseph Aved in 1766. An inventory of the collection mentioned two Poussin paintings "one of which depicts Angelica ordering the monsters, who have been turned into pleasures, to kidnap Rinaldo, and the other shows Angelica cutting off a lock of her beautiful hair with which to wrap the wounds of the fallen Medoro. These plots are borrowed from Tasso." The compiler of this inventory, the famous expert Pierre Rémy, confused the heroes of Tasso's poem *Jerusalem Delivered* with those of Ariosto's *Orlando Furioso.* The mistake was corrected in a hand-written catalogue of the Hermitage collection compiled by Ernest Minich, an expert in charge of the gallery from 1773 to 1783. Since then, these two masterpieces, *Tancred and Erminia* and *Rinaldo and Armida,* have been kept in Russian collections.

In 1768, along with other paintings from the collection of the Sachsen minister Count Heinrich Brühl, the Hermitage acquired Poussin's *The Deposition.* Formed when the Count was in charge of purchasing paintings for the Dresden Gallery, this quite large collection of about six hundred paintings was sold off by Brühl's heirs after his death through the mediation of A. M. Beloselsky-Belozersky, the Russian envoy to the court of Augustus III.

Venus, a Faun and Putti, Nymph and Drinking Satyr, Cupids and Genii, and *Putti Hunting* all originate from the collection of Louis Antoine Crozat, Baron de Thiers, bought in 1772 by Catherine the Great via Denis Diderot and Prince Dmitry Golitsyn. During his lifetime, Pierre Crozat (1665-1740) assembled one of the most representative and outstanding collections of paintings and drawings in eighteenth century

France, which, upon his death, was inherited by his nephew, Louis François Crozat, Marquis du Châtel (1691-1750). The collection then went to the Marquis's brother, Joseph Antoine Crozat, Baron de Tugny (1696-1751), and, finally, to the youngest brother Louis Antoine Crozat, Baron de Thiers (1699-1770), who held a sale of the Tugny collection, though he bought the majority of it himself. After his death it was decided to auction off the collection. Having learned of the plans, Counsellor François Tronchin, a well-known Genevan collector, passed word of them on to Diderot and Golitsyn, who, in their turn, informed Catherine the Great. The Empress entrusted Tronchin to negotiate the purchase of the entire collection, and, on the basis of an inventory compiled by him, this was accomplished in 1772.

While the paintings *Cupids and Genii* and *Putti Hunting* were immediately included in the Hermitage inventory, the canvases *Venus, a Faun and Putti* and *Nymph and Drinking Satyr* had a more complicated history. They were not listed in the Hermitage inventory for 1773-83, which was an exhaustive record, but were mentioned as being among the works of the Crozat collection. The Hermitage did not come into possession of these two paintings until 1822 when they were acquired from General Korsakov's collection, whose history is little known (record of January 5, 1822: Hermitage Archives, coll. 1, inv. VI "A", No. 87). Doubts were also expressed that these paintings were ever a part of the Crozat collection. Smith wrote in 1837 that the Hermitage *Venus, a Faun and Putti* was originally in the Dufourny collection and then passed into the Tugny collection, from which it was sold at the 1751 auction. In fact, this is impossible, because the Dufourny collection was put up for sale in 1819, that is, seventy years after the Tugny collection had ceased to exist. The catalogue of that sale, however, does list a painting, No. 92, whose description matches the one in the Hermitage exactly. It is also mentioned there that No. 92 was bought by Dufourny from Giovanni Pezzi, who had acquired it from Prince Chigi. Much more likely is that the Tugny painting passed into the collection of Crozat, Baron de Thiers, since its 1755 inventory lists the same picture, which was then included in Tronchin's 1771 compilation of paintings to be sold to Catherine the Great. Still, as has already been mentioned, the picture's name is missing from the Hermitage inventory for 1773-83, as well as from a printed catalogue published in 1774. These strange circumstances, along with the discrepancy between the inventories of both the Crozat and Hermitage collections, threw doubt upon the origin of the supposed Crozat picture.

Venus, a Faun and Putti is listed in the Livret of 1838 as having been purchased by Alexander I from a private collection. Starting in 1863 the Hermitage catalogues give the provenance of the painting as from the Crozat collection, though without producing any proof.

A catalogue of 1892 describes the painting that was sold at the Dufourny auction as being a variant of the one in the Hermitage collection. On top of that, a 1916 catalogue of the Ruffo collection in Messina lists a picture with an identical description. Various opinions as to the picture's provenance have also been expressed by experts from other countries. Anthony Blunt gave all three versions of its history in 1966; in 1974 Jacques Thuillier stated that the picture's provenance was impossible to trace; while in 1980 Doris Wild mentioned it only as listed in the catalogue of the Ruffo collection. Three stamps on the back of the painting *Venus, a Faun and Putti* finally helped to determine its origin. The first one was a stamp of the Grand Prince Paul (the future Paul I), the second bore a representation of a boat and was inscribed in Russian with the motto "Without a Captain", and the third one, as was discovered, belonged to Tronchin. This last stamp appears on many canvases shown by the inventory to have originated from the Crozat collection. Perhaps when choosing the pictures from this collection for Catherine the Great, Tronchin marked them with his stamp. Thus, the former versions proved to be incorrect and it can be stated with certainty that the picture came from the Crozat collection. An important conclusion follows from the settlement of this question: the

Hermitage painting is the original. This is documented by a letter written by Abraham Bruegel to Antonio Ruffo that speaks of two pictures: the original, which, according to Poussin, remained in France, and a replica that came into the possession of Ruffo. It is most probable that the Hermitage painting went from the French collection into the Tugny collection and is precisely the mentioned original. It is also not impossible that the copy owned by Ruffo in Messina passed into the Chigi collection and then to Dufourny, thus explaining its being sold at the 1819 auction.

Still, the unravelment of the two paintings' pre-Russian history did not at all help to solve the mystery of their disappearance in Russia from 1772 to 1822.

N. Stadnichuk, a research worker at the Pavlovsk palace museum, informed the Hermitage that they had a picture with a stamp on the reverse identical to the one marking *Venus, a Faun and Putti*, that is, the stamp bearing the boat and motto. This picture was acquired from the collection of Count Grigory Orlov in Gatchina Estate which was given to him as a gift by Catherine the Great in 1765. In all likelihood, the stamp on the back of both paintings belonged to the Count. The picture must have been presented to the Empress's favourite right after the Crozat collection was acquired. After Orlov's death all of his estates, including Gatchina with its palace and art collections, were purchased from his heirs by the Royal Treasury and given, by special edict, to the Grand Prince Paul in 1783. It was then that the picture was marked with the Grand Prince's stamp. Stadnichuk also discovered a reference to the paintings from the Gatchina Palace having been given as a gift by Paul I to General Korsakov (Hermitage Archives, coll. 472, inv. 18/110/947, year 1857, file No. 2, pp. 47, 48). *Venus, a Faun and Putti* and *Nymph and Drinking Satyr* may very well have been among those paintings. Quite possibly, Paul I made a special point of giving away the pictures that had previously been part of Count Orlov's collection.

Thus, the history of the two paintings becomes clear. After being acquired by the Hermitage as part of the Crozat collection, they were presented to Count Orlov without being entered in the inventory; then, together with the Gatchina Palace, they came into possession of Paul I, who in turn gave the pictures to General Korsakov, from whose collection they came back to the Hermitage in 1822.

Equally interesting is the story behind *Landscape with Polyphemus* and *Landscape with Hercules*, acquired from the Marquis de Conflans for Catherine the Great by Prince Golitsyn with Diderot's assistance. The latter narrated the story of their purchase in a letter written to François Tronchin on July 17, 1772: "... My downstairs neighbour is the agent for the Marquis de Conflans. The Marquis is a gambler and one night not so long ago he lost terribly. When he came back home he noticed two wonderful landscapes by Poussin that he had never really looked at before. He called his agent. 'Dumesnil', he says, 'sell these; at the moment I am more in need of money than pictures.' Dumesnil then offered them to me. Ménageaut had a look at them and I took them both for 1,000 écus. I had them cleaned and afterwards Ménageaut offered me 10,000 francs for them. I have since learned that they used to belong to M. d'Armentières who was successively offered for them first 2,000 écus, then 10,000 francs by Ménageaut and, finally, 12,000 francs...

Both are seven feet wide and about six feet high. One shows tall, magnificent hills on the top of one of which Polyphemus is shown from the back playing a reed pipe; below there is a meadow with Acis, Galatea and other shepherds. The other also shows high hills, solemn and grand. On the left side of the top of one of these hills is the entrance to Cacus's cave. There one can see Cacus, prostrate with his head down and his legs up, about to be killed by Hercules, who is stepping on his genitalia and holding a club over the scoundrel. Below there are shepherds and animals. These two pictures of Poussin's are now with Prince Golitsyn in The Hague."

In 1772 the two paintings described in Diderot's letter were brought to St. Petersburg and added to the Hermitage collection.

Commissioned by a French banker named

Cérisier, *Esther before Ahasuerus* was painted by Poussin in the 1640s. The painting was known to be part of the collection of Philippe, Duke of Orléans, in 1717, but further trace of it was lost. It appeared in the Hermitage collection sometime between 1763 and 1774, but it has so far been impossible to find out exactly when it was purchased or from where.

The three canvases — *The Magnanimity of Scipio, Moses Striking the Rock* and *The Holy Family with St. Elizabeth and St. John the Baptist* — came to the Hermitage with one of England's most prominent collections of the first half of the eighteenth century. Put together by Robert Walpole (1676-1745), Prime Minister under George I and George II, the collection was kept in his castle Houghton Hall. His son Horace Walpole compiled a description of the Houghton Hall collection in 1747. In 1778 Robert Walpole's nephew, having heard of the purchases then being made by the Hermitage, contacted Count A. I. Moussine-Pushkin, Catherine the Great's ambassador to London, offering to sell the entire collection to Russia. In 1779 the 198 works of the collection arrived in St. Petersburg.

In 1931, after a gap of 150 years, *The Holy Family in Egypt* — the last of Poussin's paintings to come to the Hermitage — was acquired by the museum. It had been in Russia since the late eighteenth century as part of the collection formed by A. S. Stroganov in Paris in the late 1770s.

Mentioned in the 1880 catalogue of the collection, *The Holy Family in Egypt* was housed in the Stroganov palace in St. Petersburg. After the October Revolution of 1917 the art collections in the palace were eventually transferred to the Hermitage through the State Museum Reserve. All of the drawings by Poussin preserved in the Hermitage and the Pushkin Museum were also acquired in the eighteenth century. They came primarily with two large collections purchased by Catherine the Great: that of Heinrich Brühl, mentioned above in connection with the *Deposition,* and of Count Johann Karl Philipp Cobenzl, a minister of the Austrian court. The latter collection was bought through the assistance of Dmitry Golitsyn. The Cobenzl collection, numbering about 4,000 drawings in addition to paintings, was a major acquisition made by the Hermitage. A few more drawings were transferred to the Hermitage in 1924 from the Academy of Arts. Formerly a part of the famous collection of the French art lover Jean de Jullienne, these drawings also came to Russia in the eighteenth century. In Russia, they were in the possession of Ivan Betzkoi (1704-1795), President of the Academy, who later donated his entire collection to the Academy. Thus, all the works representing Nicolas Poussin in Russian museums were amassed in Russia as early as the eighteenth century.

Natalia Serebriannaïa

188

BIOGRAPHY

1594
Nicolas Poussin is born in Normandy (either in the town of Les Andelys or in the village of Villers).

around 1612
Meets the painter Quentin Varin at Les Andelys. Leaves for Paris.

1612-23
The first Paris period.
For a short time attends the studios of Ferdinand Elle and Georges Lallemand. Goes to Florence. Works at the Palais de Luxembourg.

1622-23
Meets the Italian poet Giambattista Marino. Makes a series of drawings for Marino based on Ovid's *Metamorphoses*.

late 1623
Paints *The Death of the Virgin* for Notre Dame in Paris.

early 1624
Stays in Venice.

March 1624
Arrives in Rome where studies antique and Renaissance art.

1628-29
Paints *The Martyrdom of St. Erasmus* commissioned by the Vatican.

1630
Failing to obtain the expected commission for the decoration of a chapel in San Luigi dei Francesi, Poussin finally resolves to work for private patrons only. Marries Anne Marie Dughet, daughter of a pastry-cook.

1630-31
Paints *The Realm of Flora* (Gemäldegalerie, Dresden), *Midas before Bacchus* (Alte Pinakothek, Munich) and *The Plague at Ashdod* (Louvre, Paris).

1633
Paints *The Adoration of the Magi* (Gemäldegalerie, Dresden).

1636
Paints a series of *Bacchanals* for Cardinal Richelieu. Receives commissions from Parisian art patrons and becomes widely known in France.

1640-41
Arrives in France, works on the decoration of the Grande Galerie of the Louvre, etc. Has a conflict of principles with the court artists.

1642
Writes a letter to Sublet de Noyers, expounding his artistic methods. Gabriel Naudé, in a letter, describes Poussin's difficulties in Paris and informs about the artist's decision to return to Rome. Poussin leaves for Rome.

1644-48
Executes the cycle of paintings *Seven Sacraments* commissioned by Paul Fréart de Chantelou. Works on commissions from various collectors.

1649-1650
Paints self-portraits.

1660-64
Works on the cycle of paintings *The Four Seasons* (Louvre, Paris).

1664
Poussin's wife dies.

March 1665
Writes a letter setting forth his concept of painting.

April 1665
Meets a group of young French artists and shows them how to measure ancient statues.

November 19, 1665
Poussin dies in Rome.